WHAT'S WRONG
WITH CONTEMPORARY ART?

PETER TIMMS was born and educated in Melbourne. After short periods of employment at the National Gallery of Victoria and the Art Gallery of New South Wales, he was appointed director of Shepparton Art Gallery in 1973. He moved to Sydney as an exhibitions co-ordinator for the Australian Gallery Directors' Council in 1980, subsequently becoming assistant curator of the Mint and Barracks Museum.

While director of the Manly Art Gallery and Museum in the mid 1980s, he was awarded a Winston Churchill Memorial Fellowship for a period of study in Europe. He later joined the New South Wales Regional Galleries Association as a project coordinator, before giving up full-time employment in favour of freelance curating and writing.

During the 1990s, he was art critic for the *Age* and the editor of *Art Monthly Australia*.

He lives in Hobart, where he is Tasmanian art critic for the *Australian* and writes regularly for publications in Australia and abroad. His books include *Australian Studio Pottery and Chinapainting* (1986), *The Nature of Gardens* (1999), and *Making Nature* (2001).

WHAT'S
WRONG WITH
CONTEMPORARY
ART?

PETER TIMMS

UNSW
PRESS

A UNSW PRESS BOOK

Published by
University of New South Wales Press Ltd
University of New South Wales
Sydney NSW 2052
AUSTRALIA
www.unswpress.com.au

National Library of Australia
Cataloguing-in-Publication entry

Timms, Peter, 1948- .
What's wrong with contemporary art?

Includes index.
ISBN 0 86840 407 1.

1. Art, Modern - 21st century. I. Title.

709.05

Design Di Quick
Printer Hyde Park Press

CONTENTS

LIST OF ILLUSTRATIONS

AUTHOR'S NOTE

The individual artists and the particular artworks I discuss are simply those that I consider most suited to my arguments. This is not a survey, and I make no claims for fair and equal coverage. In every case, my examples are purely for the purposes of illustration and nothing more should be construed from them.

Some material in this book has already appeared in one form or another in the *Age*, the *Australian*, *Art Monthly Australia*, *Ceramics: Art and Perception*, *Australian Book Review*, *Object*, *Contemporary Craft Review*, and the newsletter of the Crafts Council of Victoria. Most of the argument, however, has not been published previously.

I am grateful to Robin Derricourt, Phillipa McGuinness, Heather Cam and Linda Luong at the University of New South Wales Press for their enthusiastic response to the manuscript, and to editor Jane Arms for the care and attention she gave it. My agent, Lyn Tranter, was, as always, supportive well beyond the call of duty. Robert Dessaix read and commented on the manuscript, inspiring innumerable thoughts and ideas, and offered endless encouragement.

Among the many others who made suggestions, engaged me in discussion, or simply listened as I sorted out my thoughts, I want to thank Kate Bochner, Roz Cheney, Jonathan Kimberley, David Hansen and Robert Hollingworth.

I also wish to thank those artists and their representatives who allowed me to reproduce their work: Antony Hamilton; Deborah Paauwe and Greenaway Gallery, Adelaide; Callum Morton and Anna Schwartz Gallery, Melbourne; Liz Dombrovskis and West Wind Press, Hobart; and Gwyn Hanssen Pigott. The National Gallery of Victoria gave me permission to reproduce the work by George Stubbs. The quotation from Terry Eagleton in chapter one is reproduced courtesy of the Times Literary Supplement, London.

INTRODUCTION

'Visual art takes our imaginations on new journeys,' according to the Sydney curator Victoria Lynn. The 'great artists of the past', she assures readers of *Australia Council News,* 'are considered "great" precisely because they took bold new steps in the history of painting, sculpture and architecture. Innovation is the key to taking such steps.'

Lynn concedes that, at times, 'artists make work that is not popular, because it is not familiar'. But popular or not, art is nevertheless essential 'for inspiration and wonder; for the encouragement to push boundaries and open our minds; to challenge our perspectives on life and society...' [1] You can just see artists, curators and arts managers all over the country nodding their heads in enthusiastic agreement.

For those outside this charmed circle, however, such panegyric, however well meant, is likely to strike a hollow note, and not only because it is all sales pitch, chock-full of clichés, unsupported suppositions and unjustified appeals to historical precedent. What is being so passionately promoted here is disconcertingly remote from

our actual experiences in contemporary art spaces, commercial galleries and museums.

Nothing would please us more than to have our imaginations taken on new journeys by contemporary art, to feel inspired and full of wonder, our minds opened and our perspectives on life transformed. As we troop dutifully from one Sydney Biennale installation to the next, however, or perch on a plastic chair at the Institute of Modern Art watching a wobbly video of the sort that even SBS wouldn't touch, the likelihood of this happening is minimal. Few of us even expect it any more.

It is the gap between the hype about contemporary art and what I believe to be the common experience of it that is the focus of this book. I want to reassure readers at the outset, however, that this will not be just another attack on the various forms of contemporary art. I certainly do not believe that everything would be all right if only artists would abandon installations and videos, learn how to draw, and get back to paint on canvas. There are many artists, working in a wide range of media, whose work I admire and respect. I do think, however, that there are serious problems with art's packaging, promotion and reception. My aim is to tease out, in a spirit of genuine enquiry, what I think these problems are, why I think they matter, and how they might be resolved.

For all that, I make no claim to neutrality. Having worked in the visual arts field for more than thirty years, I admit to feeling dismayed and occasionally angry about what I see as the increasing commodification and trivialisation of art. From my point of view, there are quite a few important questions that need answering.

Why is contemporary art so in thrall to spruikers and promoters, for example, and why do their lofty claims so rarely match the reality? Why does the market have such overwhelming power, even in areas, such as government funding and public broadcasting, previously thought to be its foil? If art has become little more than a commodity in the global marketplace, if the primary concern of artists is the furtherance of their own careers, and if the success of any exhibition is measured by the amount of publicity it generates, what does this tell us about the role of the visual arts in our culture?

The general reluctance of contemporary art professionals to engage with such fundamental questions – the curt dismissal of any

views not conforming to current orthodoxies as 'conservative', 'ignorant' or 'unhelpful' – suggests that even they sense that something has gone badly wrong. The arrogant assumption that contemporary art is unpopular because it is unfamiliar or too complex for ordinary people to understand, the retreat into mindless self-promotion, on the one hand, and arcane theoretical discourse, on the other – neither of which is a genuine attempt at communication, since both patronise audiences in an attempt to shore up power structures – surely indicate deep-seated anxieties about the present predicament of the visual arts.

There are, I would argue, good reasons for this anxiety. Art education, for example, appears to be in a state of decline, both academically and financially, while art museums are turning before our eyes from learned institutions into extravagant palaces of mass entertainment. A contemptuous federal government has cut funding to the arts while subjecting them to increasing political interference, all the while prattling on about 'intellectual elites'. The corporate sector, aware of the public's general lack of enthusiasm for contemporary visual art, remains resistant to taking over the government's responsibilities.Meanwhile, art dealers seem increasingly to be guided by monetary considerations rather than by aesthetic values – which academic theorists assure us are no longer 'relevant' anyway. Unsurprisingly, artists are finding themselves pressured to conform to market-driven models of behaviour, as though the production of art were no different from the production of fashion accessories or designer chairs.

Artists and curators, knowing that their careers depend on attracting attention to themselves at almost any cost, are increasingly turning to visual gags, titillation, public scandal or platitudinous commentaries on newsworthy social issues, under the pretence of 'challenging public perceptions'. The result is both a worrying, although perfectly understandable, lack of public confidence or involvement in what artists are doing and the marginalisation of the visual arts from intellectual discourse. Scholarship, idealism, seriousness of purpose, discernment and discrimination, being essentially non-marketable qualities, are rapidly falling by the wayside.

To recast Matthew Arnold's famous lines in a more positive

light, we seem to be caught wandering between two worlds, one dying, the other yet to be born. Modernism, we are told, is on its last legs, although the institutions of modernism appear as robust as ever. Postmodernism, far from being the radical break with tradition that it is often thought to be, is a transitional phase, a sort of clearing of the intellectual decks for whatever might happen next. While acknowledging that such linear constructions of history will be unacceptable to many, I think there is a case for seeing post modernism as a kind of mannerism.

Seen in this light, the contemporary art that is customarily promoted as innovative or 'cutting edge' – notions that also depend on a linear construction of history – is nothing of the kind. It is, rather, modernism's last gasp, an art that still clings tenaciously to the old certainties of rationalism, instrumentalism and materialism. Frankly, these may be the only available options. If you have no conception of history – linear or otherwise – then you remain a prisoner of your own time, trapped in a cycle of habit. The inevitable result is narcissism – an exclusive obsession with one's own milieu. Contemporary art is nothing if not overwhelmingly narcissistic. How often do we hear people demanding that art be 'relevant' to their own lives, that it be the mirror in which they might admire and reassure themselves?

The historian Michael Wood has remarked that 'humanity's encoded memories are being erased everywhere across the planet'.[2] A recent survey conducted by Leicester University would appear to back him up. At the beginning of 2004, the university published the results of a survey in which 2,500 young Britons aged between sixteen and twenty-four were asked to name the individual they most admired, from any period anywhere in the world. Equal last on the list, at number 123, were Jesus and George W. Bush. All of the top ten places were occupied by movie stars, pop musicians and footballers, with David Beckham at number one.

The survey results represent both the apotheosis of modernism's total rejection of the past and the triumph of post modernism's love affair with mass culture – not to mention an indictment of Britain's education system. One can only wonder at the poverty of imagination suffered by people who think David Beckham is the most admirable human being who ever lived. It is a

poverty just as crushing as the physical kind, even if the individuals concerned are unaware of its effects on their lives.

Essentially, then, I am arguing for art that seeks to play a part in arresting that process, not by means of any superficial appropriation, but through meaningful involvement in the legends, myths and stories that define cultures: as, for example, the film, *Love Actually*, reinterprets the form of Shakespearian comedy; as the compositions of the young English composer James MacMillan try to express Christian religious ecstasy in a modern musical language; or as the Yam Dreaming paintings of Emily Kame Kngwarreye preserve and reinvent ancient stories.

I am arguing for art that is reconnected with nature, not by being about nature but by employing nature's 'methods of operation', as John Cage once put it: a more poetic, romantic and idealistic art. This means more respect for the process of making art and less emphasis on the resultant product: a Buddhist approach, if you like, that sees art-making as a discipline and a responsibility in its own right, not just as a means to an end. This would mean a radical change of direction on the part of government funding bodies and art educators, one that, admittedly, they are probably not in a position to make on their own.

I am arguing for greater intellectual, emotional and psychological complexity as a counter to the trivialising market-driven popularisation that politicians and bureaucrats are so enamoured of at present, and the banal, and closely related, concept of art as a pedagogical discourse on topical social issues.

And I am arguing for art that is more respectful towards, yet at the same time more demanding of, its audience, art that is neither facile nor wilfully abstruse, rewarding patience, knowledge and dedication.

I believe that in this age of disintegrating certainties and economic rationalism such art is not only possible but already exists. To see it, and to understand its importance to our lives, we need to shut down the so-called arts industry, drive off the money-changers, hucksters and spruikers, and acknowledge that art is not merely a business, an entertainment, an expression of national pride, or a substitute for political action, but a means of asking serious and profound questions about who we are, where we have come from, and where we might be going.

1

WHY NEW MEDIA RULE

Some years ago, I did a series of spots on Radio National's Sunday morning arts program, reviewing a selection of current exhibitions. One morning I arrived at the studio eager to talk about Celia Rosser's *Banksia Project*, a set of meticulous, scientifically accurate watercolours of all the known banksias by one of the world's foremost botanical artists. The program producer was not entirely happy.

'I'm not sure that this is really contemporary art,' she said.

'Well,' I said, feigning innocence, 'it's recent art, and of very high quality, and it was done by a living Australian artist.'

'Yes, I know, but it's not what we mean by contemporary art, is it?'

Perhaps not. What, then, *do* we mean by contemporary art?

It depends, of course, on who you ask. Often, the word 'contemporary' refers to nothing more than recent art that meets with the approval of whoever happens to be talking. In this sense, it is a dialectical term separating what's considered worthwhile from what is not, just another way of marking off the good from the bad. In this way, 'contemporary craft' is that which aspires to the status of

art and is supposed to be held in high regard, as distinct from milk jugs, knitted shawls or hand-wrought metal fire-tongs.

When the Australia Council talks about supporting contemporary artists, it doesn't mean just any living artists. It means those living artists it considers 'serious', 'dedicated' or 'professional' – value judgments that neatly avoid the embarrassment of sounding like value judgments. Dealer galleries sometimes use 'contemporary' in this sense because it imparts an air of importance and quality to the works they sell. Dulcie Dollop Contemporary Art sounds classier than Dulcie Dollop Gallery, yet at the same time less pompous – and, of course, more specific – than Dulcie Dollop Fine Art. Subtle distinctions of this sort are important for market positioning.

Art auction houses, on the other hand, use the term more neutrally, since they can afford to be less discriminating. Christie's Contemporary Art will accept any work by a living or recently dead artist, so long as it will attract bidders. 'Contemporary' here simply means newish.

The most common answer to this question, however – the one you're most likely to hear from curators, artists and administrators – is that contemporary art is that which 'engages with contemporary theory': that is, the sort of basically French cultural theory taught in university humanities departments under the broad rubric of postmodernism. So entrenched has this become in the academy that it is often referred to simply as 'Theory' (with a capital T), as if no other kinds of theories existed, despite the fact that postmodern theory is a confusing welter of conflicting ideas. Metanarratives are, it seems, impossible to avoid.

Since this is not a book about art theory, this is not the place to elucidate postmodernism. Even if an explanation were possible, I am hardly the one to provide it. The English literary critic Terry Eagleton has made an attempt, however, and his is probably as good a summary as any, especially since it has the distinct advantage of being not a little post-modernly ironic itself:

> There is, perhaps, a degree of consensus that the typical post-modernist artefact is playful, self-ironising and even schizoid; and that it reacts to the austere autonomy of high modernism by impudently embracing the language of commerce and the commodity.

Its stance towards cultural tradition is one of irreverent pastiche, and its contrived depthlessness undermines all metaphysical solemnities, sometimes by a brutal aesthetics of squalor and shock ... Post-modernism signals the death of such 'metanarratives' whose secretly terroristic function was to ground and legitimate the illusion of a 'universal' human history. We are now in the process of wakening from the nightmare of modernity, with its manipulative reason and fetish of the totality, into the laid-back pluralism of the post-modern, that heterogeneous range of life-styles and language games which has renounced the nostalgic urge to totalize and legitimate itself ... Science and philosophy must jettison their grandiose metaphysical claims and view themselves more modestly as just another set of narratives.[1]

Because of its origins in cultural theory, contemporary art thus understood is more likely to be concerned with discourse than with disclosure. And it will probably be self-referential in the superficial sense of drawing consciously on art history – particularly very recent art history – in order to dissect, examine and, as Eagleton suggests, to undermine it.

Literature and the movies – in fact, all forms of narrative fiction – usually invite us to experience things. They typically work at a metaphorical level. To take a couple of very obvious recent examples, *Lord of the Rings* and the *Harry Potter* stories – in both their book and film versions – invite us to experience magic and myth, to indulge ourselves in identification. Contemporary visual art, on the other hand, is more likely to want us to stand back and examine how magic and myth function in the culture. It works at one remove, as commentary or discourse, relying not on metaphor but on metonymy. Metaphor is vertical and associative, creating value by means of hierarchies of meaning, whereas metonymy is sequential and horizontal. Instead of creating meaning, metonymy substitutes an attribute or some other parallel object for the one being considered. Metaphor, then, is romantic while metonymy is realist.

This distinction is very like the one Hanna Arendt made between metaphor and allegory:

... metaphor (when understood in its original, non-allegorical sense of *metapherein* – to transfer) establishes a connection which

is sensually perceived in its immediacy and requires no interpretation, while an allegory always proceeds from an abstract notion and then invents something palpable to represent it almost at will. The allegory must be explained before it can become meaningful, a solution must be found to the riddle it presents, so that the often laborious interpretation of allegorical figures always unhappily reminds one of the solving of puzzles even when no more ingenuity is demanded than in the allegorical representation of death by a skeleton. Since Homer, the metaphor has borne that element of the poetic which conveys cognition; its use establishes the *correspondences* between physically most remote things ...'[2]

Put simply, metonymy is what we employ when we arrange utensils on a table, saying, 'the fork represents your place, the spoon mine and the napkin here is the park on the corner'. It all makes perfect sense so long as the relationships are explained and accepted. To an onlooker, meanwhile, they remain forks, spoons and napkins. On the other hand, when we recognise that the story of Jonah and the Whale is not just about (or not even about) a man being swallowed by a sea-going mammal, we begin to see its metaphorical intent.

For a work to be accepted into the particular canon that the academy calls 'contemporary art', it usually has to be realist and allegorical rather than romantic and metaphorical. Hence, a ceramic object that is intended as a subversive comment on the nature of beauty is more likely to fit the definition of contemporary art than one that is simply beautiful.

A specific example is provided by Tony Clark's painting installation, *Large sacro-idyllic landscape with temple and details of three orders* (1983). Above a shelf containing a collection of architectural fragments, crudely fashioned from modelling compound, Clark has placed a very rough, childlike painting suggestive of a neo-classical landscape, with billowing clouds, rolling hills and a temple. Everything about this painting, from its mock-serious title to the sheer in-your-face crudity of the technique (one writer commented – approvingly – that it is like 'a messy rag retrieved from a painter's garbage bin'[3]), is meant to hammer home the artist's intention that it be read as ironic commentary. As such, it is contemporary art, no doubt about it, and Clark has built his reputation on such heavy-handed parodies of artistic conventions.

A landscape that is not meant to be read as self-referential irony, however, is unlikely to be accorded the status of contemporary art. You won't find a Jeffrey Smart in any biennale, for instance. Nor will Bill Robinson ever represent Australia at Venice. For one thing, they are too old, but more pertinently, their paintings suggest internal narratives and an interest in moral values. These artists use the medium of painting not to subvert but to observe the human condition and our relationships to our environments. That their paintings are competently done is a further mark against them, for it suggests that Smart and Robinson value the skills of their craft for their own sakes and have no wish to denigrate them. One of the many self-contradictions – the ironies, some might say – that sustain contemporary art is that its highly inflated sense of its own importance depends on a pretence of abashed self-deprecation.

Although, strictly speaking, the word 'contemporary' just means 'existing at the same time as', in recent years this meaning has been all but lost. The word has come to mean modern, up to date, and fashionable, and that's how it tends to be used by the art profession. It is distinguished from the merely new by being 'with the times', suggesting that contemporary art is the legitimate next stage in the history of art. The word 'contemporary' confers authority and style.

In this sense, it becomes a sneaky way of avoiding the term 'avant garde', with its unacceptable overtones of linear progress, while at the same time retaining the competitive edge that 'avant garde' confers.

Even as it tacitly acknowledges its own inability to break free of convention (often promoting it as a kind of fashionable nihilism), contemporary art remains obsessed with the idea of innovation, itself a remnant of the early modernists' faith in linear progress. 'Innovative' is an adjective so vital to the perpetuation of the art market that it has taken on an almost magical aura. The Australia Council and all state art funding bodies use innovation as one of their main criteria for funding, and almost all contemporary art prizes demand it as a matter of course. Curators and critics use 'innovation' and 'innovative' to frighten people, even when it is perfectly apparent that the art being considered is both formally and conceptually derivative. The schizoid disjunction between the

work itself and the claims being made for it can often be alarming.

If you can't be conceptually innovative, you can at least appear to be ahead of the game just by throwing away those stuffy old paintbrushes and buying something that plugs in. The Visual Arts/Craft Board has a funding category especially for the purpose, even though it is otherwise very keen to avoid media categorisations. Some media – painting, printmaking, drawing and the crafts – are irredeemably associated with the art of the past while others – performance, video, photography and computer technologies – definitely belong to the present moment. The use of advanced technologies is one way artists can assert their avant-garde credentials by default. These media are sexy.

Just before the opening of the 1999 Melbourne International Biennial, *Signs of Life*, its harried curator, Juliana Engberg, led a small group of journalists on a perfunctory guided tour.

'Some of you,' she said sourly, as we trooped from one room-sized installation to the next, 'will no doubt complain that there isn't enough painting' – although none of us had. The reason, she explained, was that painting is intrinsically less interesting than conceptual and installation art, a fact so self-evident that no further explanation was thought necessary.

This is a not uncommon refrain. The Sydney writer and teacher Adam Geczy, in a muddled polemic entitled 'What's the Point of Painting These Days?', has added his voice to those who, since the mid nineteenth century, have been happily trying to consign painting to oblivion. Geczy's argument, when stripped of its lofty academic trappings, hinges on completely unsupported claims that painting is 'reactionary', 'irrelevant' (to whom?) and 'anachronistic'. Like ceramics, he says, painting 'does not have the same contemporary, critical presence of installation and new media practices, nor can it be said to be speaking the international language of now'.[4] In other words, it just ain't fashionable. Apart from that, painting's principal sins, according to Geczy, are that it is associated with something he calls 'the aestheticisation of uniqueness' and

that it 'is more permeated with practices that we traditionally associate with craft'. That is, it demands a certain level of practical skill, which, as he only half admits, accounts in large part for its unfashionability. If you can't draw or paint, then denigration of drawing and painting is a good defence.

When Geczy writes about 'new media', or 'the craft of painting', or when he says painting is not 'relevant', he always uses inverted commas. He is inordinately fond of the scare quote, a sign that he is not really sure of what he's talking about. This whole painting-versus-new-media argument is inundated with scare quotes, because neither side oozes confidence. When you seek to reduce complex questions about meaning, conceptual complexity and cultural value to a simple binary opposition about which medium is better (or should that be 'better'?), then it's hardly surprising that precision and subtlety will go out the window. On the face of it, those who claim that the whole argument is a tiresome waste of time would seem to have the advantage, except that they are invariably those on the new media side of the fence who complacently believe they've already won.

Perhaps they have, at least for the time being. Few biennale exhibitions these days will include more than a tiny handful of paintings among the videos, installations and cibachromes. And it is probably possible to be employed for years in a contemporary art gallery or artist-run space without ever being called upon to unscrew a packing-case lid or peel off a sheet of bubble wrap. What paintings are exhibited will be of the sort that, like Tony Clark's, use the medium ironically, against itself.

Geczy fails to examine what he means by 'the language of now'. I think what he's referring to is that painting is essentially about seeing rather than talking. Strictly speaking, it's not a 'language' at all, at least not in the sense of being primarily a kind of discussion about external realities. As the philosopher Maurice Merleau-Ponty put it, painting celebrates no other enigma than that of visibility.

There's another, more subtle, reason for painting having fallen from favour. Because of its origins and its long development in Western art, the medium of paint on canvas – for those of us who, for better or worse, have inherited European traditions – comes pre-wrapped in its own symbolic associations, just as woodcarving

does in African cultures or pottery in those of North Asia. For us, painting works metaphorically. It is vertical and associative. Therefore, even – or perhaps especially – the simplest and most straightforward-looking painting demands a certain amount of cultural connectedness. You need to have absorbed the basic mythologies of the culture in order to understand not just what is being conveyed by a painting, but also the manner of its conveyance, for the two are inseparable. All paintings, in other words, even the most innovative, carry with them the immense baggage of the medium's history: they contain traces of memory. New media, even when they are used to express something about history, do not – at least to anywhere near the same extent. This is either an advantage or a disadvantage, depending on whether you regard history as a burden or a source of inspiration.

This is why Malevich's white squares on white backgrounds, or Barnett Newman's coloured zips on acres of flat colour are considered serious art and not just colourful decorations. Although far from being self-referential commentaries on the medium, such paintings depend for their meaning on a fairly sophisticated understanding of how that medium is supposed to work, an understanding not entirely dependent upon our having learned things, but rather upon our having at least some prior *experience* of painting.

This is true even of paintings produced in other than Western cultures. Take, for example, Aboriginal dot paintings, where the disjunction between, on the one hand, the physical form (oil or acrylic on stretched canvas) and, on the other, the subject matter and the style used to convey it, sets up its own lively cultural dialogue.

This, surely, is one reason that artists in remote communities, whose aim is generally to enhance cultural cohesiveness and reinforce traditions, have taken up painting with such gusto. Of course, the medium has obvious practical advantages for indigenous artists, for whom computers and even electric sockets may be hard to come by, and for whom a readily portable art is easier to market. Nevertheless, oils and acrylics on canvas have clearly allowed these artists to develop a rich symbolic language through which they can express those aspects of their traditional culture they want to retain and against which they can measure change.

Perhaps, in the end, these artists have a much broader and more sophisticated understanding of what constitutes the international language of now than your average inner city art-school academic.

If you're not part of a minority culture, of course, you're not supposed to be interested in cultural cohesiveness or in reinforcing traditions, only in challenging and undermining them. Installation, video and performance are much better at this than painting is because they lend themselves more readily to pastiche, indeterminacy and formal incoherence. Painting, because it is associated with synthesis, narrative, and hierarchies of value, may be (and indeed has been) accused of being inherently elitist and Eurocentric, whereas new technologies are supposedly more accessible and culturally democratic. But is this really the case?

The argument that new media are more accessible than traditional ones is not difficult to dismiss. We are told, for instance, that electronic interactives democratise art, turn passive viewers into active participants and break down the barriers between the producers and receivers of art. This argument, revealingly, depends upon a simple binary opposition between one set of media and another, which is conservative by its very nature (so much for diversity, multiplicity and dispersal). New technologies are seen simplistically as being in opposition to traditional media and, by inference, superior, because more up to date (which itself suggests a conservative belief in technical progress).

Consider, for a moment, what this traditional media categorisation might comprise. Clay, for example, has been used to make art since prehistoric times. The working of metals came a good deal later. Oil paint on canvas is very recent by comparison. What can possibly be gained by lumping all these various activities together, along with drawing, printmaking and watercolour, under the single heading of 'traditional media'? The answer is power, of course. All binary oppositions are ultimately about power.

Why, we might ask, is manual interaction – moving knobs and touching screens – automatically considered more engaging than

interaction with the eyes and the mind? New technologies, so the claim goes, allow the viewer to engage directly with the work, to move about in its metaphorical spaces and to reconstruct it. Perhaps so, but this is exactly what happens when we engage with any good work of art. The process of looking at a painting or drawing is one of interpreting, manipulating and reinventing. Certainly there are passive viewers of paintings, but there are also passive users of inter-actives. I recently watched as a whole string of people at a digital art exhibition played idly with the computer mouses and wandered off after just a few seconds. This tells me something about the audi-ence, perhaps, or about the quality of the particular works, but nothing at all about the medium.

I know of no evidence that people are less able to engage with paintings and drawings than with videos or computer screens. Almost everyone has access to pencils, paper and tubes of paint, and people everywhere, especially children, get a real thrill from playing around with them. Advocates of new technologies have no need to try to position them as more relevant or more democratic than other artforms.

The argument that new technologies are less Eurocentric than painting is a little more difficult to counter, given that painting on canvas is, undeniably, an essentially European practice, intricately bound up in Western history. Of course, you might argue that, leav-ing aside considerations of political power, there's nothing intrinsi-cally wrong with being Eurocentric, given that we in Australia live in what is still at root a European culture. We don't have to accept that being Eurocentric is always of itself a terrible thing. But even if we think it is, new media may not be the antidote. They may be no less Eurocentric than paintings are.

In a purely practical sense, installations and performances – and, to a lesser extent, videos – are a kind of welfare-state art. They are public art forms – the natural progeny of government arts funding – since they are likely to be ephemeral, unwieldy, and difficult, if not impossible, to buy and sell. This, of course, is part of their attraction, because it makes them appear to be outside the influence of the market, although, as I will argue later, that's largely an illu-sion, since the market is all engulfing. It is significant that this kind of art is not often found in commercial galleries. If your experience

of contemporary art were to extend no further than that rumbustious annual showcase of the dealer galleries network known as the Australian Contemporary Art Fair, then you might never even be aware that performance or installation existed. The rise to prominence of contemporary new-media art in post World War II liberal democracies is as much a product of government funding as the rise of oil painting on canvas in sixteenth and seventeenth century Holland was a product of the developing commercial art market there.

In the modern West, governments are usually willing and able to support the production of installation, performance and video, and to pay for the public exhibition spaces that show it, the tertiary educational institutions that teach the theory in the first place, and the public museums of contemporary art that represent virtually its only buyers.

The very notion that governments ought to fund the arts for the benefit of all citizens arises with the French Revolution in response to European Enlightenment ideals. In most of Africa, Asia, South America and the Pacific, those ideals have had far less influence. As a consequence, public funding for the arts, while it may be embraced to varying degrees, along with McDonalds and the institutions of democracy, remains a foreign concept.

Therefore, although one of the aims of the Queensland Art Gallery's Asia–Pacific Triennial exhibitions is to promote cross-cultural dialogue and an understanding of the 'vibrant contemporary art of Asia and the Pacific', the word 'contemporary' in this context really means 'Western-style'. It is instructive that a great many of the artists invited to exhibit, although they may have been born in Asia or the Pacific Islands region and bear suitably exotic-sounding names, spend most of their time in Europe, America or Australia, or at the very least are represented by dealers there.

Although Asian curators are included in the selection process (under the supervision of the Australian organisers), a stipulation is that both they and the artists chosen must be 'engaged with contemporary visual art practice and discourse', which effectively means European and American practice and discourse as decreed by art journals, curators, critics and dealers in London, New York, Frankfurt, and the various other centres. The Queensland Art

Gallery, naturally sensitive to any suggestion of cultural imperialism, does everything in its power to ensure equality and mutual respect but, if it wants to be taken seriously, it cannot flout the artworld's conventions.

So we do not really go along to the Asia–Pacific Triennial expecting to see 'the vibrant contemporary art of Asia and the Pacific', but only that part of it which conforms to Western preconceptions. There will be few, if any, ceramic vessels from Japan or South Korea, or batiks from Indonesia, or ink and wash landscapes from China, except, of course, when these traditional artforms are being used ironically as elements of some critique. That there are many highly skilled and original artists working in these traditional artforms, trying to reinvigorate them from within instead of subjecting them to detached observation, is of little interest to the international artworld.

I single out the Asia–Pacific Triennials only because they demonstrate so clearly that international contemporary art, like global free trade – to which it is inextricably linked – is fairly much a one-way street, a subtle and largely unconscious form of cultural imperialism. However witty, perceptive or poetic the work may be, however much it might draw upon cultural specifics for its immediate impact, its basic method of operation will be a post-Marxist dialectical one, since that is what the audience for contemporary art in Western liberal democracies will understand and respond to.

The painting-versus-new-media battle is not as trivial as it might seem. It has had a profound impact both on the sort of art being produced at the beginning of the twenty-first century and on the institutions that display and promote that art. The battlelines have been drawn and the adversaries are firmly entrenched in their respective bunkers, so it's worth considering the reasons for its perpetuation.

The advocates of 'real painting' (those scare quotes again) have the biggest armies and the greatest number of supporters. They are, by and large, however, a relatively disorganised lot with no recognised parade ground. They seem to spend most of their time sniping around the edges of the battlefield, taking the odd pot shot. They are decent and well meaning, yet ineffectual and always, it seems, on the defensive.

Those in the new-media army, on the other hand, are energetic, well organised, disciplined and highly effective. Importantly, they control most of the forums through which ideas are dispersed. By this means they've managed to garner most of the public and corporate funding. As the British critic Tom Lubbock says, '[t]hey present a pretty clear target. They raise suspicions of a "programme". Their work doesn't look at all the same – it isn't a visual thing – but it's informed by a keen and knowing awareness of the art of the (recent) past and of the ideas around it. Vocabularies, references, discourses are to hand and to be used. No patient, authentic struggling. They know the game. Many of these were artists consciously on the make, worldly about the art-world and its ways, who organised themselves, curated their own shows, got themselves noticed and taken up by dealers.'[5]

The English journal *Modern Painters* is one of the very few creditable forums for the painters' case. One of its correspondents wrote that the argument was essentially 'between adherents of all modes [of painting], up to and including Greenbergian abstraction, versus true believers in the conceptual revolution'.[6]

The baffling combination here of vagueness ('all modes of painting') and apparently arbitrary specificity ('up to and including Greenbergian abstraction') indicates just how loosely sketched in the ground rules of this dispute are. The magazine's founding editor, Peter Fuller, although an admirer of Clement Greenberg, would not have agreed with the inclusion of modernist abstraction. He described his own taste as 'neither modernist nor academic', but 'a third way' which encompassed such artists as Stanley Spencer, Paul Nash, David Bomberg, Frank Auerbach and Lucian Freud. (He was nothing if not parochial.) Early issues of *Modern Painters* carried a series of scrupulously gentlemanly debates between Fuller and the American critic Hilton Kramer, in which Kramer pays homage to Fuller's attempt to 'rescue the discussion of art from the poisonous combination of commercialised triviality and ideological nihilism that is now dominant on both sides of the Atlantic'[7] while at the same time lamenting his negative attitude to modernist abstraction.

If there is, in reality, such a subtle range of differing opinions across the board, why are we still being presented with this simple

binary opposition pitting advocates of painting against supporters of new media? The reason is that this has nothing to do with individuals at all, nor with the relative merit of different works of art. It is, as I suggested earlier, about power, about the control of public institutions – specifically art schools and museums.

The professor, a vital, energetic woman in her thirties, was noticeably cooler after I'd given my lecture than she had been when I first arrived. The warmth and enthusiasm with which she had introduced me to her students had now given way to polite formality. A little puzzled by her sudden change of demeanour, I sheepishly asked her what she'd thought.

'It was very interesting,' she said stiffly, 'but I don't think Gombrich is a suitable reference to be citing.'

'Really,' I asked, 'why not?'

'Because he's just not relevant.'

'Relevant to what?' I might have persisted, but didn't, for I already knew the answer to that. My lecture, an appreciation and a critique of Gombrich's *Art and Illusion*, had failed to conform to the model of theoretical thinking the university's art theory department approved of. In my innocence, I'd assumed that one of the reasons guest lecturers were occasionally invited in was to provide students with alternative ways of thinking to those they were accustomed to, and that academics might welcome in practice the diversity, dispersal and indeterminacy they so earnestly advocated in theory.

The students were less constrained. Several of them approached me later to say that the ideas I'd been explaining were entirely new to them and quite a revelation – which shocked me, I have to say. No doubt this only added to my unpopularity with their teacher. I was never invited back.

This is not a particularly unusual example. Teaching staff in art schools frequently see it as their job to decide on behalf of their students what theoretical positions are relevant, rather than to present as objectively as possible a range of ideas, allowing their students to

decide for themselves which they are most interested in pursuing. Despite all the post-modern rhetoric, their teaching of art theory is a form of indoctrination. Any conflicting ideas, far from offering a welcome element of new enquiry, are regarded as an annoying disruption to the institution's ideological program.

This is one of the reasons that most university art schools teach art theory based on cultural studies rather than art history. It would not, after all, be possible to teach art history without having to seriously consider the ideas of Gombrich, Panofsky, Pater or Ruskin. Or, perhaps more importantly, Goya, Delacroix, Ingres or Bernini, for to teach art history without careful consideration of, and intimate engagement with, the paintings, sculptures and decorative arts of preceding generations is virtually impossible. Art theory, when it does, as they say nowadays, 'make reference to' the art of the past, will do so only in order to co-opt it into some contemporary intellectual construct. Theory is didactic, generalising, and self-contained. It does not encourage – it actively discourages – intimate emotional engagement with individual works of art.

Of nineteenth century European artists, only Courbet and Manet are likely to be called into service in university art theory departments these days as precursors of realism and transgressiveness respectively. Their importance lies only in the dialectical uses to which we can put them today (or, in other words, their 'contemporary relevance'). Piero della Francesca, who, for a brief moment in the 1980s, was used – misleadingly – as a lesson in minimalist formalism, has now more or less dropped out of sight along with minimalist formalism itself. This is how art history is used: not as open enquiry, but in order to give recent art a legitimising historical lineage and to reinforce the notion that art is nothing more than a variety of rational discourse about social issues. The only valid response to an individual work is an analytical one.

It is not good enough to assume that Panofsky's famous theory of perspective as symbolic form, for example, is simply irrelevant to students' needs and can be safely ignored – that it is not part of 'the language of now'. Students need to understand what that theory was, why it was so influential, and how it has been argued against and discredited since. Then they will know not just that it is irrelevant – if that's what it proves to be – but why. The difference is cru-

cial, since it is the difference between asking students to accept what they are told and making them figure things out for themselves. It's about fostering the ability to think independently, to argue cogently and to make sense.

Generations of students are graduating from university art departments with some garbled – and these days largely second-hand – notion of cultural and literary theory, yet little or no knowledge of the development of their own discipline, nor any conception that other ways of thinking might even exist. Little wonder, then, that so many of them will go on to produce work that continues to parrot the same limited set of ideas. As the Sydney journalist Suzy Baldwin has said, being civilised means not being imprisoned in your own time. [8]

(I once fell into conversation with a young artist who had turned an inner-city art space into a cave of cardboard boxes. Naturally enough, I asked him whether he had intended some kind of homage to Kurt Schwitters. 'Who?' he asked, without a hint of embarrassment.)

Meanwhile, canny curators from university art museums and publicly funded spaces, almost all of them academically trained and in thrall to Theory, are trawling the end-of-year student exhibitions, trying to spot the next artworld star. Students, anxious to be noticed, are well aware of the sort of work they will need to come up with, and it's not likely to be an oil painting. It is now not at all uncommon for young installation or video artists only just out of art school (sometimes even while still undergraduates) to be selected for contemporary survey exhibitions. All they need is the right look and the ability to attract attention to themselves. A deal with a commercial gallery can be expected to follow and their careers are off to a flying start. From that magical beginning, most of them will never recover.

The winning factor is an intimate knowledge of contemporary urban mass culture – commonly, and misleadingly, called popular culture – and the student's ability to replicate its interests and methods, as well as to use its media. This has the severely limiting effect of concentrating students' interests on what they already know and rewarding them for expressing themselves about it, rather than encouraging real exploration of the world beyond their ken.

I remember seeing an exhibition prepared by an honours student at the Canberra School of Art which comprised a series of constructions using common forms of abuse against gay men: the words 'poofta' and 'faggot', for example, were spelt out in Lego or woven into little tapestries. Naturally one assumed that their perpetrator was gay and therefore using these terms ironically, although no specific clue was provided. Had he been a skinhead fascist who really intended to be abusive, he probably would not have got to honours level. It was all very fetching, of course, but what, I wondered, did this student actually have to say and how was he demonstrating, through these rather desultory tableaux, that he had actually learnt anything during his years at art school. All the same, he got his PhD. The important thing was that his work looked the part, that it expressed the right attitudes, and that it lent itself to written or verbal explanation.

Clive James has written that the 'secret of success in the popular arts is to bring the punters in on the event, and you can't do that if you are manifestly doing something they can't do. You have to be doing something they can do, so that they can dream. It's just that you do it better, so that they can admire. Essentially they are admiring themselves: it's a circuit, and too much obvious bravura will break it'.[9] It's a lesson that art students, if they are to succeed as artists when they get out into the wide world, have to learn. It may be the only one.

In a series of articles in *Art Monthly* some years ago, the artist, critic and academic Peter Hill vigorously defended the awarding of studio-based PhDs in university art schools.[10] As a teacher in just such a school, he had some incentive, of course. Hill's argument was that artists have always done research and that academic qualifications simply provide official recognition of this. If art schools are part of universities, he claims, 'they should be able to offer the full range of qualifications up to and beyond PhDs', which, he adds revealingly, offer 'genuine benefits ... in terms of funding and promotions'. I'm sure they do. Although there are clear advantages to the universities in having tertiary art schools under their wing, as well as to the career prospects of students who want to go on to perpetuate the system by becoming teachers, however, it's not nearly so clear that the incorporation of art schools into universities has

provided any benefits to art, to the communities it is supposed to serve, or to the culture as a whole. I would argue that it has had at least one very damaging effect. Surely it is disingenuous of Peter Hill to assume that turning art schools into university departments has had no impact on the sort of art being produced.

He describes the nature of the research required for a studio-based PhD as follows: 'In the university art school system, your PhD thesis would normally be in the form of an exhibition, and you would begin by writing a proposal defining your research goals.' In other words, the idea must precede the work and the exhibition of the work must confirm the idea. Consequently, right from the start, painters who prefer to work intuitively – who stand trembling with expectation before a blank canvas with no preconceived idea of where they might be headed – are at a distinct disadvantage, if not out of the running altogether.

'Accompanying the final thesis by exhibition would be an exegesis,' Hill continues, 'Through words, it explains the work and puts it into context.' Needless to say, writing, 'I fell into ecstatic reverie and it all just sort of happened,' won't earn you a gong.

My point is that, by privileging words over visual expression, the university's rewards system, while it might suit the bureaucracy, encourages a narrowly didactic approach to art making. And, by implication, it demands that art be constructed from a blueprint, discouraging whatever springs from the unconscious: metonymy, in other words, rather than metaphor. No room for healthy anarchy or freewheeling experimentation here!

By way of example, Hill refers to *Adorno's hut* (1986–87), a massive construction by the Scottish artist Ian Hamilton Finlay shown at the Eighth Biennale of Sydney in 1990. *Adorno's hut* is like a three-dimensional cartoon of a Greek temple, replete with columns and a pedimented roof. One half is constructed from steel I-beams, welded into shape and bolted together. The other half is made of wood: dressed timber for the roof beams and raw logs for the columns. I read it at the time as a rumination on barbarism and civilisation, the primitive and the refined, or perhaps the pre- and post-industrial.

Hill tells of giving a lecture to students at what was then the City Art Institute in Sydney, during which he provided them with a

comprehensive explanation of what Finlay's intentions were and the work's connection to the writings of Theodor Adorno. Hill is a lively and enthusiastic speaker and has the great advantage of knowing Finlay personally, so his lecture was no doubt quite an occasion. Nevertheless, he says, 'I sensed a growing anger in the room', although not, as it turned out, because they were unhappy with what he was saying. 'The students were angry because in the two months that this sculpture had been on display in Sydney, nobody had ever explained any of this to them before. If Finlay's work has been so poorly presented, they said, what of the other 150 artists? What don't we know about them?'

'What *Adorno's hut* needed,' writes Hill, 'was an exegesis: an explanation of its content and symbolism, just as a non-Christian viewer might need an explanation of a Renaissance altarpiece or a non-Aboriginal viewer an explanation of an Aboriginal bark painting. The exegesis is not a cosmetic addition to academicise a PhD or an MFA by research. It is as much a part of the work as saddle bars and tracery are to a stained glass window.' This is not a good analogy, since saddle bars and tracery have nothing to do with interpretations of a window's meaning. Nor do Hill's comparisons with Christian altarpieces and Aboriginal bark painting hold up, since those art forms express cultural meanings that are perfectly comprehensible to the cultures for which they were intended, while Finlay's symbolism is personal and cannot be expected to be fathomed by anyone who isn't Finlay or a personal friend of his – at least not without that essential exegesis. *Adorno's hut*, like most of the other 150 works in the Biennale exhibition, to the extent that it is dependent on exegesis, is the natural outcome of the academic approach to art making, which has helped to alienate art from its publics.

Another point to be made, just as an aside, is that since no art school, to my knowledge, teaches research methodologies in any systematic way, few art students even know what research entails. In the second of his articles, published the following month. Hill acknowledges that what artists do does not usually fit the definition of research (which is, essentially, organised, methodical investigation into a subject in order to discover new facts, to establish or disprove a theory, or to develop a plan of action, with results that must

be capable of replication).[11] His solution is simply that we need to change the definition.

The problem with art schools, as the educator Alan Lee has pointed out, is that they try to produce artists.[12] In other words, they are narrowly vocational. English literature departments don't aim to produce novelists and short-story writers, yet, as Lee puts it, 'there is no suggestion that because of this we have a shortage of writers in Australia, nor that those we do have are incompetent because they lack vocational training'.

My own guess is that the vocational emphasis is a hangover from the days before art schools were absorbed into the university system. At that time, of course, art schools were more diverse in character, teaching a greater range of subjects, and, given that they were smaller and less centralised, less constrained by the need to keep student numbers up in order to earn continued funding.

'It is just because art schools are focused on the impossible goal of producing artists,' writes Alan Lee, 'that they may have been doing more harm than good, not only by producing fewer good artists than Australia might have had without them, but also through having misled tens of thousands of students into the vain pursuit of careers that could never have opened to them under any circumstances. The provision of tertiary art education in Australia has always been sustained by the level of student demand, rather than by evidence of outcomes.

'So long as about one in thirty school leavers wants to become an artist, then the art schools will be able to point to a large unsatisfied demand for the vocational courses they offer. And so long as this is thought to be reason enough for training so many aspiring artists, then awkward questions about the fate of graduates can be left in convenient obscurity.'

I would only add that, so long as art schools remain narrowly vocational, and so long as they teach contemporary cultural theory in place of art history, those few who do succeed in becoming artists will go on making work that conforms to the style of the moment without having it in them to express anything of much depth, substance or originality. In the meantime, perhaps it's just as well that post-modern theory provides a convenient explanation for why depth, substance and originality are no longer desirable qualities.

Nearly one hundred years ago, the futurist F.T. Marinetti declared that art could be vital and energetic only when museums had been violently consigned to history. 'We will destroy the museums, libraries, academies of every kind ...' he declared. Gathering momentum, he cheered on those who would perform this necessary task in the name of art: 'So let them come, the gay incendiaries with charred fingers! Here they are! Here they are! ... Come on! Set fire to the library shelves! Turn aside the canals to flood the museums! ... Take up your pickaxes, your axes and hammers and wreck, wreck the venerable cities, pitilessly!'[13]

Although most artists could see little advantage in getting their fingers burnt, Marinetti's flamboyant call to arms set the scene for nearly a century of struggle by artists against the institution of the museum. It was a struggle marked all along by compromise and ambivalence. After all, artists knew, even if they were not always prepared to admit it, that museums were potentially useful to them. Their actual destruction would not be in anyone's interests. Not even Marinetti's beloved fascists were prepared to go that far. It was not so much a matter of getting rid of museums, but of gaining more power over what museums did and how they did it. As for the museums, they had little alternative but to roll over and be complicit in their own emasculation. Often they ended up looking a bit like abused puppies, smarting from all the attacks but continually having to come back, wagging their tails warily, for more.

In the sixties and seventies, artists tried to turn their backs on the museum and make it seem irrelevant by creating works that supposedly could not be bought, sold or collected, such as conceptual art, process art, anti-form, land art, happenings, site-specific art, even unrecorded experiences and unspoken ideas. The Dutch artist Jan Dibbets, when asked in 1968 if he was interested in selling his work, replied, 'Sell my work? To sell isn't part of the art. Maybe there will be people idiotic enough to buy what they could make themselves. So much the worse for them.'[14] Or perhaps not, as it turned out. Dibbets's pieces now sell for substantial amounts and are collected enthusiastically by contemporary art museums the world over.

Needless to say, artists found they couldn't live on ideas alone. Whatever they did, the market found a way of selling some form of it. Museums dutifully followed suit, and artists were more than happy to abandon their principles when it suited them. Official recognition still counted for something, despite all the denials. In 1967, when Marcel Duchamp had negotiated the acquisition by the Philadelphia Museum of Art of an extensive collection of his works, he was asked if he ever went to museums.

'Almost never,' he replied. 'I haven't been to the Louvre for twenty years. It doesn't interest me, because I have these doubts about the value of the judgments which decided that all these pictures should be presented to the Louvre, instead of others which weren't even considered ...'

'Still,' said the interviewer, 'you accepted the idea that *your* entire work would be in a museum?'

'I accepted because there are practical things in life that one can't stop. I wasn't going to refuse ...'[15]

When organised attempts to ignore the museum proved ineffectual, artists then moved on to infiltrating it and trying to undermine its systems from within. One of the low points in this battle for control came in the 1970s with *Doomed*, a performance piece for which the American Chris Burden proposed to lie on a museum floor for forty-five hours without food or water. After a time, museum officials, on the advice of doctors, intervened to bring him sustenance. Burden said later that he had known this would happen. His intention was to force the museum to destroy either the work or the artist. Not an especially edifying aim. And, of course, he made sure in advance that he couldn't lose either way.

Eventually, the American critic Lucy Lippard, although an ardent supporter of so-called dematerialised art, wrote in frustration that 'artists who claim that they are making non-art or anti-art should have the grace to stay out of art galleries and art museums and art magazines ...'[16]

They didn't. By the late eighties they were vehemently criticising museums for not acquiring enough conceptual and anti-art. One Australian artist – getting older and therefore more concerned about his position in posterity – told me earnestly that it was the duty of museums to collect and document such work for future

generations, in spite of the fact that it had been deliberately designed to subvert the museums' collecting systems. He was right, of course, but there was more than a little bad faith in the demand.

Despite the reported death of the author, one consistent *leit-motif* in the history of art museums over the past century is that of artists trying to refashion themselves as *auteurs*, assuming ever more control not only over the creation of their work but also its presentation and elucidation. As artworks become more didactic in intent and intrinsically less open to differing interpretations, artists are seeking to further limit the opportunities museum curators may have to suggest a range of viewpoints through thematic exhibitions or other forms of re-contextualisation. The audience – those who go to contemporary art exhibitions in the expectation of a lively exchange of ideas – have never felt so constrained or undernourished.

Consider, for instance, Hans Haacke's installation *The freedom fighters were here* (1988). Haacke is a German artist living in New York. *The freedom fighters were here* comprises a large photographic transparency (the photograph presumably taken by a journalist and appropriated by the artist) showing three Nicaraguan peasants, two men and a woman, standing on a dirt road. The men shoulder small coffins, and one of them holds a wooden cross. The grieving woman clasps a handkerchief to her face. Above the photograph, the work's title is emblazoned on a cinema-style billboard, with a border of flashing light globes. It is a heavily didactic (some might say plodding) statement about ex film-actor Ronald Reagan's support of the Nicaraguan contras, whom he regarded as freedom fighters. It addresses political events of the 1980s so specifically that a new generation today, having little knowledge of those events, would no doubt find it entirely unintelligible.

Given Haacke's interest in using his art to expose corporate and institutional power structures (he made a series of works highly critical of Benetton's controversial advertising campaigns of the early nineties, for example), it is instructive to consider the comprehensive way he keeps charge over where, how and when his own work is shown.

The freedom fighters were here was purchased by the National Gallery of Australia not long after it was made, but it was sold only on the condition that the gallery sign a contract granting Haacke

extensive control over its display. Accordingly, in 1994, the curators
Mary Eagle and Christopher Chapman were obliged to write to the
artist seeking his permission to include the work in a group exhibi-
tion they were assembling entitled *Virtual Reality*. Although the
gallery owned the work, Haacke said no. He also vetoed the inclu-
sion in the exhibition catalogue of his letter of refusal. On the basis
of the exhibition outline provided to him by the curators, he did
not think his work suited the theme and he objected to 'the
planned integration of commercial products of the communications
industry and their makers' direct involvement in the exhibition'.[17]
Eagle and Chapman wrote back meekly to thank him for his 'elo-
quent and moving letter of rejection'.[18]

Haacke was perfectly within his legal rights to refuse permission
for his work to be displayed in a way of which he disapproved. But
his response was not in any way unique. What the story tells us is
that we can no longer assume that the institution is always in a posi-
tion of power over the individual artist. Those such as Haacke, who
have achieved considerable status as personalities on the interna-
tional circuit (along with many others who have not) can exercise
almost total control over how museums, galleries and art magazines
present their work to the public.

Museum curators, understandably, tend to construct this state
of affairs in a very positive light. Far from forfeiting any of their
authority to artists, they insist, they have made themselves more
open, democratic and accessible. They now welcome the participa-
tion of contemporary artists on the grounds that it promotes an
active dialogue. There's a good deal of truth in this, although it
overlooks the fact that artists often participated with museum cura-
tors in the past. There's nothing especially new about it.
Nevertheless, the state gallery curator who sighed, after working on
a collaborative installation project, that 'dead artists are so much
easier to work with', was probably speaking for many of her col-
leagues.

There can be little doubt that the participation of artists in the
curatorial process has resulted in some lively and creative
exchanges. Museums are now much more responsive to the work-
ing art communities around them than they used to be. The
artists' victory, however, has had its price. Although they were

never going to pursue the Futurists' option of physically destroying the institutions of learning, and although their always compromised efforts to sideline the museum were thwarted by their complicity with the market, artists, by successfully infiltrating the museum and making it responsive to their own immediate needs, have not broadened the scope of its interests so much as subjected it to even tighter control.

Cities such as Sydney, Brisbane and Melbourne now have, in addition to a large network of commercial galleries showing a steady stream of solo contemporary exhibitions, a number of publicly funded contemporary art spaces, several university art galleries, and – in Sydney and Brisbane – large contemporary art museums. Nevertheless, the state galleries in each city, virtually the sole repositories of historical art, are under immense pressure from a market-driven contemporary art lobby to devote more of their acquisition budgets to work by living artists and to turn over more of their display space to it.

The losers are the artists of the past, who are in no position to lobby on their own behalf, the traditions of scholarship and connoisseurship that museums once upheld, and the members of the public, who find their choices becoming increasingly limited to 'exciting, challenging, confronting' new art and whose pathetic enthusiasm for the occasional old-masters blockbuster, when one happens to come their way, is derided as lazily conservative.

One of the great joys of being a curator comes from a rummage through the store room in search of paintings, prints and drawings, a sculpture or two, and some furniture or ceramics that can be mixed and matched, played with and combined in various ways in the gallery's public display spaces. A chronological hang might be favoured this time, or the selection restricted to artists from a certain place. A thematic display could perhaps focus on an established art-historical category such as landscape or abstraction, or respond to an issue of topical interest. I once put together a touring exhibition called *The Black Show*, which was made up entirely of minimalist black squares and rectangles – by Ad Reinhardt, Peter Booth, Anne Graham, Brent Harris, and others. Wherever it was shown, gallery visitors – many of whom, I am sure, had they come across a blank black canvas on a gallery wall under normal circumstances

would have dismissed it out of hand – responded enthusiastically to the juxtapositions, appreciating the evident playfulness of the enterprise and the various meanings it generated. The possibilities are endless and the results can bring new meanings to works previously thought to be over-familiar.

I never thought of this as an exercise of power. I thought I was facilitating creative conversations among the various works, suggesting to the viewer a range of alternative interpretations. It was a shared act of discovery, allowing visitors to exercise their imaginations and construct their own narratives by juxtaposing disparate things. This is one of the reasons – a vitally important one – that art museums have permanent collections: regular visitors will become familiar with individual works over a long period and have the opportunity to discover them again and again in different company. Perhaps museum administrators, for so long concerned with counting the hoards as they flock through the door, are no longer interested in the needs of their regular visitors.

Nicholas Serota, director of London's Tate Gallery, is just one museum professional who would disagree entirely with my views about the curator's role. He is sceptical about curatorial interpretations of works of art on the grounds that they are 'establishing relationships that could not have existed in the minds of the makers of these objects ...' (to which I would want to say, 'So what?'). 'This principle of interpretation,' he continues, 'of combining works by different artists to give selective readings, both of art and of the history of art, is also one of the fundamentals that has underwritten curatorial practice since the mid-nineteenth century.'[19] In other words, it's old fashioned. If that's the way they did things in the past, *ipso facto*, it shouldn't be the way we do them now.

The solution, as Serota points out, is often to give over entire rooms to individual artists, so that their work may be seen 'without distractions' (that is, without the presence of works by other artists).

'The Pollock display at the Museum of Modern Art is but one example of a much wider trend which within ten years has established a new, now even dominant convention for the presentation of twentieth-century and contemporary art. It is a convention which gives absolute weight to the work of individual artists, which

favours presentation over analysis and which undermines the traditional priority given to the curator as the person who exercises discriminating judgment over selection and display in the museum'.[20]

I don't think it does undermine it at all. Rather, it hands the exercise of judgment to the artist, who becomes sole curator of his or her own work. This new convention goes hand-in-glove with the tendency for artists to make installation works that demand an entire room of their own, which simply cannot be displayed alongside works by others and are completely self-contained. A great expense for organisers of biennale exhibitions these days is to build the partitions necessary to ensure that no artist's installation will be sullied by a glimpse of some other artist's work in the background. Artists, when offered their own spaces, have been more than keen to take them over entirely, to the exclusion of all else.

The apotheosis of this tendency came with the re-opening of New York's Guggenheim Museum in 1992, for which Frank Lloyd Wright's monumental building – always thought to exemplify Modernist architecture's tendency towards arrogance – was finally beaten into submission. The whole museum was given over to an installation by Dan Flavin. Its purpose was to make the building part of, yet subservient to, the artwork. It also turned the Guggenheim's curators into little more than functionaries.

I am not arguing here against installation work in favour of 'flat art' in frames. I am simply observing that installations, whatever else they might do, serve the interests of artists who want to maintain control not only over the creation but also the reception of their work, who want to insist that we see them in exactly the way that they intend, and who don't take very kindly to third parties suggesting alternative interpretations.

Painters cannot do that nearly so easily, simply because their works are more portable, more adaptable, more metaphorical. The indications are that most painters are not especially bothered by that. They are usually happy enough to send their creations out into the world and let them fend for themselves.

Both the nature and purpose of the tertiary art school and the art museum have changed beyond all recognition over the past thirty years or so. Although some of those changes have had a positive and invigorating effect, especially in opening up these

previously rather hermetic institutions and making them far more accessible, one important negative effect has been to encourage ideological positioning instead of independent thought, leading to a certain sameness and lack of vigour. In the popular vernacular, there's been a dumbing down. Over a generation, the radical democratisation of the art school and the museum has been accompanied by a wilful abandonment of scholarship, connoisseurship and seriousness. Perhaps the two go hand in hand.

Of course, museums and art schools must change with the times. All the same, it is worth looking more closely at what drives these changes and what effects they might be having, both on the kinds of art being made and the role that art might have to play in the culture. Are democratisation and accessibility always desirable? What are their costs? Museums and art schools must be responsive, but to whom or what? I would argue that it's not often to their users, who are increasingly becoming the pawns of bigger interests.

At a time of 'private wealth and public squalor', in John Kenneth Galbraith's famous phrase, we can no longer make a clear-cut distinction between government-funded institutions and their corporate counterparts. As governments retreat ever more from their social responsibilities, the market is taking over as the primary determinant of our lives. So surreptitiously has the market's power crept up on us, and so little resistance has it come up against, that we are hardly aware of its corrosive effect.

2

THE WHEELS OF COMMERCE

Hello, I am calling as part of a national opinion poll:

... How important are the arts to you personally and how important are they to Australia today?

... What are the main ways, if any, that you would like to see the arts change in future?

... Which one of the following statements is the best description of your own attitude towards the arts:

I *really* like the arts

I like the arts

I neither like nor dislike the arts

I don't like the arts

I *really* don't like the arts?

Most of us, finding ourselves on the receiving end of such a call, would quickly hang up and get back to *The Simpsons*. When the advertising agency Saatchi and Saatchi asked these questions – and more than twenty-five others of similar ilk – on behalf of the Australia Council a few years back, however, they elicited enough

responses to fill a book. *Australians and the Arts*, published in 2001, is, supposedly, a detailed analysis of our national attitudes.

What prompted the questionnaire was a general feeling that we in this country do not value the arts highly enough. It was necessary, then, to find ways to promote them to all Australians and to engage the general public more fully in arts activities.

'... if the arts sector would like Australians to have a higher level of regard for the arts,' we are told, 'then it is incumbent on the arts sector to take steps to make this happen. This starts with each individual artist and extends to the sector as a whole. In those areas where the task requires the involvement of people outside the arts sector, such as in the media or the education system, then the responsibility falls with the sector to work with those people to promote the arts more effectively.'[1]

What this means is that 'every person within the Australian arts sector who feels that they would like to see change in attitudes among the general public, needs to examine the effect of every aspect of their own activities to see how they can create a more positive image and experience of the arts for others'.[2]

And so it goes on, for nearly four hundred pages.

Australians and the Arts is an interesting document not so much for what its welter of graphs, diagrams and percentages might tell us – which I suspect is actually very little – but because of what it so clearly fails to achieve.

Its author, Paul Costantoura, for example, is quite unable to define the terms he finds himself having to use. His attempt to explain what is meant by 'the arts' is almost comically convoluted and, by his own admission, unsuccessful. For this reason, the questionnaire puts the onus on respondents to define the term for themselves, which means, of course, that they are all talking about different things. Some think only of Verdi and Michelangelo; others are happy to accept an episode of *Neighbours* as art. And it is never made clear what is meant by 'value' or 'the arts sector'. Saatchi's researchers have been placed in the impossible position of having to justify in commercial terms an activity that, at its heart, has very little to do with commerce. The entire exercise is about quantifying the unquantifiable. No wonder whole chunks of it read like the script for a Monty Python sketch.

More important, however, Costantoura never asks why we should be trying to make the arts more popular with the general public in the first place. We can't blame him for this: Saatchi and Saatchi were paid to find out how to make us more arts-friendly, not to question the wisdom of doing so.

Having spent a great deal of taxpayers' money compiling this document, the Australia Council then set up a twenty-three member committee to implement its recommendations, which essentially boil down to the arts needing to be 'rebranded'. This committee comprised business people, media personalities and sports stars – the sort of folk who presumably knew what rebranding meant – with just a couple from what an Australia Council press release called 'the creative industries'. Among the dozen or so recommendations they were given to grapple with was this one, which gives some idea of the general tone: 'Shape a vision for the future of Australia which sees the arts playing a role that Australians see is relevant and meaningful to their lives – personally and nationally – and distinctively Australian.' Whatever this means in practice, it was to be achieved through more frequent and more flattering coverage by the mass media, a greater emphasis on the arts in school curricula, and a series of initiatives to counter the apparently common conception that the arts are 'elitist' – yet another term left undefined. The committee quickly got stuck into the task.

Today, a few years later, it is difficult to pinpoint a single positive outcome. Since the report was published, the arts have continued to fare badly in the media. Australian arts coverage on television, for example, is still virtually non-existent, and most newspapers have significantly reduced the amount of critical commentary they publish. School curricula have fared no better, with whole modules in art schools having been closed down across the country owing to lack of funds. Overall, attendances at public galleries have declined. Federal government arts funding has also been reduced, despite claims to the contrary by government ministers.

It could be argued that the real effects of the Saatchi report have been the direct opposite of those intended: that it has actually facilitated a decline in arts funding by playing right into the hands of a federal government that appears contemptuous of intellectual and artistic activities, regarding their funding as a waste of

taxpayers' money. When the then Minister for the Arts, Richard Alston, announced at the end of 2002 a review of national cultural institutions with a view to improving their performances 'at the box office' and making them 'more efficient', his justifications might have come straight from the pages of the Saatchi report: 'You need to be sure,' he was reported as saying, 'that you are getting the box office results ... You need to make sure that the population appreciate [sic] what's on offer.'[3]

With its simplistic, functionalist emphasis on making the arts enjoyable for all, the report has no doubt also encouraged newspaper editors to give over more of their arts pages to personality profiles and other promotional material at the expense of criticism and discussion.

The response of public museums to declining attendances has been to offer more of the same: more aggressive marketing and more populist programming. The director of the National Gallery of Victoria, Gerard Vaughan, claims that gift shops, wine bars, interactive touch-screens and restaurants 'make easier and more enjoyable the core process of engaging with great works of art'.[4] He seems to believe that engaging with works of art is still the gallery's core activity. A survey done recently by the Queensland Art Gallery suggests otherwise. Thirty-eight per cent of its visitors said they were not there for the art at all, but for shopping, organised entertainments and relaxation.

What documents such as *Australians and the Arts* cannot acknowledge is that any meaningful appreciation of art, music, literature, dance or theatre demands a fairly high degree of skill, concentration and dedication. They are not entertainments. You have to learn about them and to gradually develop your taste and discrimination. The personal rewards are great for those who want to put in all the time and effort required, but not everybody does. And not everybody needs to. Attempts to turn the arts into just another popular family activity are alienating the real audience for art, yet there's no convincing evidence that they are helping to create any new audiences.

The assumption that the arts, like fresh greens or vitamin pills, are good for us and the more who take them the better – even if it means having to sugar-coat the pill – is fatuous and ultimately counterproductive. If asked what kind of message will cause a

positive shift in people's attitude to the arts, I would want to reply that it's not a matter of 'messages' or 'image problems'. And when I hear that some 50 per cent of Australians show no particular interest in the arts, I don't ask myself what kind of promotional campaign we can pull together to make them change their minds. I assume these people are quite capable of making up their own minds about what they are interested in. I have never expected that such intellectually and emotionally demanding activities would appeal to a majority, and nor do I want them to.

So why this frenetic insistence that the arts be 'more accessible and available to average Australians'[5] given that the arts are already accessible and available to almost everybody who is prepared to put in a bit of mental effort? The common answer is the one about the arts being good for us. They make our lives richer, more meaningful and more fun. We have only to open our arms to them in order to feel their soothing embrace. Those who have not yet been enlightened, or who feel somehow excluded, are missing out and must be helped. There's more than a hint of religious proselytising about all this, and the Saatchi report is full of it.

Nevertheless, despite all the guff about personal enjoyment, satisfaction, relaxation and excitement, the real goal of exercises such as this is not to make people's lives culturally richer but to make the arts industry economically richer. Although it is almost never acknowledged, the purpose of promotional campaigns for the arts is always to make us more avid consumers of arts product.

It goes without saying that increasing arts consumption, while it may help to improve the commercial prospects of certain individuals and organisations, does nothing to improve the quality of the art being made. A healthy arts industry does not necessarily mean healthy art. Broadening the market is likely to have the opposite effect. In the end, campaigns to promote the arts as a trendy lifestyle package, of which the Saatchi report is but the most prominent recent example, can only lead to a diminution of seriousness and conceptual complexity and a retreat into triviality, or worse. We need only to look back to Stalin's Soviet Union or Hitler's Germany to see what can result from attempts to make art conform to the 'people's will'. This is precisely what I believe the commodification of art is doing, by stealth. Market forces do not, of course,

actively prevent artists from doing what they want, or condemn them to prison, or worse, if they fail to toe the line. Nevertheless, when an advertising executive employed by the Australia Council to help improve the image of the arts speaks of the need 'to improve the relationship between the arts sector and audiences by challenging perceptions and re-evaluating stereotypes', a whiff of the commissars seems to hang ominously in the air.

The author of *Australians and the Arts* gets tied in knots because he is unwilling or unable to consider the problem of quality. He talks about 'big A' arts such as 'opera, ballet and art galleries' and suggests that more people would like the arts if the definition were broadened to include newer media such as movies, television and photography. He is too embarrassed to mention anything that might suggest the necessity for making value judgments, however, lest this be construed as elitist. The idea that art might be an expression of the highest aspirations of the culture, for example, cannot be entertained because that troublesome word 'highest' might discourage 'ordinary people', who are presumably not meant to have aspirations. Given that these 'ordinary people' are, in his view, the majority, they represent a fair share of art's potential 'consumers' (a very revealing term used frequently in the report), so there are considerable financial benefits in ensuring that they are not discouraged.

Anyone who believes the arts to be about the exploration of philosophical ideas, metaphysical enquiry, the formulation of cultural – as distinct from nationalist – aspirations, the working through of founding mythologies or collective moral values, will find *Australians and the Arts* perfectly useless, if not offensive. To be fair, they are not the people for whom it is intended. Bureaucrats, managers, publicists, dealers and others employed to service the so-called arts industry no doubt have it constantly to hand on their desks, every other page annotated with Post-It notes, ready to be quoted in their next funding application.

And make no mistake, these people are everywhere. According to an inquiry into employment in the cultural sector conducted in May 1998 by the Cultural Ministers' Council, there were at that time 5,250 professional visual artists and craftsworkers in this country and 4,268 people employed as visual arts service providers. I am quite sure the proportions are even more alarming for theatre,

music and literature. Needless to say, statistics of this kind should be treated with a great deal of scepticism – what is a 'professional' artist, for example? If the Cultural Ministers' Council figures are anywhere near the mark, however, then there are almost as many people in visual art support and service areas as there are artists.

Is this a surprise? Not a big one, certainly. Over the past thirty years or so, the practices both of making and of appreciating art have become increasingly institutionalised. This has happened both in the day-to-day sense of accelerated systematisation, regulation and commodification of every aspect of art practice as well as in the more profound – and, I think, more insidious – sense that bureaucratic institutions of one sort or another now largely determine what art gets made and what is paid attention.

The argument could be made that art has always been institutionalised to one degree or another. In Britain and Europe from the mid eighteenth to the end of the nineteenth century, for example, the academies were the dominating influence. London's Royal Academy, founded in 1768, was both a club and a kind of trade union. It set standards and ensured the social status both of its members and the work they produced. It fostered competitiveness, exclusivity, and a moral code for art that served the interests of its members. Interestingly, many of the nineteenth century artists we now think of as important not only worked outside the influence of the hundred or more academies scattered across Europe but in opposition to them. Towards the end of the century, the French Impressionists finally gave the anti-academicians their decisive victory.

The academies arose in the first place because the patronage of the church, which had sustained European art since the Middle Ages, was in decline and, given the increasing secularisation of European society after the Renaissance, the church had gradually ceased to be the main source of art's iconographical motifs.

Today it is neither the official academies – certainly not the art schools – nor the church, but rather the institutions of the market

that exert the dominating influence on art. The market's power is acknowledged without question because there would appear to be no alternative. You cannot work outside of, and in opposition to, the market because, unlike the academies, it is universal in its influence. If you do attempt to, you will simply disappear. Although it is highly centralised and hierarchical, the immediate effects of the market are nevertheless experienced at a local level. Structured in much the same way as the church, it gives the irresistible impression that it cares about each and every individual it exploits. By this means it secures loyalty.

I use the term 'the market' in the broadest possible sense to refer to a complex network of organisational structures whose main purpose is to promote artistic activities – and the individuals who engage in them – as products to be bought and sold: art as a tool of commerce. The modern art market includes front-line organisations such as commercial galleries, art fairs, public relations companies, art auction houses, the mass media and others that directly benefit from both the trade in artworks and the promotion of artists as marketable personalities. It also embraces nominally independent organisations such as art journals, publicly funded museums, government arts agencies and academic fine art departments, which these days take their lead from, follow the example of, and ultimately serve the interests of, those who do the actual buying and selling.

By way of example: when most contemporary art purchases of a publicly funded museum come from a handful of high-profile commercial dealers whose artists are widely promoted in the arts press, that museum is not only taking its lead from the market, but becoming part of the market's structure. When a committee selects a particular artist to represent the nation at an overseas biennale on the basis that that artist has 'a high profile' or a 'significant reputation', it is being subservient to, and is helping to promote, market interests. And when the Australia Council commissions an international advertising conglomerate to research the likes and dislikes of arts consumers, the market's infiltration into the public sphere would seem to be almost complete.

Just four or five years ago, according to a recent report in the *Australian*, there were no 'significant' sculpture awards in this country. Things have now changed for the better, we are assured.

Elena Taylor, curator of the National Sculpture Prize, is quoted as saying that sculpture, once the bridesmaid of the art world, is now 'a supermodel'. How, we might ask, has this sudden transformation come about?

In the past, a 'significant' award would have been one that carried some important official imprimatur, one with a long and distinguished history or one closely associated with some important public event. The prize itself would more than likely have consisted of a medal or certificate indicative of social status, awards and prizes being usually symbolic expressions of esteem. Today, however, a 'significant' prize is simply one that offers a lot of money. The article in the *Australian* provides a list of our richest sculpture prizes, pointing out that '[e]very one of them is worth more than the richest painting prizes in Australia ... and richer by far than the nation's only significant [sic] photographic award ...'[6]

A year or two ago the Macquarie Bank Foundation agreed to 'bankroll' the National Sculpture Prize. Then the McClelland Gallery in Victoria upped the ante by announcing an even richer one, also funded by corporate foundations. Such prizes are the direct result of growing commercial interest. 'Companies including Gandel Group, which has acquired sculptures to display throughout its shopping centres, and MAB Corporation, which has commissioned works as public art for its Docklands development in Melbourne, are using the prominent and (relatively) durable art form to add value to their enterprises in the eyes of potential customers,' the *Australian* enthuses.[7] Private collectors have not been slow to respond. 'Sculpture can be doubly attractive in this respect because, although creatively rich, the price tags tend to be modest compared with painting.' Artists, too, have begun to cash in. According to Ken Scarlett, a long-time advocate of the medium, the number of sculptors in Australia has risen from about 450 in 1980 to more than 2,000 today.

It would appear, then, that a handful of large corporately backed cash prizes has arisen in response to the interests of property developers, which has led to increased sales by art dealers, which in turn has encouraged more artists to turn to sculpture.

The compelling aspect of this report is that although an art dealer, a curator, an artist, an art critic and a gallery director are quoted, in addition to business people, they all talk only about

financial benefits. Money is, it would seem, the sole driving force of sculpture's supposed renaissance. Yet there is nothing at all out of the ordinary about this article. Few people who read it would have worried that its priorities might be seriously warped.

This is not to say, of course, that artists shouldn't be going where the money is. Good luck to them. We should, however, be questioning the extent to which we want to allow real-estate developers to determine the course of art practice.

Nor do I mean to imply any conspiracy; only to point out that there is a general consensus among dealers, curators, art educators, critics and arts bureaucrats about which kinds of art are important and which are not, and that this consensus is largely determined by commercial considerations and ultimately serves the interests of commercial institutions.

Market control is not necessarily always a bad thing, either. Like art's earlier institutions, those of the market work in a practical way to promote and support the day-to-day 'business' of art. The market, like the church before it, maintains social structures that link arts activities to those of the rest of the community. This, of course, is helpful and necessary. Someone has to keep the wheels turning, and in this respect the market, because of its diversity and relative disinterest – or perhaps, more accurately, its lack of interest – permits artists a degree of independence that would have been unthinkable under the popes or even the academy committees. Unlike church, state or the academies, the market does not impose a rigid ideology, at least not directly. Instead of dictating, it seduces.

In the late nineteenth and early twentieth centuries, before the art market became institutionalised, it was an important force for change and artistic freedom. As the Royal Academy's sectretary for exhibitions, Norman Rosenthal, has pointed out, '[t]he great decisions in art have not been made by critics in the last hundred years, they've not even been made by curators: they've been made by dealers – Picasso was led by Kahnweiler – they've put their money where their mouths were. One or two dealers made Monet and van Gogh. If van Gogh had lived another three or four years he would have been incredibly successful like Monet.'[8]

Dealers are still the ones making those decisions, although today they are much less likely to be great decisions, for dealers no

longer enjoy the freedom and independence they once had. They are hardly in a position to be the autonomous, rebellious individuals they could once have been, striking a blow against conformity and conservatism. They are, instead, cogs in a complex system of wheels. If they don't conform to what is expected of them they will lose the respect of the market and find it difficult to survive.

For, while the market is generous with practical things, it makes heavy demands in return. Although it may ensure a healthy, functioning arts industry, providing employment, infrastructure, grants, prizes, overseas studios, a wide choice of promotional opportunities and at least the promise of a career, not to mention all those huge new museums, with their bistros, bookshops and million-dollar sponsorships, it would be naive to think that any of this comes free. Do museum directors really believe, when they decide to base their marketing campaigns on those of lifestyle stores such as Bunnings and Ikea, that the art or its reception by the public will remain blissfully unaffected? No, Adam Smith's benevolent 'hidden hand of the market', as it turns out, holds a pretty tight leash.

'What has happened,' writes Fredric Jameson, 'is that aesthetic production today has become integrated into commodity production generally: the frantic economic urgency of producing frequent waves of ever more novel-seeming goods (from clothing to airplanes), at ever greater rates of turnover, now assigns an increasingly essential structural function and position to aesthetic innovation and experimentation. Such economic necessities then find recognition in the varied kinds of institutional support available for the newer art, from foundations and grants to museums and other forms of patronage.'[9]

The market's pernicious effect is to impoverish art's expressive power through its constant demand for conformity to its interests. The result is conservatism constantly kitted out in new clothes, a comforting sense of security that gives the irresistible impression of being perpetually new and exciting: in other words, something very like pop-culture trivia, but with an ominous overlay of reproach.

Hype provides a good illustration of Jameson's point about aesthetic production's integration into commodity production, although probably not quite in the hip kind of way its curator intended. It's a good title for an exhibition whose purpose was to

look at the way art interacts with fashion and advertising. Unfortunately for the artists involved, however, fashion and advertising had virtually the whole show to themselves.

Hype was shown at the RMIT Gallery in Melbourne in March 1998 as its contribution to Fashion Week. One of the key works – by accident rather than design – was not made as a work of art at all. It was a brief television commercial for Jean Paul Gaultier perfume in which an impossibly beautiful young couple in skin tight clothing tongue-kissed until they ever-so-gracefully fell over, while an operatic aria swelled and all around them neon lights exploded rhythmically. It was glamorous, scandalously sexy and hilariously self-mocking: an irresistible feast of high-class kitsch. No wonder so many visitors stood watching it over and over again, while granting the other exhibits only a cursory glance.

Nothing any of the artists could do was ever going to come close to competing. Christopher Langton's big inflatable lips and his oversized hypodermic needle looked decidedly limp by comparison; Maria Kozic's post-pop paintings of flowers overlaid with swear-words hectoring and patronising; Susan Cohn's installation – in which handcuffs were used to symbolise the ties of love – clichéd. The Gaultier advertisement was taking on French artists Pierre et Gilles at their own game, re-appropriating art's heavily ironised appropriations of pop-culture vulgarity and then turning them back on themselves, piling irony upon irony. Anything you can do, it seemed to be saying, we can do with loads more wit and aplomb. And so they did.

Significantly, not one of the artworks in *Hype* was openly critical of the advertising or fashion industries. I doubt the curator would have been able to find any even had he been looking. As in all the many art exhibitions shown around Melbourne each year for Fashion Week, the mood was joyful, celebratory and cool. The great tide of anti-globalisation protest turning entire cities into battlefields, the street demonstrations that forced Nike to change its policies on third-world sweatshops, the newspaper exposés of worker exploitation in Melbourne's garment industry – all this remained a world away. These artists were safe indoors playing elegant appropriationist parlour games with the likes of Jean Paul Gaultier.

Is Kylie Minogue an artist? A real artist, I mean, as distinct from a pop celebrity. Or does the distinction even mean anything any more? Many people would see no qualitative difference between Kylie and, say, the Australian Chamber Orchestra. They're both in the business of performing music, after all, and they both do it well in their own way. You can't – so the argument goes – legitimately claim that the sort of music the Australian Chamber Orchestra plays is 'better' than Kylie's, it's just different. (The word 'better' seems to demand quotation marks these days, having become such a terrible embarrassment.)

But if all notions of quality are now to be consigned to the dustbin of history, how do we decide who will represent Australia at the Venice Biennale: by putting the names of all our artists in a barrel and drawing one out? How do we decide which works will be acquired by our public galleries, or, indeed, which exhibitions we will go to see and which we will stay away from, which television programs we will watch, or which breakfast cereal we will buy? The truth is, of course, that we make judgments about quality all the time, happily discriminating between the various choices on offer. Strictly speaking, we usually allow the market to make them for us and to flatter us into thinking we're making them for ourselves. But when it comes to the arts, we're supposed to pretend that value judgments are a thing of the past. You'll often find art theorists earnestly discussing whether a particular activity can be considered as art or not, but you will almost never find them arguing about whether something is good or bad art.

Nowhere is the fear of making qualitative judgments more apparent than in the arena of youth arts. Young people, it seems, don't need to learn anything and must never be subjected to criticism. They must be encouraged to believe that everything they do is exciting and worthwhile and that inexperience, naïveté and lack of skill are no barriers to success. It's an attitude that many take with them into adulthood, where it appears to do them no harm.

Take, for example, the visual arts component of the *Noise* festival. *Noise* – or *noise*, actually, since capital letters are uncool – is a

federal government initiative, managed by the Australia Council, first held in October 2001 to 'celebrate and salute' artists under twenty-five years of age. 'In publicly profiling these artists,' said the project manager, Krissie Scudds, 'NAVA [the National Association for the Visual Arts] and *noise* are blowing apart old misconceptions of what visual arts is [sic] all about.'

What those old misconceptions might have been is anyone's guess, but Ms Scudds did not pause to enlighten us. Nevertheless, despite the breathless hipness in which *noise* came dressed, the artwork it showcased was, in a word, conservative: a predictable mix of received ideas and woolly thinking. Nowhere was this better demonstrated than in some of the artists' statements: 'My inspiration or objectives for this fake ad is concurrent with my whole artistic practice,' being one lamentable but not untypical example. The videos, graphics, photography and computer animations on the *noise* website included appropriated images from comics and cartoons, colourful abstract-expressionist drawings, computer-generated collages of advertising imagery, fashion designs, and photographs of the artists' friends and their urban environment. Most were slick, energetic and entertaining. *Noise*'s claim to being 'the future of modern culture', however, rested principally on its participants availing themselves of off-the-shelf electronics. What the work expressed were the sort of unmediated perceptions and emotions that preoccupy all self-absorbed young people in affluent Western societies. *Noise* was notable for its narcissism. Very few works demonstrated any concern for anything outside these young people's own small circle.

I'm sure this was a lot of fun for those involved, and I do not mention *noise* just to ridicule it. What does concern me is its packaging. Quite frankly, most of the claims made in the festival's publicity were preposterous. How, for example, is it possible to justify the claim that young artists get less recognition or credit for what they do than their older colleagues, even if we were to accept that someone just out of high school automatically deserves equal recognition? And given that most of the visual artworks featured in *noise* presented clichéd responses to the sort of social concerns aired daily in the mainstream media, and given that artists all over the world, young and old, routinely use digital technologies, how can

it be said that these artists were reinventing anything, let alone 'the very idea of art'?

Perhaps we have become so inured to the excesses of the public relations industry that absurdities of this sort just wash over us. They are an integral part of modern image mongering and there seems little point in railing against them. It is, however, worth asking why a federal government agency is so keen to support and perpetuate such nonsense, especially since it does so very selectively. The really interesting question is about double standards and why they are so readily condoned.

Although I realise the comparison may seem mischievous, the *noise* events do bear some striking and very uncomfortable resemblances to the *Camberwell Rotary Club Art Show*. This annual Melbourne extravaganza is billed as 'the largest traditional competition display and sale of paintings in the Southern Hemisphere and among the largest art shows in the world'. It too is open to anyone within a certain loosely defined target group, regardless of their talent or experience, and also wears its absence of selection criteria as a badge of honour. Like *noise*, the Camberwell Rotary exhibition has a mission to promote and celebrate a group of artists perceived as being under-appreciated: not young ones, necessarily, but those who work in a 'traditional style'. The terminology is imprecise. 'Traditional' doesn't necessarily refer to 'realist', in this instance, because many abstract works are submitted and displayed. It is just as difficult to work out what 'traditional' means as it is to fathom 'innovative' in relation to *noise*. Neither word is intended to be descriptive of anything. They are ideological signposts, a way of declaring allegiances.

Revealingly, however, were we to do a mix and match of images from both these exhibitions – leaving aside, for a moment, that those from Camberwell are typically on canvas or paper while those from *noise* will be downloaded from the internet – we would, I think, be startled at the resemblances. Presented with a random sampling of colour reproductions, nobody would be able to say with certainty to which show many of them belonged. While the forms are a little different, the iconography is equally amateurish, predictable and bland.

This raises the question of why we accept, even applaud, Australia Council funding for *noise* when any such funding for the

Camberwell Rotary Club Art Show would be greeted with howls of outrage. Clearly it has everything to do with that magic word 'image'. It is perfectly clear from the publicity for each exhibition that *noise* is cool while the Camberwell exhibition is daggy.

Image is nothing if not a marketing tool. Today, the relative importance of artists is determined not by the inherent quality of the work they produce, since nobody can agree what that is anyway, but on their availability to marketing – their ability to generate wealth. Not in the crude sense of how much money they can ask for their product, but to what extent they can be used to facilitate commerce.

The main difference between Kylie and the Australian Chamber Orchestra is that Kylie is an industry while the Australian Chamber Orchestra is not, although its savvy promotion, which emphasises youthfulness to create a glamorous image, tries hard to make it so. The jobs of many people depend upon Kylie Minogue and what she does – managers, publicists, merchandisers, record company employees, clothing and cosmetics stores, photographers, magazine editors, and so on. If she were run over by a bus, an entire economic house-of-cards would collapse. Her wealth-generating potential is self-perpetuating and ever expanding, at least for the time being.

And so it is – albeit on a vastly reduced scale – with *noise*. People under twenty-five represent a big market while men and women in the suburbs do not, partly because young people have more disposable income and partly because they are more brand conscious and more gullible. The first thing you notice when you go to the *noise* website is an impressive list of commercial tie-ins. Magazines, fashion houses, record manufacturers, rock-music radio stations and others all have their part to play. *Noise* was quite a good opportunity for businesses wanting to polish their images in the youth market, including nominally non-commercial ones such as Triple J and SBS. The proceeds from the Camberwell exhibition, on the other hand, go to local charities, an area of no interest at all to the commercial world.

When the Australia Council's PR department boasts that youth programs such as *noise* are 'aimed at reducing barriers to arts participation by young people', it is drawing on no concrete evidence

that young people face more barriers to arts participation than any-one else. The council's characteristic preoccupation with statistics is, in this case, conveniently put aside. Rather, it is tacitly acknowl-edging that, since young people are of more interest to the market, their participation in the arts is of greater economic value.

This is not the official line, of course. We are told, instead, that enthusing people while they are young is 'an investment in the future' – the language of economics is hard to escape. No doubt this is true. Certainly it is important to enthuse people about the things we think are important and culturally worthwhile at a time when their minds are presumed to be open to new ideas and influ-ences. But it is not the whole truth. It does not account for the cri-teria by which we assess the work of young people being far more liberal than those we apply to others, why we seem so frightened to offer them guidance and criticism, or why anarchic self-expression is thought to be more useful and important than disciplined dis-covery. Nor does it account for the overwhelming concentration on young artists by funding bodies, arts sponsors and curators. Of about 430 art prizes, awards and fellowships available to Australian visual artists and craftworkers, for example, not including Australia Council or state government grant programs, some thirty-three are restricted solely to young artists, many more are aimed at 'emerg-ing' artists, and most of the remainder tacitly favour artists under thirty-five. Only two are specifically aimed at rewarding mature artists.[10]

The demand that 22-year-olds with very little life experience be given the same recognition and status as artists who have been honing their skills and philosophies for decades is indicative of the sort of instant gratification the market needs. 'Encouraging' young people means encouraging them not to learn but to believe they do not need to. Maturity, experience and skill, far from being admirable qualities, are disparaged because they have no commercial value.

The English writer, George Walden, has said that 'when you do not know or care enough about the arts to make discriminating judgments, indiscriminate enthusiasm is the safest bet'.[11] It's pithy, yet I don't think the contemporary art world's various enthusiasms are entirely indiscriminate, although at times they might very well

seem so. They are almost always guided by some innate apprecia-
tion of what will make money for someone.

The Tiwi people make tutini, or pukumani poles, for two quite dif-
ferent purposes. Some are for use in burial ceremonies, others for
display and sale in capital city galleries. The Tiwi people regard both
as legitimate and important. Proud that city folk appreciate their
work, they give just as much care and attention to the poles made
for sale through galleries as to those used in their own ceremonies.
They do not seem to be concerned about the commercialisation or
commodification of their art because they are confident enough in
the strength of their cultural traditions to believe that selling to city
art dealers poses no threat. Remote from the intricate machinations
of the art market, they see it as a benign institution that generates
income, helps to disseminate Tiwi culture, and brings credit to their
people, with no apparent ill effects on their belief systems. They see
no reason that pukumani poles should not serve two completely dif-
ferent purposes, provided, of course, that a clear distinction is
drawn between them. How long that distinction can be maintained
is open to question.

The poles they make for burial purposes quickly disintegrate in
the humid climate. Yet their existence, although short, is relatively
unproblematic. Their role and purpose are accepted without ques-
tion, their place in the culture is secure. Those made for galleries,
on the other hand, are destined to be treated with infinite care and
will probably last for centuries. Nevertheless, they will see out their
days in an unending purgatory of disputation.

No form of contemporary art is more contested or fought over
than that produced by indigenous communities. At the same time,
the discussion of indigenous art is tightly constrained by cultural
sensitivities. Even the most benign and well-intentioned commen-
tary is likely to fall victim to accusations of ignorance, condescen-
sion or racism. Normally, cultural insensitivity is the very stuff of
contemporary art. Shock, ridicule, disturbance, and the ritual dis-
embowelment of traditions – or 'accepted ways of thinking' – are

the customary goals. Special reverence and respect, however, are accorded to the accepted ways of thinking of Aborigines and Islanders.

Most of the qualities we admire and encourage in so-called traditional Aboriginal art are those we usually deride in contemporary non-Aboriginal art. Aboriginal art promotes cultural cohesion and religious orthodoxy; it helps, for example, to protect and maintain respect for social hierarchies, honours and perpetuates traditional practices, and reinforces the subordination of the individual to strict communal laws.

The claim has often been made that, because urban dwellers are so alienated from their cultural traditions, they value in tribal art what they feel their own art no longer offers. They compensate for the loss of their own collective values by trying to appropriate those of another culture. Although this view is increasingly out of favour among professionals, I think there is a good deal of truth in it. Enthusiasm for desert community acrylics among collectors and gallery goers in the big cities no doubt does reflect a certain longing for art that offers engagement rather than commentary and expresses collective as opposed to individual values. Even if the cultural mythology is largely incomprehensible to outsiders, just knowing it's there, somehow embedded in the dots, stripes and circles, is important in itself. We like Aboriginal art because it tells stories, even if we don't know what those stories are.

According to Peter Sutton, Philip Jones and Steven Hemming, 'In traditional Aboriginal art, there is basically only one public text: the story, or spirit, or animal represented and its representation. The artist does not say things like: "In this painting I am trying to show the relation between power centred in the gerontocracy and what has happened to young people in my society." Meaning is not made exterior to its representation, and the message is not distinct from the myth or image itself. There is a quantum gap between this kind of mythic interpretation and an ethics-based overt analysis of the social order.'[12]

Marcia Langton, concerned that this interpretation diminishes the status of urban Aboriginal artists, rejects it, asking rhetorically, 'Were the Futurists detached from the European tradition?'[13] Yes, they were, which is precisely what is at issue.

It is because of such detachment that people living in cities, who may feel their lives to be, in some inexpressible way, fractured and decentred, are drawn to what they perceive to be the certainties and rootedness of tribal art. Whether or not we approve of this attraction is rather beside the point. Although such people probably have no desire to go back to a time when religious icons in Christian churches were not just art but sacred embodiments of faith, they nevertheless sense that something fundamental has been lost. The example of indigenous art may at least suggest what that something was. It is not enough to dismiss this as sentimentality, or misguided primitivism, or mere longing for the exotic other.

All the same, it represents a highly reductive view of indigenous art, relying on an ill-defined notion of authenticity. It does not take into account the sheer multiplicity of so-called traditional Aboriginal art and the extent to which it so often deviates from tradition. Acrylic dot paintings, for example, did not even exist before 1971, so authenticity is, in this case, purely symbolic.

The Tasmanian Aboriginal artist, Judith-Rose Thomas, for instance, makes a point of not using dots in her paintings because they were never used by Tasmanian people in the past. 'They have nothing to do with Tasmanian Aboriginal art,' she says.[14] Instead, her abstract paintings incorporate Tasmanian rock inscriptions – or petroglyphs. The truth is that nobody really knows who made these ancient engravings or what their purpose was. Thomas can claim no more affinity with petroglyphs than Jackson Pollock can to the stone-age painters of the Lascaux caves. By copying some of their designs into her geometric abstract paintings, she expresses no meaningful cultural connection. Instead, she makes a point about contemporary indigenous politics. There's nothing wrong with this, of course. Many artists use their art, and the art of other people, to assert a political position, but that is not the same as establishing a lineage. When artists from an indigenous background make reference to cultural traditions, as Judith-Rose Thomas does, in order to comment on contemporary social issues, the term 'Aboriginal art' becomes a subject-matter categorisation rather than a substantive artistic one. Once Aboriginal art has severed its connections with tribal knowledge and religious ceremony, how is it different from any other kind of art?

Academics, critics and professionals tend to decry the false dichotomy between traditional and urban Aboriginal art, and with good reason. Financially, however, it is very useful indeed, and the market is not going to give it up in a hurry. The words 'authentic' and 'traditional' crop up again and again in catalogues and press releases – although they would be completely meaningless if applied to non-Aboriginal contemporary art.

The marriage of such high-flown ideals with the rather less exalted demands of the marketplace does, however, create some baffling inconsistencies of tone. Authenticity and cultural continuity might be the pitch, but the art auction houses know that there has to be more than that on offer if collectors are to open their chequebooks. The work must also be a good investment, and that will partly depend upon some form of endorsement from the buyer's peers.

Sotheby's and Christie's make much of the potential for profits from the Aboriginal art trade, their boasting – and the way it is reported in the press – often verging on the vulgar. 'In 2002,' enthused *The Bulletin* recently, in an investment report about a forthcoming auction, 'Sotheby's shifted a record $5.1m in precious paintings and artefacts. This year [2003], the 560 lots to be knocked down at Sydney's Museum of Contemporary Art on July 28 and 29 have been pegged at an upper estimate of $9.69m. With more than 20 lots listed with estimates above $100,000, records will likely fall for the established hit parade of indigenous artists: Emily Kame Kngwarreye, Ginger Riley Munduwalawala, Alec Mingelmanganu, Johnny Warangkula Tjupurrula, Rover Thomas, Dorothy Robinson Napangardi and Clifford Possum Tjapaltjarri ... [Tim] Klingender [Sotheby's Aboriginal art consultant] says there are around 100 serious private collectors. However, only about 10 wave their paddles at works worth more than $500,000.'[15]

Presumably, when Sotheby's talks about serious collectors, they don't necessarily mean those with a scholarly interest in Aboriginal art, but those who wave their paddles a lot with serious intent. Interestingly, the article goes on to say that most of the really serious collectors are wealthy businessmen living in Switzerland, France, Holland and, of course, America.

As for peer-group endorsement, almost anyone will do. Of course, it is nice to know that the artist who painted the work

you're thinking of buying is a respected senior member of his or her community. This adds to the work's authenticity – although, as we've seen, youthfulness is usually more valued in whitefella's art. How much more reassuring it is, however, to be told that it was shown in the artist's first solo exhibition in Sydney, that it 'can be closely compared to the large works of the same period collected by Dr Stuart Scougall and Tony Tuckson for the Art Gallery of New South Wales'[16] or even, for want of anything better, that it is 'from the collection of C. M. Murphy (former manager of the rock band INXS)'.[17]

As Sotheby's list of 'the established hit parade of indigenous artists' demonstrates, the market demands names. The ethnographic museum system of labelling indigenous works as coming from a particular group or geographical area has now largely been replaced by the art gallery system of attributing them to an individual creator. This has paralleled – and helped to drive – a shift away from art as an expression of group identity to art as personal commentary. It is a big shift.

As a result, the market finds itself in the rather curious position of working to promote indigenous art as a genuine outcome of age-old cultural traditions while, at the same time, assimilating it into a particularly post-Enlightenment Western notion of the artist as individual genius.

This is welcomed by some as a healthy convergence of the two cultures to the benefit of both. The monetary benefits to indigenous communities, especially those that have adopted dot painting techniques, are cited with enthusiasm. Aboriginal art accounts for more than half of the overall value of visual art sales within our borders and the overwhelming majority of our art exports. On average, more than $100 million worth of Aboriginal and Islander art is sold every year. Not all of this money finds its way back to the indigenous communities, of course, and certainly very little of that raised at auction. Nevertheless, some communities have now become almost completely dependent upon art production for their survival.

Aside from the material benefits, the encouragement provided by the art market has, we are told, helped to rejuvenate Aboriginal cultures, with art having become a vital tool in the passing down of traditional knowledge and customs. I think this is overly optimistic,

based as it is on a misunderstanding of what cultural traditions are and how they work. It's a complex subject, which I explore more fully in a later chapter.

Obviously the urban art market is also benefiting. Many dealers and collectors are doing well out of Aboriginal art sales, especially those enthusiastic paddle-wavers in Switzerland and the US. Financially, at least, it's a win–win situation, as an accountant might put it, although it has to be said that the basis of this particular economic boom appears fragile, vulnerable as it is to the exigencies of fashion as well as to the threat of marketing overkill. It is worth remembering, by way of illustrating the power structures involved, that if the Aboriginal art market did happen to collapse at some time in the future, white art dealers, academics, critics and curators would be able to move on to other things. For the creators, on the other hand, it would be a social tragedy of monumental proportions.

More difficult to quantify, although ultimately far more significant than the financial gains, is the impact that indigenous art is having on urban moral and artistic values. The market, as I suggested earlier, must be responding to – and trying to exploit – something.

One of the clearest indications of Aboriginal art's influence on the hermetic interests of the academic art establishment is the revival of interest among urban artists in landscape and the environment. This has come about only in the past couple of years. As recently as 1997, for example, 'Art and Nature' was an unusual choice of theme for *Australian Perspecta*, being, as it was, so morally loaded, and demanding, as it did, a fair degree of social and political engagement. The response from artists, according to most reviewers, was timid and confused. Nature was too big a subject and contemporary artists ill prepared to deal with the moral and ethical questions it posed. Moreover, the long tradition of landscape painting in this country, stretching from Conrad Martens and Glover all the way through to Fred Williams, had become so closely associated with artistic conservatism and the worst kind of nationalism that it was thought best avoided altogether, except by those, such as Ian Burn, Imants Tillers, and others, who wanted to do a hatchet job on its conventions. As the Melbourne writer Janine Burke once wrote, the landscape 'has stimulated, centred, typified and constrained art in this country since the arrival of the white colonists and their

prisoners two centuries ago'.[18] It can hardly be surprising, then, that almost everyone was eager to escape its grip.

Today, artists are less afraid of dealing with moral and ethical questions, and more confident about working with rather than against conventions. Now that we have finally got around to taking an interest in the way that Aboriginal cultures have interacted with, and interpreted, the land, we are beginning to realise not only that the Great Australian Landscape Tradition was much smaller than we could ever have imagined but, importantly, that we need not feel defensive about landscape as a subject for art.

The abstract paintings of Judy Watson and Brian Blanchflower, John Wolseley's visual diaries of his journeys, Bonita Ely's mystical performances and Sieglinde Karl's installations of found natural objects, to cite just a few random examples, are attempts at a holistic interpretation of the landscape that owe much to the example of traditional Aboriginal art. Not content just to picture the environment, such artists try to engage all the senses, articulating processes of change, both natural and cultural, thereby creating narratives about the landscape as a theatre of myth and symbolism, with no hint of didacticism or easy moralising.

Yet, despite these happy cross-fertilisations, and despite the economic benefits the Aboriginal art market brings to both its producers and its consumers, the evidence is that the consumers have the upper hand, purely by dint of their controlling the purse-strings. The convergence that many art professionals cite approvingly can look like the worst kind of assimilation.

From one point of view, it is encouraging and exciting that designs once subject to strict control by senior law men or women are now applied to cars, T-shirts, or giant murals in corporate boardrooms. This represents a kind of freedom. But that freedom comes at a price. There is no reason to think that Aboriginal art will be any more immune to the culture of forgetting than Western art has been.

The artist Richard Bell won the *Telstra Aboriginal and Islander Art Award* in 2003 with a didactic painting made up of the words: 'Aboriginal art – it's a white thing'. Like all sloganeering, it's crude and simplistic, but Bell does have a point, which can't easily be brushed aside with bland assurances about adaptability and convergence.

Consider, for example, the fleeting art movement at Wingellina, in the Central Desert where Western Australia, Northern Territory and South Australia meet. Under the guidance of its arts advisor, Amanda Dent, the art of this tiny desert community became a hot art-market property between 2001 and 2003, with paintings by some of its more competent artists selling for $30,000 or more. Sadly, jealousies and arguments over money brought it all to a halt, threatening to break up the community entirely. Wingellina demonstrates, writes Nicholas Rothwell, 'how fragile a new wave breaking in the hectic world of indigenous art can be'. The few months in which this art movement flourished, he says, '... may well be understood in time as the brief final gleam to come out of the western desert – for the last men and women raised with traditional beliefs, in pre-contact conditions, are all passing away now, and what follows them, what comes from their children, raised in bush communities rather than beside desert rock-holes, will be something new'.[19]

A lot will depend upon whether the art market remains interested in this something new, which, in turn, will depend partly on how long some symbolic notion of authenticity can be sustained.

In late 1997, the National Gallery of Victoria hosted an exhibition of colour photographs by the American artist Andres Serrano. They were, in the main, deliberately clichéd, pseudo-sentimental images of masturbation, fellatio and intercourse heavily burdened with Catholic guilt. One work, *Piss Christ*, depicting a crucifix being showered with urine, had already established Serrano as a figure of controversy overseas. So, before the exhibition opened here, the National Gallery of Victoria ran some titillating advertisements that shamelessly capitalised on his reputation. 'Confronting! Provocative! Sensational!' ran the slogan, printed in heavy block type set at an angle, as in a supermarket or used-car commercial, to lend it extra urgency.

The Melbourne press, hungry for scandal, seized its opportunity. The media know they can rely on the contemporary art world

for the occasional public furore. The art world, in turn, is usually quite happy to oblige, while sanctimoniously condemning media sensationalism. Consequently, even before the exhibition opened, Serrano had generated more publicity than most artists get in a lifetime. Concerned, perhaps, that things might be getting out of hand, the director, Timothy Potts, and the curator of photography, Isobel Crombie, retreated to the high ground, observing stiffly that it was the gallery's responsibility to show the work of important overseas artists regardless of how disturbing or challenging it might be. Maudie Palmer, art consultant to the Melbourne International Festival, under whose auspices the exhibition was shown, stated decisively that Serrano was 'one of the most important contemporary fine-art photographers in the world today'. Her anachronistic use of the term 'fine art' is an indication of the special pleading that characterised this whole affair.

Given that the National Gallery of Victoria has something of a reputation for the infrequency with which it shows the work of contemporary overseas artists, the question naturally arose: why this one? What criteria was the gallery using to decide which artists were important and which were not? Potts, Crombie and Palmer were not to be drawn on these vital questions.

As was perfectly clear to everyone, it was not any conviction about Serrano's artistic importance that had convinced the gallery to display his work, but his promise to shock and disturb. A scholarly and expensive Rembrandt show was on at the same time. Serrano was to provide the milling throngs with the excitement that the dull old Dutchman couldn't be relied upon to produce for himself. As it turned out, however, the plan backfired spectacularly.

When a gallery promises that an exhibition will be confronting, provocative and sensational, it doesn't really expect many of us to be genuinely confronted, and it certainly doesn't want us to be literally provoked. It is all a game: they pretend to be shocking, and we, in turn, pretend to be shocked; or at least we are smugly convinced that someone less mature and sophisticated than us will be shocked.

Federal and state arts ministries happily fund so-called subversive art on this understanding. If they thought the art was really subversive, they wouldn't fund it. (Conservative senators in the

United States have successfully stopped public funding for works by
Richard Serra and Robert Mapplethorpe which, by threatening to
be genuinely disruptive, broke this tacit agreement.)

As George Walden has written, 'Democratic peoples must be
more creative than non-democratic ones, if only because the idea
that the opposite might be the case is intolerable. Whatever the
merits of the contention that repressive or authoritarian regimes
have produced the finest literature or most brilliant artistic move-
ments, it would be a bold politician who took the next logical step
in the argument. Democratic publics also have a *right* to art, for
which they pay through their taxes and lottery tickets, and a plen-
tiful supply must be forthcoming. Like health care and education,
art is a public good, a commodity whose provision must be offi-
cially guaranteed and overseen.'[20] Governments and big business
alike can position themselves as tolerant, forward-thinking and
democratic by financing art that appears to oppose everything they
stand for. In doing so, they know they have a lot of democratic
brownie points to gain, and very little to lose.

Serrano's exhibition threatened to upset only those with a
strong moral objection to the public depiction of sexual acts,
Catholics in particular. They are, it has to be said, a very soft target.
Having very little real power, their influence on the commercial
world is minimal. Their objections, therefore, could be brushed
aside with alacrity, even exploited by the gallery to bolster its pub-
licity. This was a textbook case of an artist and a public gallery play-
ing the shock game without risking anything, or so they thought.
The gallery would never, for example, have taken the real risk of
showing work by an artist from Pakistan who was being equally
insulting about Islamic moral codes – were it possible for such an
artist to exist – or an exhibition that made a mockery of traditional
Aboriginal beliefs. There is a clear distinction between those it is
safe to offend and those it is not, and that distinction has a lot to
do with economic and political consequences.

Quite unexpectedly, real danger did emerge for the National
Gallery of Victoria in the form of a young man who, taking
the publicity at face value, was provoked into smashing *Piss Christ*
with a hammer. Potts, with a worried eye to all those valuable
Rembrandts in the next room, closed Serrano's exhibition only a

day or two after the opening, while loftily disclaiming any responsibility for what had happened. Serrano was reduced to making a series of saccharine portraits of Melbourne children for the *Herald-Sun* newspaper before departing, unnoticed, for home.

The young man with the hammer probably thought he was defending a fixed moral principle. The National Gallery of Victoria and Serrano probably considered him just an isolated loony. Their view, no doubt, was that there are no fixed moral principles any more and that acting out games of supposed subversion and transgressiveness is an integral part of capitalist culture: hence their claim that they had a duty to show important work, regardless of how disturbing or challenging it might be. They failed to acknowledge that there are limits.

Those limits are generally set according to the market's expectations. Any artist who wants to 'challenge' or 'disturb' must be prepared to do so in inverted commas, so to speak: to play the game according to the rules. Sponsors, promoters, government funding agencies, galleries and museums and, of course, the media all expect, even demand, some semblance of revolt, some supposed challenge to accepted ideas, even if there is generally no clear idea of what those 'accepted ideas' might be. They expect artists to play the role of court jester, just so long as it doesn't hurt anyone important or disrupt the smooth progress of commerce.

A perfect illustration of this was provided in 2002 by the Tasmanian Labor Premier, Jim Bacon. In what was widely interpreted as a cynical political manoeuvre, he announced that the 2003 state arts festival, *Ten Days on the Island*, was to be sponsored by Forestry Tasmania, a much reviled state-owned company best known for clear felling old-growth native forest for woodchips. No doubt he thought the association with an arts event would be good for the company's tattered public image. Bacon was ill prepared for the highly organised and vociferous protest that followed, which threatened to discourage other potential sponsors.

He and Robyn Archer, the festival's artistic advisor, panicked. Angrily, they accused protesting local artists of trying to destroy the festival – by which they meant its commercial potential – and mounted a campaign of vicious personal abuse. In a five-page letter to the protestors, Archer called them naive, dangerous, stupid and

– somewhat contradictorily – ineffectual. 'You have misunderstood the nature of arts sponsorship in a most naive, and therefore dangerous, way,' she thundered. 'Your protests against our first named sponsor have caused extreme nervousness in the other potential major sponsors ...'[21] In a later newspaper article, she claimed that with sponsorship, as with sausage meat, it's best not to ask where it comes from.

Bacon's response was no less hysterical. He railed in parliament against these 'cultural fascists' – a statement he quickly came to regret, but for which he never apologised. 'I find it appalling,' he wailed, 'that the Green thought police think they can go round and tell everyone else what they must believe ...'[22] Needless to say, he wasn't appalled at all. For him, this was politics as usual. But he had to pretend to be appalled for the sake of appearances.

Revealingly, one of the first alternatives they came up with – the only one – was an exhibition or some other art event through which the artists' concerns about clear felling could be channelled. '... [T]he best way to convey your message, as artists, would be in a creative approach ...' said Archer.[23] Bacon and Archer knew that social protest in the ritualised form of an art exhibition or theatre performance would be, from their point of view, contained and relatively harmless. The alternatives – television coverage of street demonstrations and newspaper articles in support of the protesters – were much more dangerous because they occurred within the purview of big business.

When their alarmism proved unfounded and they had secured all the sponsorship they needed, Bacon and Archer suddenly turned conciliatory, eagerly affirming the artists' right to have their say 'in a democracy'. For them, this was clearly not a moral question, but a monetary one. The moment the financial threat was over, the issue ceased to matter to them.

Whatever else we might say about the values of the church and the art academies – however open they might have been to exploitation and corruption – they were at least real values, firmly rooted in cultural tradition, widely accepted, non-negotiable and an end in themselves. The values of the market are not real values at all. They are endlessly negotiable and no more than a means to another end: that of keeping money in circulation.

Basically, there are two kinds of market: mass markets and niche markets. General Motors wants to sell its Commodore to as many people as possible, so it promotes it heavily and keeps its price down. Daimler–Chrysler, on the other hand, knows that only a tiny number of people can even think about buying its luxury Maybach ('the high-end luxury car at the very peak of the passenger car market'). You can buy more than twenty Commodores for the price of a Maybach, but almost nobody believes the Maybach is really twenty times better at getting you from A to B. What you're paying for is that mysterious thing called prestige. Luxury goods like the Maybach are valued precisely because they are prohibitively expensive.

The dilemma facing many of those who serve government arts bureaucracies – such as the authors of the Saatchi report – is that they are required to promote niche market goods to a mass public. The art is acknowledged to be difficult and obscure, yet every man, woman and child must be encouraged to enjoy it. The usual response of curators and academics is that the public will have to be 'educated'. They see themselves as interpreters, rendering down the gnomic utterances of the art world into a form that will be understood by lesser mortals. The customary response of politicians, on the other hand, is to demand that artists should stop being so bloody incomprehensible and start communicating in ways that 'ordinary people' can comprehend. Museum administrators try to avoid the dilemma altogether by presenting us with ever more spectacular buildings crammed with bistros, bookshops and video screens, in the hope that we will be so enamoured of the packaging that we won't care about the contents. These three responses dovetail very neatly and all undoubtedly have something to recommend them. Yet all are deeply patronising, since they assume without question that those in the art world are smarter than everyone else.

The Saatchi report people, however, are much cannier than that. Being advertisers by profession, they understand that difficulty is, in itself, art's strongest selling point, although they are reticent about saying so openly. These are, after all, the people who routinely append the terms 'luxury', 'classic', 'premium', 'gourmet' and

'unique' to all kinds of cheap mass-produced goods. They know that since the 1980s, luxury spending in the United States has grown at more than four times the rate of spending overall, because luxury goods are no longer chiefly the province of the wealthy but of the upwardly mobile middle classes with their high credit-card limits. Luxury goods are not necessarily high-quality goods, merely ones that advertisers have designated as such and are priced accordingly. By much the same logic, difficult, obscure, incomprehensible art can be marketed as good art purely by reason of its being difficult, obscure and incomprehensible. Art becomes another luxury product, with the notion of difficulty defining its market niche.

I think they are on the right track, although sadly they miss the implications, since they are unable to get past art's commercial utility in order to understand what its real value might be. They either fail to understand art's potential for complexity and why it is important, or else they deliberately distort it in order to turn it into a commercial proposition.

Their basic insight, however, is correct. Understanding is not the issue. We do not seek out works of art in order to have things explained or clarified, but for the opposite reason – to have our world made more mysterious, to invest it with strangeness, to bring the metaphysical and incomprehensible into the ambit of thought. From art we seek insight and illumination, not information or guidance on how we should think and behave.

Understanding a work of art, however, in the sense that curators and critics generally use the term, involves nothing more than a decoding, however convoluted and demanding that may prove to be. The decoding of difficulty is what curators' descriptive labels usually attempt. By this logic, the public can be 'educated', as long as the right keys are provided.

Such an approach neatly accommodates the demands of marketing, which must at least hold out the promise of solutions and closure – although it is always a false promise. The whole point of marketing is to convince us that fulfilment is perpetually just around the corner. This is the source of the market's irresistible eroticism. Branding art as difficult, then, eschews the wishy-washy vagueness of personal insight and enlightenment – that is, it eschews complexity – for the concreteness of mere obscurity.

Decoding it is someone else's job, but it is important that we be aware that explanations are available if we want them. The only thing the marketers need do is to convince us that, precisely because of its difficulty, this is a unique, luxury, classic product.

There's nothing at all complex, for example, about Tracey Emin's unmade bed, littered with blood-stained underpants, used condoms and vodka bottles. But we can perceive some difficulty, even if it's only that we find it difficult to understand why such an object is being called a work of art in the first place. Once that is explained to us, we can either accept it ('Oh, now I get it!') or not, depending on how sympathetic we feel.

As art, Emin's bed is difficult yet simple. It is difficult in just the way a naughty child can be. On the other hand, it is possible for a work of art to be complex without being at all difficult: a Giacometti figure, for example, a Japanese raked-sand garden, or one of Monet's waterlily paintings. Ian Hamilton Finlay's *Adorno's hut* strikes me as both complex and difficult. Peter Hill's students were apparently interested only in solving the difficulties, which Hill's exegesis was obviously able to do very well. But it could not help them with the complexities, which they could tackle only by drawing on their own life experiences and exercising their own imaginations.

It should be obvious to anyone with eyes that Imants Tillers, Mike Parr or Barbara Kruger are no more conceptually complex than Rembrandt, Beckmann or Tom Roberts. Very often they are decidedly less complex, deploying wilfully abstruse and alienating means to express quite basic things. The difficulty we encounter in their work is not the complexity we find in Goya's chillingly strange *Black Paintings*, for example, which carry us into terrifying places in the mind and leave us stranded there. It is, instead, the difficulty of the masonic ritual, which excludes our participation until we have gone through all the hoops of initiation. Initiates may feel smug about their feelings of exclusivity but, if they are honest with themselves, they will have to acknowledge that contemporary art, when you do eventually break the codes, often turns out to be just as dumb as it looks.

What modern art marketing tries to do, consciously or otherwise, is to convince us that difficulty is the same as complexity, or

at least an adequate stand in. That involves surrounding simple, straightforward works with an air of mystery and exclusivity.

Written discourse and arcane theory is one way to do it, but that must be backed up at the point-of-sale. Therefore the most prestigious galleries, selling the most difficult contemporary art, will usually be shrine-like spaces with discreet entrances, austere hushed interiors, and reverential low-key displays. Everything about them is cabbalistic and esoteric.

There's nothing necessarily wrong with that. We need some secular shrines. We are generally quite accepting when we think the works on display deserve the reverence their surroundings demand. All too frequently, however, we do not. Although the presentation promises enlightenment, what we get is all too clearly a pretence.

I once had the great privilege of being present as a high-powered art dealer tried to interest a couple of obviously wealthy middle-aged collectors in one of Kathy Temin's woolly constructions. (Actually, I was in the gallery, they were in the back room, but the dividing wall was thin.) The Temin, as I remember, looked something like a rabbit hutch made of cardboard covered in white fur. Although it was a difficult work in that it was impossible to make much sense of it without its secret codes being explained, the dealer's pitch did not include any attempt to do so. She was treating it as if it were genuinely complex, concentrating entirely on subjective, unsubstantiated claims for the artist's 'importance' and the 'centrality' of this work in her oeuvre. What was on sale here was not a furry cardboard box, but a ritual object, a splinter of art's True Cross. This was an important work, not because of any inherent qualities the viewer could discern, but because someone in authority was declaring it so. The work's high price tag provided confirmation. If the same object, through some dreadful misunderstanding, had turned up at an opportunity shop for five dollars, it would have had no significance at all, for its difficulty was entirely reliant on its context.

For these wealthy collectors to have asked, 'Yes, but what does it mean?' would not only have exposed them as philistines, but would also have ruined the work's magic aura. So they limited themselves to appreciative grunts.

At the beginning of the twentieth century, difficulty in art served a particular, practical purpose. The new dealer–critic system,

which had taken over from the academies, defined the importance of individual artists in terms of the extent to which they had broken from the shackles of the past. Art became a weapon in modernism's battle against the bourgeoisie. Quality came to be measured by how much a work of art deviated from the norm and was consequently disliked by the general public, since the assumption was that people always preferred what was familiar. This was not an entirely unfounded assumption, of course, although the public's more willing embracing of scientific, social and political changes at this time – in particular, those that people thought would be of benefit to them – suggests that, rather than objecting to the unfamiliar as such, people may have been wary about a possible breach of faith.

After all, Nietzsche had written in *The Will to Power* that a 'declaration of war on the masses by higher men is needed'. Modernist artists, naturally seeing themselves as higher men, were keen to lead the fray. Can we wonder that the masses were not all that keen to follow?

The English academic John Carey maintains that this patronising attitude was, in part, a response to education reform in the late nineteenth century, which threatened to give common folk ideas above their station. He quotes numerous instances of intellectuals imperiously condemning universal education as ill conceived and dangerous. They included Virginia Woolf, Aldous Huxley, T. S. Eliot and Ortega y Gasset, who wrote an entire book on the subject.

Intellectuals, says Carey, could not actually prevent the masses from attaining an education, but they could up the ante by making art too hermetic and difficult for them to understand. 'The early twentieth century saw a determined effort, on the part of the European intelligentsia, to exclude the masses from culture. In England this movement has become known as modernism. In other European countries it was given different names, but the ingredients were essentially similar, and they revolutionised the visual arts as well as literature. Realism of the sort that it was assumed the masses appreciated was abandoned. So was logical coherence. Irrationality and obscurity were cultivated.'[24]

Carey's argument is convincing as far as it goes, but it doesn't go far enough. Although it's true that many modernist artists were motivated by contempt for those they thought of as their

intellectual inferiors, an artist's personal prejudices don't necessarily effect the quality, or even the character, of his or her work. Are we to believe that Picasso's synthetic cubist portraits are any less interesting because Picasso himself might have been arrogant and contemptuous?

Personal disdain for the masses is not sufficient to account for the entire phenomenon of modernism. One can easily accept that the Dadaists were spurred on by contempt for middle-class values. Mondrian's exacting coloured squares and rectangles, however, could hardly be interpreted that way, nor could Bonnard's luminous nudes, nor Matisse's interiors. Such works, like a good deal of modernist art, and pre-modernist art, was not just difficult but highly complex. It was obscure by necessity, not out of obduracy.

Since he concentrates entirely on the motives of artists and writers, Carey loses sight of outcomes, at least one of which was entirely positive. By destroying the compact between art and its public and casting off in a new direction, artists may have sacrificed much, while demanding that the public sacrifice even more, but they also found the freedom to explore ideas in ways that had not been available to them before. The works of Nolde, Brancusi or Duchamp may have been hard for the public to understand, but they rewarded concentration and commitment. When people came to that understanding – when they realised that their efforts would not be in vain – they were able to cast aside their doubts. Or at least a certain number of them were – enough to completely reshape the Western world's perceptions of itself.

As the dealer–critic system became entrenched, however, so too did its founding notion: that the quality of a work of art was measured by the degree to which it broke with convention. Nobody seemed to notice that constant radical change was now the only convention in almost every facet of people's lives, so that breaking with convention had become an oxymoron. Avant-gardism in art had become nothing more than a habit. The war against the masses dragged on purely because nobody could imagine what a peace might be like. In any case, both sides rather enjoyed it, in a perverse sort of way. It had degenerated into one of those longstanding family feuds that continues

down the generations, providing everyone involved with the only sense of identity they know.

Britain's Turner Prize provides the perfect illustration of how practical jokes and weak visual puns can be marketed as profundities to a mass audience that no longer knows the difference and isn't interested in finding out, but finds it all a bit of a hoot nevertheless. Although the press may still try occasionally to drum up a scandal over the price that some museum has paid for a can of artist's shit or a bisected cow, the public doesn't care. The sting has gone out of it all. People just trust the market to tell them what they should notice. If the market isn't interested, then they will not be either. If there's a scandal going, they're happy to be in on it.

As recently as the early 1990s, when a French sociologist surveyed the attitudes of contemporary art collectors, he found that their most commonly cited criterion for purchasing a particular work was that it should ' "disturb", "shock" and even "assault" them, or that it "displease most people" '. He also found that when local authorities commissioned public artworks in order to boost their images, the possibility of hostile reactions from the general public had almost no influence on their decisions.[25]

What, then, could artists do, given that their assaults on public taste had become so formulaic? How could they stay one jump ahead of the masses? Two possibilities suggested themselves. The first was to increase the likelihood of shock by resorting to obscenity. The Serrano exhibition is an – admittedly fairly tame – example. There are many others: the Chilean artist, Antonio Beccerra, for instance, held an exhibition in Santiago in 2002 of dead dogs pierced with spikes; a show at New York's Holocaust Museum the same year included photographs of concentration-camp inmates into which the artist had inserted pictures of himself holding a can of Coke; the German, Gunther von Hagens, has exhibited partly dissected preserved human corpses and conducted a public autopsy as art. *Der Spiegel* magazine has since revealed that von Hagens used the corpses of executed Chinese prisoners.

Shock, however, as the American philosopher Philip Fisher has pointed out, is a knee-jerk response to boredom and habit. 'Shock is a rejuvenation within fatigued systems of representation and thought ... With shock we face the all or nothing, the Russian

roulette of a mind or a system at the end of its rope. It is a last rather than a first move within experience.'[26]

More subtle, and certainly more civilised, was the strategy of refining the idea of difficulty. Commonplace items could be reinvented as ritualised objects by investing them with a spurious aura of vision and faith, as witness, for example, Kathy Temin's furcovered cardboard box. By this means, artists and critics have been able to take the war from the old battlefields right into people's homes. No longer can we talk about this special category of human endeavour called Art, which is probably too difficult for you to understand. All the ordinary things you think of as part of your lives – popular songs, comic books, advertising, television sit-coms, pornography, packaged food, toys, shopping – are actually also too difficult for you to understand. We're here to tell you what they *really* mean. Mass culture, far from being openly reviled by artists and intellectuals as inferior and unworthy of their attention, has been problematised and claimed as their own territory.

If we remain indifferent to Vivienne Shark Le Witt's crudely drawn cartoons of modern life, or Brenda Croft's family photos overlain with text, or David Noonan's repetitive appropriations of science fiction films, it is not because we cannot accept that cartoons, family photos or sci-fi movies may be signifiers of cultural meaning. It's just that routine explications of cultural meaning are not really what we want from art, or at least they are only a very small part of what we want. This is art that demands decoding, and we're rarely given enough reason to be convinced that it will be worth the effort.

Our exposure to the public relations industry, party politics, advertising and popular commentary has left us well aware of any possible interpretations these common things might prompt. As the *Hype* exhibition proved, we know it all already. We're well ahead on the irony thing.

We also instinctively know that garbage bags, family photographs, suburban project homes, cars, handbags and dog kennels, however much we might invest them with a bit of harmless nostalgia, don't deserve the status of sacred cultural objects. They are a sham. They can't enact any dramas, they can't make life strange and wonderful, they cannot enlighten us. They can only describe the

world we already know, over and over, without variation.

Artists who wryly observe the ironies of our everyday lives have got themselves stuck in neutral. They rarely appear to believe in anything. They often make a point of not believing in anything. They simply adopt positions.

The problem with so much contemporary art, therefore, is not that it is too complex. Quite the contrary: it is merely difficult. Its difficulty – unlike the genuine complexity of Mondrian or Beckmann or Rauschenberg; or Monet, Ingres or Grunewald; or, for that matter, Joyce, Schoenberg or Laurence Stern – amounts to little more than obfuscation.

But if you want to be effectively obscure and difficult, you require an obfuscator, a spruiker, someone to convince people that there is more here than meets the eye, even when there isn't. This is where writers, critics and theorists come in. Increasingly, their job is not so much to elucidate or to enhance our enjoyment of art, but to complicate matters, to blind us with science, to convince us that the work they are talking about, despite all appearances to the contrary, is complex.

Sometimes *une pipe* is just a pipe, but we must never be allowed to think so.

3

BUILDING A NOTION

Sensing that a lot of the art they are called upon to defend just can't bear the weight of too much examination, art critics and theorists are frequently forced to obfuscate and cajole. Subjective opinions are presented as facts, platitudes as insights. Neologisms and jargon are enlisted to conceal the fact that neither the writer nor the art being written about has anything very interesting to say.

We may, for example, be told that a work is 'disturbing', 'powerful', 'strangely beautiful' or 'deeply moving' – all terms I took at random from a single art-journal review. These are not qualities inherent in the work, although they are often presented as such. At best, they describe only the effect it had on the writer, and art writers, it has to be said, seem a great deal more susceptible to being disturbed and moved than the rest of us are. Of course, critics and reviewers should express their opinions – they must be partisan – but those opinions need to be substantiated if readers are to take them seriously.

Instead, the tactic is usually to hint at hidden qualities that will reveal themselves only to those who have insider knowledge. Art

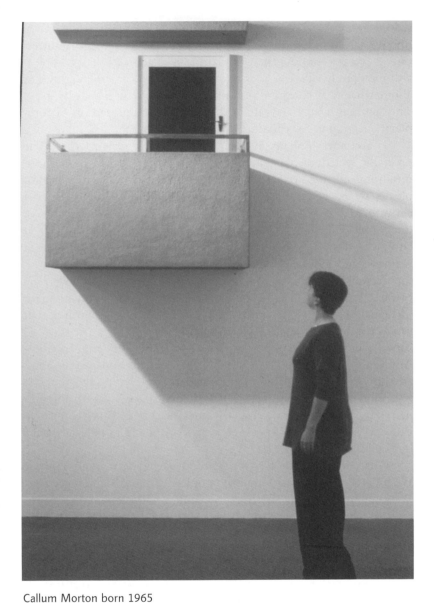

Callum Morton born 1965
Liminal no. 2, 1994
Mixed media
Dimensions variable
Reproduced courtesy of the artist and Anna Schwartz Gallery, Melbourne

writing these days tends to be exclusionist, a very unsubtle game of one-upmanship. Although a work might *look* simple and uninteresting, we are confidently assured that it is actually very complex, although rarely will a critic make any genuine effort to enlighten us about what that complexity consists of or how it manifests itself. The fact that what I am calling difficulty can be passed off as complexity is enough for the purposes of marketing.

The curator, Juliana Engberg, for example, claims that 'The precisely scaled down balconies that Callum Morton has been mounting onto gallery walls over the past few years have a complexity which belies their prosaic appearance'.[1] At this time (the early to mid 1990s), Morton was making replicas of the sort of unadorned reinforced concrete balconies and exterior walkways commonly found on high-rise public housing units, with simulated windows and doorways behind them.

To walk into an otherwise empty gallery space and discover one of these structures high up on the wall is to experience a moment of genial surprise. Essentially, they are minimalist sculptures that mock the high-seriousness of the genre by drawing attention to superficial similarities between high art and mundane artefacts. Although, in a formal sense, they are as elegant and restrained as anything by American minimalists such as Carl Andre, while evincing none of Andre's interest in the particular qualities of different materials, their deadpan realism introduces a disruptive note of irony. Morton's model balconies are a wry deflation of modernism's high ideals.

What, in the end, however, are these works actually about? Where is the complexity that Engberg writes about? It lies, she suggests, in their role as social commentary. 'Morton's versions [of high-rise balconies] stand in as models of the failed projects of a utopia-driven modernity.'[2]

Engberg's confident assumption that high-rise housing has failed is worth pausing over, since Callum Morton's entire body of work is said to be about the 'failure' of modernist architecture.

I am reminded of how a proposal by the former Victorian premier, Jeff Kennett, to tear down some of Melbourne's ageing Housing Commission flats in the 1990s provoked outrage among their predominantly Vietnamese residents, who actually enjoyed the

convenience and spacious grounds of these tatty structures and the opportunities they presented for social interactions. These people had no intention of moving. That was not, of course, what the more affluent residents of Carlton and Fitzroy wanted to hear, although some of them lived in modernist apartment blocks themselves, albeit of a more salubrious kind and worth a great deal more money.

High-rise housing may have its horrors, but it has also provided millions of poor families, especially in Asia, Latin America and Africa, with cheap, clean accommodation, and such previously unimaginable luxuries as running water, electricity and sanitation. The quaint old Hutongs of Beijing might provoke nostalgia in the passer-by, but if you had to live in one of their draughty dwellings, preparing your dinner on an old oil-drum out the back and trooping to the pit lavatory at the end of the street in temperatures of minus ten, then a high-rise apartment might be a very attractive alternative. The supposed failure of modernist architecture is, at the very least, a matter for argument.

Still, as Engberg unconsciously acknowledges, Morton does not appear to be interested in the way people live, only in style and ideology. '... Morton's models,' she goes on, 'are eerily body-less. Blank doors and mute walls, deflect any sense of human-ness: their size incapable of true inhabitation.'

This might be the sum of Callum Morton's social message: that modernist architecture can be dehumanising. But are his 'eerily body-less' balconies really a protest against the de-humanising abstractions of modernism, or merely a reflection of his own ideological preoccupations? One reason the emptiness of Morton's simulations strikes Engberg as eerie may be that real high-rise balconies are invariably crowded with pot plants, children's toys, freshly washed clothes, and people chatting to their neighbours.

The only other points that Engberg produces to support her claims for complexity are that the scale of the balconies and their placement high on the gallery wall ('to affect the viewer's gaze upwards') in some unexplained way cause 'weird' disruptions to our customary ways of seeing. Most of us look up and down all the time, however, and are quite used to seeing scale representations of real objects. As social commentary, Callum Morton's balcony

simulations evince very little, if any, complexity. They simply restate a commonplace ideological stance, albeit with touches of gentle humour and the occasional hint of nostalgia. They may prompt in us some complex thoughts, but then almost anything, including a real high-rise building with its serried rows of balconies, can do that. What writers often say about such works is that they 'draw our attention'. The artist, having drawn our attention to something, may be expected to have some insight into it worth sharing. Drawing attention is only the first and easiest part of the process, the essential prerequisite.

As sly observations on recent art history, however, Callum Morton's balconies may be more rewarding. Even so, the mocking of minimalism's high ambitions has by now become something of a post-modernist formula. The sleek, clean lines of minimalist painting and sculpture are frequently cannibalised by post-modernist artists because they conform to a 'look' that the market still deems highly fashionable – serving, as it does, a fantasy of efficient, streamlined, electronically controlled contemporary urban life – while any reference to the ideals that originally gave that style meaning are derided, thus cutting it off from its own sources. An art style of the recent past is sent up, its embarrassing excess of seriousness revealed as deeply uncool, while at the same time its superficial appearance – its empty shell, if you like – is cannibalised as a cover.

With *International style* (1999), Morton makes the point again, this time with more wit, although no more complexity. *International style* is an accurate scale model of Mies van der Rohe's famous Farnsworth House. Built in Illinois in 1950, the Farnsworth House is an icon not only because it was technically inventive – its floor and roof are two concrete slabs suspended between steel columns – but also because it represents the culmination and one of the most succinct expressions of modernist ideals of transparency, light, the interplay of interior and exterior spaces and extreme simplicity of form, all of which have made it a sitting duck for post-modernist deflators.

In Morton's meticulously made model, the windows of the house are curtained. This is an in-joke since Mies van der Rohe forbade curtains. Through them we hear the sounds of a party going

on inside. Suddenly, there's a woman's scream, then a gunshot, then all falls silent – until the tape loop begins again.

'It's a cute touch,' writes Charles Green. 'Morton makes a model of modernist patriarchy (the Farnsworth House remains a symbol of modernism at its hegemonic, dominating extreme), then stages a murder.'[3]

Are we to conclude from this that Morton regards architectural modernism as so insignificant a phenomenon that its supposed 'death' should be the occasion of nothing more than a cute joke? If so, there is certainly not much complexity there. Morton is playing to the gallery, confident that his audience shares his disdain for the institutions of modernism and will find the joke reaffirming.

A question that immediately suggests itself, however, as we savour Callum Morton's cute touch, is 'Why now?' Hasn't all this been played out a thousand times before? The Farnsworth House is, after all, nearly sixty years old. Only four years after it was completed, Jose Luis Sert, dean of the Harvard Graduate School of Design, which had pioneered modernism in the US, was damning modernist architecture's 'appalling poverty' and calling for a new vocabulary. By the mid sixties – at around the time Callum Morton was born – influential books by Jane Jacobs and Robert Venturi had already knocked away most of modernist architecture's ideological foundations. So Morton is going over very well-trodden ground, perhaps because that's easier than having to deal with the much more interesting and difficult question of what Sert's new vocabulary might look like.

Modernism's supposed death, like that of God nearly a century earlier, has left a hole that nobody quite knows how to fill. As a result, modernist-style buildings, sometimes with little twiddly bits added to make them appear post modern, continue to be built in a theoretical and aesthetic vacuum. All Morton seems to be doing is trying to suck a bit more air out of that vacuum.

It's not entirely fair of me to single out Callum Morton's work in this way. Any number of artists would have served equally well to illustrate how commentary is used not to clarify and elucidate but to browbeat us into believing that simple artworks are more highly developed and subtle than they actually are. The common threads are: conceptual naïveté presented as sophistication and complexity;

conservatism kitted out as innovation; a lofty concentration on theories and ideologies which masks a lack of real engagement with the work in question; and the encouragement of in-jokes about the art of the recent past in an effort to distance contemporary art from its antecedents and emphasise its uniqueness.

As the art educator Michael O'Toole has noted, writing of this sort, which is based not on what we can all observe but on ideological constructs extraneous to the work, '... often leaves the reader feeling as disempowered as we felt in the face of traditional literary scholarship: there the artistic text was merely a hunting-ground for examples of a biographical or social-historical generalisation, and the people who led the hunt had a stake in making it appear as difficult and recondite an enterprise as possible. The generalizations were too vague to be validated and the tone with which they were uttered or printed too authoritative to be questioned. The same tendencies are becoming evident in several forms of "Post-Structuralism"'.[4] O'Toole's 'becoming evident' strikes me as much too reticent and polite.

The conceits of art writing are nothing if not self-contradictory. As the right hand of art reviewing and commentary is busily trying to rebrand simple works as deep and meaningful ones, the left hand of art theory is steadfastly maintaining that it is pointless even to be talking about meaning, that a work of art can be no more meaningful than a packet of Cornflakes, and a visit to an art gallery no more culturally edifying than a trip to Woolworths. There are many writers, theorists and academics who appear to hold both views simultaneously.

This need not present a problem if you have no brief for consistency or logic, but the outside observer might wonder why, if art has given up any claim to being special – if, as Charles Green maintains, '[a]n identifiable art world clearly separate from that of mass culture no longer exists'[5] – then why do we still have public art galleries and museums, government grant schemes, subsidised art publishing, of which Green's book is itself an example, and art schools?

Why do we need to spend millions of taxpayers' dollars on international biennale exhibitions to remind ourselves that art is no different from shopping or clubbing? As the critic and historian Rex Butler puts it, '[i]f there is no difference between art and the public space around it, why bother with art at all?'[6]

One reason is that art – even, or especially, art that pretends not to be art – still holds out the promise of financial and career opportunities. It's all about status. The kid who spray paints graffiti onto railway viaducts can expect no recognition or financial reward, just a fine if he's caught. But when an artist such as Adam Cullen copies those designs onto canvas and hangs them – dripping with irony – on a gallery wall, they add another notch to his meticulously detailed CV as well as bringing in the cheques. Then, when one of Cullen's paintings pops up in an ABC television advertisement without his permission, Cullen rushes to the arts copyright agency, complaining that his work 'is art ... not a random image ... it's been cretinised [by the ABC] into something that has nothing to do with the art's original conception, production and eventual context'.[7]

There are endless other examples of artists who, while freely appropriating pop-culture imagery on the basis that art and mass marketing are all just part of the same game, retreat very quickly into the old fine-art rhetoric when they, in turn, are appropriated. The artworld is still quite separate from, and still sees itself as very much superior to, the inchoate world of ordinary folk.

In reality, the economics of the artworld are closer to the old Soviet model than to anything resembling capitalist mass marketing. This so-called arts industry depends on the massive oversupply of products for which there is no identified demand, an artificial pricing structure that bears no relationship to actual material value and continuing public subsidies. In economic terms, it resembles no other free-enterprise industry I can think of, except perhaps wood chipping.

That is not an argument against the public funding of art, of which in general I think there should be more, not less. It is, however, to suggest that attempts to promote the arts as an integral part of mass marketing are misguided and misleading, playing right into the hands of anti-intellectual governments who want to be free of arts funding altogether. Art and mass culture have not blended into

a happy alliance of equals. Rather, the mass market has adopted art as its trophy, a bit of boardroom entertainment, to be exploited when some polish or intellectual cred is required, but ignored the rest of the time. Artists are no more than the market's puppets.

I go to my bookshelf and take down the first contemporary art exhibition catalogue I come to: *Every Day: 11th Biennale of Sydney, 1998*. As its title suggests, *Every Day* was a celebration of what its curator, Jonathan Watkins, claimed was 'a growing interest among contemporary artists, world-wide, in quotidian phenomena and the power of relatively simple gestures'.[8] There is an intriguing suggestion of Buddhist transcendence here, but the exhibition itself offered nothing of the sort. In his catalogue introduction, Watkins pours scorn on any suggestion of 'new age transcendentalist gestures', which he claims are 'all-too-familiar in living memory'. Every day, in this context, means the superficial manifestations of consumer capitalism, observed with ironic detachment: the blank world of mere things. A Marxist materialist emphasis – which, one could argue, is also all too familiar in living memory – is common to all exhibitions that purport to examine so-called ordinary lives, ignoring the fact that our day-to-day existences are filled not just with supermarkets and Gameboys, but with love, hate, sadness and joy; with birth, death, grief, violence and all kinds of small personal epiphanies. While we might wake up at 3am worrying about whether we left the oven on, we are just as likely to wake up and worry about the nature of God.

I open the catalogue of *Every Day* at random to a work by Ceal Floyer, who, we are told, lives in London and Berlin. It is nothing more than a polythene garbage bag filled with air, sitting on the floor with its top secured by a plastic tie. The catalogue entry is an unconsciously hilarious parody of standard museum classification systems:

Garbage bag, 1996
Edition of 5
Garbage bag, air and twist tie
60 x 50 x 50 cm (approximately)
Courtesy of the artist and Lisson Gallery, London ...

'Edition of 5' is especially good: a caution to any of us who thought we might circumvent the vanities of the artmarket by

inflating our own garbage bag. That Floyer's bag appears to be full but contains only air is, we are assured, a 'paradox' that heightens our engagement and turns the ordinary into the extraordinary.

Another of the exhibition's artists, Clay Ketter, an American living in Sweden, is represented by a sleek, life-sized kitchen unit, real in every respect except that it is resolutely non-functional. The materials that Ketter has used are listed in forensic detail, like the obsessive inventories of brand-names in a Brett Easton Ellis novel: 'wallboard compound, net wall covering, plastic laminate, stainless steel, PVC pipe, plastic baseboard, moulded plastics, steel corner bead, gypsum wallboard, wood framing, particle board base, IKEA cabinets, melamine and glass'. (Here is another instance of museum professionals unwittingly making a mockery of their own professional conventions.) The severely formalist anonymity of Ketter's structure is disrupted only by a splash of white undercoat on one of its top panels and a small patch of exposed tiling grout, as if hinting that this doggedly cerebral artist might have succumbed to a momentary flash of nostalgia for personal expression.

I have to say I rather liked Ketter's kitchen cupboards: not for the reasons the catalogue essay tells me I should have, but for purely aesthetic ones. They look nice. This is something the writer of the catalogue note cannot say, of course, because aesthetics is now something of a taboo subject. Instead, he plays up the ironies, lauding the fact that the artist 'builds on a legacy of art precedents'[9] (but then what artist can't make that claim?), while at the same time trying hard to give Ketter's work an aura of sophisticated radicalism.

It could be argued that, rather than building on his art precedents (minimalist abstraction and modernist design), Ketter trivialises them by subjecting their seriousness and idealism to crude parody. Nor is his work in any way radical or innovative. It does not, as claimed, explore 'the relationship between paint, surface, frame, fixtures and the wall', or the 'interface between art, architecture and interior design'. This is all meaningless waffle, the sort of thing people write when they've been asked for a thousand words by the end of the month and really don't give a damn. What Ketter is really doing is playing around harmlessly with the superficial similarities between minimalist sculpture and modern product

design. He makes no attempt to 'explore' those similarities, or to provide any clues to why they exist or are worth our attention.

Both Ketter's wall unit and Ceal Floyer's garbage bag are Duchamp's urinal warmed up with minimalist aesthetics and pop culture chic. Another catalogue, I notice, has fallen to the floor in front of the bookcase, a much more modest one: no more than a folder. *Gulliver's Travels* was an exhibition that toured Australian contemporary art spaces in 2002 under the auspices of Contemporary Art Services Tasmania and the Australian Centre for Contemporary Art in Melbourne. It, too, was about everyday objects. Included were some replicas of road cones (of the sort used to warn motorists of obstructions or to temporarily enforce no-parking areas) made by Matt Calvert from car windscreen glass. There was also a life-size dumpster-bin made from scrap cardboard by Richard Giblett. The catalogue essay, either deliberately distort-ing or else misunderstanding what Wordsworth and Coleridge meant, claims that these reproductions of commonplace things 'make the familiar strange'.

But that is one thing they cannot do. They can only translate one kind of banality into another by means of elementary reversals in the use of materials. They are visual puns and nothing more. Coleridge was talking about a process of transformation that depended on the belief that some states of being could be 'higher' or more profound than others. Such a belief, we have been assured, is untenable these days. In Jonathan Watkins's words, 'new-age tran-scendentalist gestures ... gratuitous mediation or obscurantism' are nowadays 'deemed pointless'. Without some sort of belief in tran-scendence, however, 'making the familiar strange' in any meaningful way is a fraught enterprise. At the very least, you need poetry.

To take a garbage bag out of the kitchen cupboard and set it up in an art gallery, or to make reproductions of road cones, kitchen cupboards or rubbish bins does not give such things complexity, or make them extraordinary in any way. It simply reminds us, if we need reminding, that these things exist, that an artist has noticed them and wants us to notice them as well.

As Jonathan Watkins might respond, however, that's all art can, or needs, to do. All the old grand narratives have gone out the win-dow. 'Transcendentalist gestures', metaphysical enquiry, and hierar-

chies of value are now 'deemed pointless'. (His use of the passive voice gives this deeming a distinctly grand-narrative quality of its own. What he's not willing to say is, 'They seem pointless to me'.)

To complain about lack of meaning, therefore, is to miss the point. And the point is that there is no point. If you do wake up at 3am and worry about the nature of God, then you're on your own. Art, or at least art of this kind, does not share your concerns. Its job, in fact, is to belittle them. Better concentrate instead on whether you turned off the oven.

In the past, writes the Queensland academic Rex Butler, 'the spectator actually had to *choose* between thinking that the work had a meaning behind the obvious one and that it had no meaning at all. By the time of the Warholian 1960s and camp, however, the spectator no longer had to choose, but simply had to recognise that this undecidability was what the work was *about* ... The spectator, that is, is no longer subject to the necessity of determining the meaning of the work, but merely has to acknowledge this as a problem'.[10]

Acknowledge what as a problem? If we accept that we needn't even be thinking about looking for meaning, then where's the problem? No meaning, no point, no problem.

The outcome might be a fashionable post-Warholian camp, but that carries its own dangers, as another commentator has so eloquently put it: 'Men of talent,' he observed wryly, 'troubled by the anomaly of things, tried to distinguish the true from the false and thereby obtain peace of mind. But their inquiries ended in puzzlement. Whenever they could find a plausible argument on one side of a question, they could find an equally plausible argument on the other. The arguments being equipollent on every issue, it was never reasonable to plump for this side or for that. The men of talent suspended their judgment. They affirmed nothing. They denied nothing. They believed nothing. And, wonderful to relate, a great tranquillity came over them.'[11]

If tranquillity is what you're after, then convincing yourself that nothing has meaning is, I suppose, one way of achieving it. No more worries either about God or the house burning down. As the author of this passage (the Roman philosopher Sextus Empiricus, writing in the second century AD) discovered, however, it can be something of a dead-end.

In any case, the spectator in the past was not called upon to decide whether or not a work of art had a particular meaning. Rex Butler's whole premise is wrong. The spectator was part of the creative process that brought meaning to the work, which was a springboard for thought, prompting speculation and opening out creative spaces in his or her mind. It suggested, cajoled, teased, pleasured and terrified. Butler mocks the futility of trying to discover a 'final meaning' in a work of art, but, as far as I'm aware, that was never the issue.

The historian John North, for example, has recently published a 350-page analysis of Hans Holbein's painting of 1533, *The ambassador's secret*, an analysis full of conflicting interpretations and varying suggestions.[12] 'It is a significant scholarly achievement,' says Theodore Rabb, 'to explain, as have Panofsky and others, the moral, political, or philosophical aims that may lie behind a painting's surface subject matter. What is important is to recognise the limits of that explanation, especially when its complexities multiply, and not to assume, without further evidence, that the meanings were always clear to an artist's audience.'[13]

The argument that contemporary postmodern art has broken down hegemony and authoritarianism by means of irony, ambiguity and indeterminacy betrays great ignorance about the art of the past. Are Daumier's or Hogarth's social satires lacking irony, or Picabia's mechanistic portraits, or the court paintings of Velasquez or Goya? Are William Blake's mystical musings over-determined, or Leonardo's deluge drawings, or Pollock's drip paintings?

Contemporary theorists, having decided that works of art cannot offer up any single authoritative meaning, conclude, like the ancient Stoics that Sextus Empiricus was referring to, that it is therefore pointless to talk about meaning at all. Theorists of the recent past, however (Panofsky, Warburg, Pater, and so on), fully aware that the single authoritative meaning was a fallacy, concluded, much more generously, that this allowed for an entire range of meanings, all as potentially rewarding as each other. Meaning is not something contained within the work, like sultanas in a fruitcake. It is the many faceted and always fluid outcome of a fruitful dialogue between the work and its viewer. There are, by this reckoning, as many meanings as there are viewers.

Perched on a shelf of the Japanese cabinet in my living room is a small, dark-green bowl made by one of Japan's most influential avant-garde potters, Hamanaka Gesson. I love it, and I paid a lot of money for it, but I have to admit that, if you're not really into Japanese avant-garde ceramics, you might mistake it for some trifle I'd picked up at the local trash and treasure. So I keep at the ready a large coffee-table book about Gesson, which, when the need arises, I draw out of its doe-skin slipcase to reveal pots just like mine spectacularly illustrated in glowing colour. People are always impressed. If this guy can justify such an expensive-looking publication, he must be good.

What I'm doing is using secondary discourse for the purpose of endorsement and, in doing so, I unwittingly acknowledge its power.

Artists' monographs here in Australia are not usually so elaborate. Besides, doe-skin slipcases are hardly our style. Nor are monographs as prevalent here as they are in Japan, the United States and Western Europe, where the market for them is much larger. There the monograph has become an almost essential rite of passage in any young artist's career.

A Brisbane art dealer I heard at an art publishing conference some years back produced a pile of publications he'd just received from Germany.

'Here's a young artist,' he said, taking a book from the top of the pile, 'who's only twenty-five. She's had four or five solo shows. Yet she's already had this monograph published about her. It's a magnificent production, very professional. Why can't we do this sort of thing here?'

Why, I wondered, did he think we should? What seemed to him an indication of the German artworld's sophistication struck me as marketing gone completely mad, and I'm afraid I was tactless enough to say so. Nevertheless, commerce has its own manic momentum and Australia is doing 'this sort of thing' with increasing regularity. More and more monographs are being published here about ever younger and less significant subjects.

There is no better example of the power of commentary and its

manipulation by the artmarket than that of the artist's monograph. At one time, monographs were published about artists only when they were nearing the end of a long and distinguished career, or else safely dead. It was a mark of the highest esteem. Today, it's a sign that someone thinks you're a commercial possibility.

These publications have several key elements in common. They are large, expensively produced, and bursting with colour plates: luxury items that aim to impress. They are often written by intimates of the artists concerned: a close friend or colleague, or even a spouse or partner. This suggestion of cosiness will be confirmed by a glance at the acknowledgments page, which will make a point of thanking the artist for allowing a book to be published about him or her, and even for such services as 'supervision of the manuscript before publication'. The artist's dealer will be thanked, too, as will the private collectors who 'generously agreed to their works being photographed'. Supplementing this orgy of self-congratulation, and giving scholarly weight to the glossy pictures which are the book's main purpose, will be a laudatory essay and the standard critical apparatus of minutely detailed CV and bibliography.

Perhaps the most revealing fact about these books, however, is that very few of them are published by standard commercial publishing houses for the simple reason that the market for them is minuscule. They are simply not profitable. A large percentage will not be offered for sale but will be given away for promotional purposes. Unless the artist is very well known – a Rosalie Gascoigne, for example, or a John Olsen – very few will be offered for sale on the open market. Since they must therefore be sold at a big loss, they have to be subsidised by grants, the artist, or the artist's dealer.

What all this tells us is that the monograph is not an ordinary book. It has very little to do with the disinterested dissemination of knowledge and ideas. Instead, it serves specific interests. Purely as an indicator of status, it offers a real career boost to the artist concerned, as well as to the author, who can add a 'major publication' to his or her CV, although, of course, the more of these books that are published the less exalted that status will become.

The monograph will be even more valuable to the artist's dealer, who will use it to encourage potential clients to pull out their credit cards. And it happily ties in with the interests of those

who own the artist's work, by validating their taste, increasing the monetary value of their possessions, and, as in the case of my Gesson bowl, by confirming that those works are art, at a time when nobody can ever be entirely certain, just by looking, what is and what is not. It's extraordinary the way a pile of old bricks on the floor can be transformed into valuable art commodity by the magic of publishing.

There can be no doubt that monographs provide a useful record and, on occasion, an informative and pleasurable read. Nevertheless, you'll search for a long time before finding one about any living artist that is genuinely critical or exploratory. That is simply not their purpose. Such books are about erasing doubts and fears, not about raising questions.

Art magazines present a more complex case because, for one thing, they are not all of a type, as monographs tend to be. Scores of visual art periodicals are published in Australia. They include newsletters published by galleries and other arts organisations, which may be anything from a photocopied sheet to a glossy illustrated magazine; special interest journals such as *Imprint* or the quirky *Art Visionary*, which focus on particular areas of practice; academic and scholarly journals, of which the *Australian Journal of Art* is a prominent example; email bulletins and zines, which can originate almost anywhere and which, being so easy and inexpensive to produce, can be among the most freewheeling and independent publications; and about half-a-dozen quarterlies – and one monthly – that we might call, for want of a better word, mainstream: that is, published on a regular basis, sold both by subscription and retail distribution, dependent at least partly on advertising revenue and aiming to cover a broad spectrum of contemporary art activity.

Given Australia's relatively small population, this is a huge number of art publications. It will come as no surprise, therefore, to learn that few of them, whatever category they belong to, are viable commercial propositions. Those that apparently are, such as *Ceramics: Art and Perception*, tend to be aimed at niche markets both here and

overseas. The rest are subsidised by their publishers, by an institutional or private benefactor, or by government funding bodies.

That does not, however, guarantee their independence of market influence. The distinction between editorial content and advertising is rarely clear-cut. It is at its muddiest, however, in the case of the glossy quarterlies.

The cover of the Autumn 2003 issue of *Art and Australia*, for example, featured a striking close-up of one of Dani Marti's woven constructions. His densely textured strands of clashing orange, pink and white synthetic fabrics certainly made the magazine stand out on the newsagent's shelves and induced me to purchase a copy. Inside, Victoria Hynes had contributed an eight-page feature on Marti which was an unashamedly puff-piece. 'Until recently unrepresented by a commercial gallery and still largely undiscovered by the wider public,' she wrote, 'the artist has nevertheless built up a strong following among architects, designers, institutional bodies and critics.' The experts appreciate him, but the general public hasn't caught on yet: it's the perfect sales pitch. 'Over the past three years', Hynes continues, 'this prolific artist has held solo exhibitions in Sydney at Gitte Weise Gallery's Room 35, Rubyayre, First Draft, Casula Powerhouse Arts Centre, Artspace and Gallery 4A, in Melbourne at Span Galleries, and at Galeria Alejandro Sales in Barcelona. He was also included as a finalist in the 2002 Helen Lempriere National Sculpture Award.'

Prominently situated at the front of the magazine was a full-page advertisement for a Dani Marti exhibition at Gitte Weisse Gallery's Room 35, and another full-page advertisement reminding us that Dani Marti is represented by ARC-one at Span Galleries in Melbourne.

Now this confluence of cover, feature article and paid advertisements might, of course, be just a happy coincidence, but it's the sort of coincidence that occurs with alarming frequency in art journals, where editorial content often reads like extended promotion and serves to complement the advertising pages only too well.

I don't mean to suggest any conspiracy. The editors of *Art and Australia, Art and Text, Artlink, Object, Craft Arts*, and so on, no doubt see it as their job to be supportive of artists and the commercial apparatus that sustains them. It's just that their conception

of what constitutes support is limited very narrowly to career advancement. To be fair, they are caught in a bind. Since their advertising revenue comes almost exclusively from commercial galleries and art dealers, they cannot afford to bite the hand that feeds them.

As the editor of a government-subsidised art magazine, *Art Monthly*, in the 1990s, I tried to maintain a strict separation between advertising and editorial by, among other things, discouraging profiles of individual artists and reviews of solo exhibitions. This didn't make life easy. Regular advertisers were sometimes genuinely puzzled that their loyalty was not being repaid. One dealer cancelled his advertising contract in protest at an article showing one of his artists in a negative light (he was so astonished that an art magazine could do such a thing that he made a complaint to the Commercial Galleries Association); several refused to advertise unless we promised to publish laudatory articles about the artists they represented. Sometimes artists would take matters into their own hands, commissioning flattering profile pieces about themselves which they would then send to the magazine in the confident, but, in our case, misguided, expectation of publication.

In the commercial world, none of this would be considered unusual. The *quid pro quo* is standard marketing behaviour. It probably matters less if the publication has a broad advertising base. You can do all kinds of deals if you have enough room to manoeuvre. The small art magazines' reliance on commercial art galleries means that those galleries can exert great influence on the magazines' content.

There is also a perception, not always unjustified, that commercial galleries are doing the magazines a favour by taking out advertising contracts, so it is seen as something of a betrayal of trust if the magazine is not supportive of them in turn. In this sense, art magazine advertising is not really a purely business proposition, but an integral part of a mutual support system that keeps the artworld smoothly ticking over.

There is, admittedly, something very attractive about the contemporary artworld's dependence on camaraderie and a sense of shared purpose. The downside, however, is a stultifying parochialism that discourages critical debate, thereby weakening the

intellectual credibility of the entire field. From outside the charmed circle, it can all look depressingly hermetic.

In Britain, the critical culture would seem to be much more robust than Australia's, partly because of less restrictive libel laws, but also because British journalism has always fiercely defended its tradition of feisty independence. The artworld in Britain thrives on vigorous intellectual stoushes that in our more timid and protective atmosphere would be unthinkable. Perhaps, too, given that French theory has always been more steadfastly resisted in Britain than it has here or in the USA, the British may be less likely to dismiss any fiercely negative commentary as an exercise in power and to see it in a less threatening light.

Oddly enough, newspaper reviewing is the least circumscribed form of art commentary in this country today, if only because art galleries rarely advertise in the daily press. As a newspaper reviewer, I have always felt quite free from external constraints – except, of course, the libel laws and the conventions of good taste. There are many more limitations on what I can say in a catalogue essay, a monograph, or an article for an art magazine.

From time to time, everyone succumbs to a fit of exasperation, newspaper art reviewers being no exception. An excessively silly exhibition at one of Melbourne's university galleries occasioned one of my lapses during my time as an art reviewer for the *Age*. Almost immediately after my somewhat intemperate review was published, I began to have second thoughts. The angry response I had anticipated, however, never materialised. Gallery staff remained friendly – at least to my face – and tactfully never mentioned it.

A year or so later, however, some much less negative and more carefully considered observations I made in an art magazine about another of that gallery's exhibitions drew an immediate complaint from the director. This was puzzling. I'd assumed that the magazine's relatively minuscule readership would have made it much less important to her. Perhaps she felt intimidated by the power of Fairfax, but without fear when it came to leaning on a small

publisher. Or she may have concluded that the magazine article would be read by people who mattered to her – by her own constituency – whereas the newspaper review was aimed at the general public, which hardly showed up on her radar. That academic art writers generally regard newspaper reviews as beneath their notice is borne out by the fact that they rarely refer to or quote from them – although admittedly this might say as much about the quality of newspaper reviewing as it does about the priorities of academics.

No doubt the university gallery director would also have had in the back of her mind the fact that newspapers are ephemeral. She could be confident that my review, however distasteful she might have found it, would quickly be forgotten. Quarterlies, on the other hand, are assumed to be more a part of the historical record.

More important, however, she would have accepted intuitively that newspapers are and have always been a forum for debate about politics, economics and social issues. Partisan arguments are the very essence of the daily press. It seems only logical that exhibition reviews should be part of that ethos. The press, in other words, being outside the charmed circle, represents a more vigorous critical culture than the relatively timid and self-protective world of the art magazine.

The relative freedom of expression that newspapers offer comes at a price, however. Since art galleries are not significant advertisers, there is no compelling economic reason for newspaper editors to take visual art reviews very seriously. Book and film reviews are much more prominent, both because publishers and cinemas are more frequent advertisers and because journalists are by nature more sympathetic to popular narrative forms – and know what their readers want. Even so, as formerly quality broadsheets head further down market in a desperate bid to compete in a shrinking market, less and less space is being devoted to critical commentary of any kind. Arts coverage is becoming increasingly promotional in nature, lumped in with entertainment, fashion and 'lifestyle'. Of all the leading newspapers in this country, the *Australian* is the only one that consistently devotes significant space to critical commentary on the visual arts, and, as far as I am aware, is the only one that still has arts pages, as distinct from arts and entertainment, or arts and 'lifestyle'.

A survey of arts coverage in the American media, conducted by Columbia University in 2002, concluded that, while the visual arts were faring very well in newspapers in terms of column inches, almost half of that coverage consisted of mechanically generated listings and most of the rest was really about entertainment. In other words, quantity was up but quality down. There is little reason to think the situation in Australia is very different. '... [A]rts and entertainment sections of major newspapers are indeed riding high ...' the report says. 'Arts and feature editors tell of support from their superiors for a robust commitment to arts coverage – in the context of feature, entertainment, recreational and "leisure" packages. The success of these sections with readers and advertisers has much to do with their populist, mass-entertainment tilt.'[14]

In short, although, among the print media, newspapers offer the best opportunities for hard-hitting independent visual arts commentary, those opportunities tend to be wasted by editors with very little interest in or understanding of the subject whose choices are, in any case, constrained by narrow commercial considerations.

Speaking of the ABC's *Coast to Coast*, which screened on Sunday mornings until being axed in mid 2002, the ABC's then director of television, Sandra Levy, correctly observed that the attempt to cover a wide range of arts practice in a single program guaranteed superficiality 'and made an assumption that people who were interested in a magazine item about pottery were just as interested in fringe theatre in a regional centre'.[15]

Locally produced arts programs (and I'm referring, of course, to the ABC and SBS, since arts coverage on the commercial stations is practically non-existent) are almost always in a jaunty magazine-style format, flitting lightly across a wide range of subjects. Invariably they are relegated to dead timeslots.

Margaret Seares, who heads the ABC's independent arts advisory group, has said that, although she would be 'horrified if [ABC arts programming] was driven by pure ratings ... it still needs to communicate with a broad range of audiences'.[16] Why? Coverage of

golf and netball doesn't try to communicate to a broad range of audiences, targeting only the minority with an interest in those sports. The crucial difference is that golf and netball require almost no intellectual engagement. However small the audience is for their broadcast, the ABC is therefore safe from any accusation of elitism. Under intense and unrelenting pressure from the federal government, the ABC has become terrified of appearing too serious and intellectual. Superficiality may not please the people who want to watch arts programs, but it's just what our so-called political leaders demand.

The trouble with television, of course, is that it's very expensive. *Coast to Coast* absorbed most of the ABC's arts division's meagre budget. The need to fill even one hour every week made the producers largely dependent on the publicity departments of arts organisations. And this is what most television arts programs end up looking like: PR department pickings, dressed up with slick graphics.

Nevertheless, it can hardly be just a matter of money. With a bit of imagination, it should be possible to put together a short, punchy program about the visual arts which engages minds without eating up the budget, even if it's nothing more than a couple of lively, intelligent people standing in a gallery arguing about an exhibition for fifteen minutes. All that's needed is a willingness on the part of management to engage minds. The argument – often heard – that this sort of thing wouldn't attract an audience is based on assumption rather than experience, since nobody, to my knowledge, has ever seriously tried. That programs such as *Coast to Coast* haven't worked should be an argument for a completely different approach rather than for giving up altogether. A half-hearted attempt to come up with a new format can be seen in *Critical Mass*, a panel discussion about the arts which, sadly, suffers from the same old 'arts package' approach. When you're asking three people to discuss a new novel, a Hollywood blockbuster, a BBC costume drama and an art exhibition all within the space of half an hour, depth can hardly be expected. To quote the ABC's own cringe-inducing publicity, *Critical Mass* is supposed to be about 'what's hot, hip and happening on the arts scene'. Ironically, in its desperate efforts not to appear boring, it ends up engaging the attention of almost nobody.

There's a fatal circularity in this approach. Producers, assuming an inattentive, unsophisticated audience, produce bright, breezy, unsophisticated programs which serve only to further lower audience expectations. By contrast, when the BBC commissioned Kenneth Clark's *Civilisation* series in the mid sixties, and John Berger's *Ways of Seeing* in the early seventies, it was assuming that a number of intelligent viewers existed and made no attempt to talk down to them. These quite demanding programs rated well, however, and, more importantly, were seminal contributions to cultural life that are still discussed today.

These days, even the BBC opts for the fatuousness of Matthew Collings, whose series, *This is Modern Art*, shown here on the ABC a few years back, managed to fill six hours without ever delving much below the surface. In the hour-long program devoted to beauty, for example, Collings gave no indication that he was aware of the vast literature that exists on this subject, from Plato to Wendy Steiner, making no attempt even to consider what beauty might be. I am perfectly prepared to believe that audiences in the sixties and seventies were a good deal more sophisticated than audiences are today, but we have to assume that the sheer timidity of television executives has been at least partly to blame – along with the radical dumbing down of the education system – for the decline in people's ability and willingness to tackle big ideas.

Unlike television, radio is not expensive. ABC Radio National, virtually the only non-print-media forum for ideas in this country – and indispensable for that reason – has made some valiant efforts to encourage discussion about visual art over the years, with varying degrees of success. One obvious problem is that radio is not a visual medium. You can do a brilliant series analysing modern and contemporary music, as Andrew Ford did for ABC Classic FM a couple of years back, but an equally scholarly dissection of the visual arts would lack the essential illustrations.

Quite likely it would also lack an Andrew Ford. His combination of rigorous scholarship and a knack for communicating it is rather rare. How many Fords, or Clarks, or Bergers or Robert Hugheses does any generation produce? The contemporary visual arts are not likely to gain any such champions so long as intelligent elucidation continues to be treated with indifference both by the

media and the academic art establishment. No Berger or Hughes is likely to emerge from the primaeval ooze of our art school theory departments.

As the Radio National producer Kate Bochner points out, it is not only the apparent opacity of the visual arts but also the shortage of articulate representatives that make radio and television programs about art such a challenge to make. [17]

Margaret Seares claims that '[t]here is a constant dilemma between catering to a younger generation interested in quick sound-bite delivery and an older generation who want in-depth analysis'.[18] Perhaps she's been taking too much advice from the advertising industry. For a start, this is not a generational thing: older people want sound bites just as often as young people hunger for analysis, but only the sound-bite enthusiasts show up on the marketing industry's radar. If you profess to only watching SBS and the ABC, for example, you won't even be allowed to participate in ratings surveys. In any case, Seares's dilemma is a furphy. Statements of this kind are fundamentally anti-intellectual in assuming that people cannot find ideas exciting in their own right and that they need to be dressed up with party tricks to make them palatable to the masses.

If only a minority of people want in-depth analysis, then surely it is a public broadcaster's job to provide it – that's what public broadcasters are for – especially given that in this case we're talking about a socially influential minority. Those who want sound-bite delivery can go elsewhere. Instead of kow-towing to the demands of philistine politicians, public institutions might be doing more to educate our parliamentary representatives about the intellectual needs of the population.

On the other hand, however, the whole point of television and radio coverage of golf and footy is to communicate the excitement of the event (some people do, apparently, find golf exciting), not to discuss and analyse it. You only have to listen to commentators arguing earnestly over Macka's knee injury or the birdie on the fourth to realise how dire sports commentary can be. Radio and television, being narrative forms, are good at describing what's happening, and nothing much happens at an art exhibition. The media may have a role to play in fleshing out ideas and opinions, and they could, I

think, be doing it better than they are, but you can't actually experience works of art via radio or television as, arguably, you can a football or tennis match. You can only experience commentary. And commentary does have its limitations as well as its dangers.

A snowy white albino fox has been strung unceremoniously from the ceiling by a steel meat hook attached to a length of wire. It is skewered through the animal's back leg at the joint, leaving a vicious little hole in the flesh. The fox, preserved after death in a trotting position, has its legs outstretched, its bushy tail raised. Its pinkish snout prods the air expectantly. Seen the right way up, it would look animated and alert. Suspended head down like this from its back leg, it is horribly stiff and lifeless. Not so its sharply defined black shadow, which gallops briskly across the floor, slightly distorted by the angle of the spotlight above, which compresses it into a cartoon-like silhouette. Piled unceremoniously beside this dancing shade, within the circle of bright light on the floor, are a couple of rolls of fencing wire and some more carcass hooks.

Antony Hamilton's *Hung white fox and shadow* (1999) is a simple, spectral tableau, or 'situation' as the artist prefers to call his found-object constructions, which is, in essence, a play of metaphysical contrasts. The frail beauty of the fox is contaminated by the brutality of its defilement. Despite the poor animal's distressing condition, however, the bounding shadow suggests some kind of triumph over death, or at least the perseverance of life in the face of barbarism. Earthly existence may be hard and cruel but, Hamilton seems to suggest, it can be redeemed by poetry. *Hung white fox and shadow* is a kind of visual poem, concise, elegant and compact: a small rise in the terrain, which anyone may ascend with ease, but from which the view is extensive.

It is the metaphorical crossing of five carefully chosen elements, none of which would be particularly meaningful on its own (feral animal, fencing wire, meat hooks, spotlight and surrounding darkness), which brings out the contrasts that animate our imaginations: between brutalism and refinement; life and death; freedom and

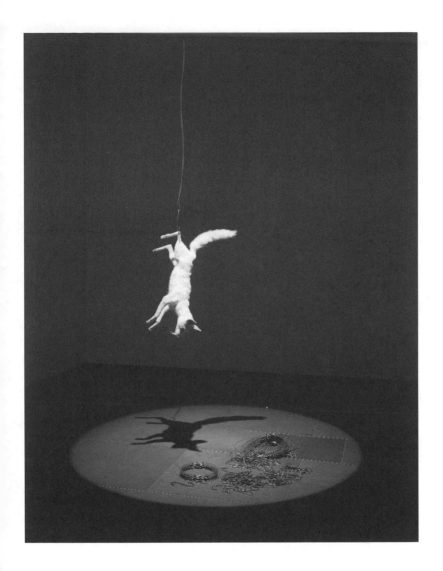

Antony Hamilton born 1955
Hung white fox and shadow, 1999
Fox, fencing wire, carcass hooks
287 x 237 cm
Photograph, Art Gallery of South Australia, Adelaide
Reproduced courtesy of the artist

confinement; the mundane and the mystical; darkness and light; nature and artifice. Nevertheless, although Hamilton's concerns may be universal, he expresses them through creative, lived attention to local context (the arid inland of South Australia). This is a Romantic art, linking personal to cultural memory.

The whiteness of the fox is important, for it alerts us to specifics, to the danger of abstractions. Foxes are supposed to be vermin. It is necessary to kill them. Yet this one is special, a rare individual: a reminder, perhaps, that killing, whatever its justification, always involves moral compromise. A lesser artist might have used a kangaroo or possum, turning the whole assemblage into an easy environmental polemic. Hamilton's deployment of a feral animal – a rare and beautiful one at that – effectively stymies any pat responses.

Everything I have written about this work, however, and a lot more besides, could readily be discerned by any attentive and reflective viewer. *Hung white fox and shadow*, although full of mystery, harbours no secrets. It suggests much but avoids recommending to us any particular point of view. In short, it has little need of interpretation.

And that, in a sense, is its problem. Unlike Clay Ketter's kitchen unit or Callum Morton's critiques of modernism, which positively beg for explication, *Hung white fox ...* is an immediate visceral experience. At a time when words prevail, that is almost enough to guarantee its marginalisation. To paraphrase the critic Patricia Rubin, it is the task of artists to produce works of art and the task of theorists to make those works problematic. It follows, then, that artists who want to be noticed by theorists, who, after all, are the ones who put together the exhibitions, write the essays for art journals and sit on the grant-giving committees, must make work that lends itself to problematising.

Recently, I was one of seven writers asked to contribute a short essay to the catalogue of an exhibition of minimalist abstract paintings by Allan Mitelman.[19] Almost all of us began by saying that Mitelman's spare, subtly coloured surfaces defied written explanation. Then, dutifully, we all went on to provide some, because, aside from wanting to honour an artist we admired, that's what we had been paid to do.

To compensate for this embarrassment, we all attempted, in our own ways, to match the subtlety and refinement of the paintings with poetry of diction, to not just say something about beauty and ineffability, but to try to demonstrate it. It was hard work and I for one was painfully aware of being not entirely equal to the task, mainly because words were no substitute for the experience of looking. Each of the essays in the catalogue is well written, informative in its own way, and interesting. But none could be called necessary.

We don't really know what to do with art that just *is*. We have no way of dealing with beauty, with art that, in the words of Walter Pater, '... comes to you proposing frankly to give nothing but the highest quality to your moments as they pass, and simply for those moments' sake'.[20] Discourse rules. And that tends to rule out the ineffable. Art like Mitelman's and Hamilton's, which invites an aesthetic and emotional response, doesn't stand much chance in the urbane academic milieu of thesis and exegesis, a world in which aesthetics is regarded with distrust and emotion is confused with sentimentality.

In Sam Mendes's film, *American Beauty* (1999), one of the characters, a troubled teenager named Ricky Fitts, videos a plastic supermarket bag being blown around in a parking lot, meditating on the beauty of its dance. It is, he says, a sign of 'the entire life behind things'. The movies are good at showing us how everyday events can be beautiful. Ricky Fitts's video is just the sort of thing we might see in an art exhibition, but there it would be stripped of any poetic context. The film, however, by making it part of a fictional construct, gives it metaphorical weight rather than just leaving it to us to decide what we want to do with it. Mendes does not try to explain why it is beautiful, only to show us why the experience of it matters. Some things are just beautiful, in a completely off-hand, accidental way, and they pop up in the most mundane of situations, taking us completely by surprise. If we slow down and are attentive, if we observe the life around us without seeking meanings, then epiphanies are possible.

The point is not to know, but to notice. But not only to notice. For the deeper point, as Antony Hamilton shows – and as advocates of everyday art fail to understand – is to make poetic connections.

The story goes that Stravinsky, as a young man, was troubled by his dislike of Beethoven. While everyone else seemed to regard the choral symphony and the last quartets as heights of musical accomplishment, Stravinsky found them pompous and dreary. There was only one thing for him to do. For nearly a year, he devoted himself to Beethoven, going to every performance he could, playing the works endlessly on the piano himself, and carefully analysing their scores. At the end of it, although he still couldn't claim to like Beethoven, he at least held him in high regard, confident that his own lack of rapport was not a result of ignorance.

Needless to say, such careful attention to the work is exceptional. For one thing, few of us possess Stravinsky's specialised interpretative skills, his admirable capacity to question his own judgments or his dogged determination. Of course, not many bodies of work are as conceptually complex as Beethoven's. Most would simply fail to reward such careful analysis. Importantly, Stravinsky's response was that of someone who made a distinction between personal taste and the inherent qualities of a work of art, acknowledging that the two did not have to coincide, that it was perfectly possible to dislike art that one nevertheless acknowledged to be good. It's a distinction that is much more difficult to draw today, when objective notions of quality are regarded with suspicion.

What Stravinsky was doing was exercising his powers of connoisseurship. 'Connoisseurship' is a dirty word today because it is inimical to the idea that art should be readily accessible to the general public, that it should offer opportunities for everyone to participate in something that demands little understanding, without effort or the taking of time. 'Connoisseurship' suggests work, application, dedication and passion: all those qualities the market is so eager to devalue. It also suggests dilettantism, which is contrary to the idea that the interpretation of works of art for the general public should be left to the professionals. The disinterested pursuit of understanding and insight for their own sakes – purely for one's own fulfilment – is regarded with suspicion, if not downright hostility. We don't really like the amateur whose knowledge is

entirely empirical, because he or she is outside the system and not readily subject to control or influence.

The relationship of artist to viewer is now, more than ever, one of supplier and consumer whereas it was once much more one of mutual creativity. Connoisseurship is, after all, a kind of creative engagement with the work, which parallels that of the artist: the sort of creative engagement that cannot be encouraged in the arts consumer because it discourages unquestioning consumption.

The next time you visit a gallery, sit yourself down in an inconspicuous place and, instead of the art, watch the visitors. Most people will spend no more than five seconds in front of each work. They will probably devote more time to reading the labels. Very often, they will simply saunter past without pausing, their heads cocked to one side. Thirty seconds for each work is an unusually long time, and more than a minute starts to look pretentious. All you can do in thirty seconds is to take in the visual hit: what the work looks like and whether or not it pleases or excites you. You can't begin to make even the most superficial assessment of it. If a work happens to prick your interest, that will rarely induce you to contemplate it longer, but instead will send you off to learn more about it from some other source. Maybe you'll buy the exhibition catalogue and read the essay, or wait for the exhibition to be reviewed in the newspaper. Perhaps you'll ask someone with more knowledge than you have to explain it to you. In other words, you will seek information from some source other than the work itself. We don't usually regard the viewing of a work of art as an act of discovery but rather as a prompt or cue for investigation elsewhere.

By their very nature, most galleries do nothing to encourage intimate encounters with the art they show. They are interested in getting as many people as possible through the front door, not in fostering contemplation of the art. Even the most visitor-friendly tend to be cold and unwelcoming, designed to impress rather than reassure. If seating is provided, it will be of the sort that says: 'You may perch here for a moment or two, but don't make yourself comfortable'. Many contemporary art museums, such as the Australian Centre for Contemporary Art in Melbourne, seem designed as statements of naked power and intimidation. Not even the most seductive art can induce us to linger in such hostile environments.

Projects that try to make art more accessible by dragging it out of the gallery and onto billboards or into the streets serve only to compound the problem, since public spaces are even less conducive to close study or contemplation. As a result, unless you buy a work and install it in your home, you will be given few opportunities to consider its complexities – if indeed it has any.

Even critics, curators and scholars, given the task of assessing an artist's oeuvre, will rarely take the Stravinsky option of going to the source and studying it in depth. What they write or say about the works will be less a response to the works than a response to what others have written or said about them. In many cases, this is simply a matter of practicality. A deadline is looming, and the payment being offered is miserable, so one naturally takes the easy option. Commentary, like everything else, is a commodity, subject to the usual constraints.

The unfortunate outcome, however, is that art commentary has turned into an inadvertent game of Chinese whispers. The more a particular artist's work is commented upon, the greater the discrepancy is likely to be between that work and what is being said about it. Talk begets talk. The discourse becomes self-sustaining, gradually breaking free of its actual subject.

As we have seen, a great deal of contemporary art cannot stand up to too much scrutiny, in any case. So you might reasonably retort that superficial art brings in its train a superficial response. Or might it be the other way around? Perhaps artists, intuitively understanding that opportunities for deep engagement with their work are few, have little incentive to provide anything complex. Maybe it's a simple case of supply and demand. If all the public demands is superficiality, and that's what you are rewarded for, then that's all it is necessary to provide.

With a bit of experience and the right skills, you can write interestingly about anything. As I once proved to myself, just for my own satisfaction, it is possible to compose an essay that makes a matchbox seem almost as compelling as a Monet. Yet any such account is convincing only so long as readers do not return in a sceptical frame of mind to the source, in which case they would quickly discover that they had been taken in by authorial sleight of hand. The matchbox was just a matchbox after all.

Critics, reviewers and writers of catalogue essays have reason to be confident that most of their readers will not go back to the original work in a sceptical frame of mind. Most have sought out the writing as a validation of their viewing experience, not as an adjunct to their own cogitations. As Peter Hill discovered, his students were quite unable to discern any of the complexities of *Adorno's hut* for themselves and obviously lacked the will to try. After Hill gave them an explanation, they were satisfied. How many of them, I wonder, went back to look critically at *Adorno's hut* again to test whether that explanation tallied with their own experience of it?

If commentary is being relied upon to validate art – if audiences are using it not as a springboard for their own exploration of the work but as a substitute – and if commentary is capable of validating just about anything, then not only are artists not obliged to invest their work with conceptual complexity, they are actually discouraged from doing so.

Commentary is a leveller. It is capable of convincing us – if we fail to check its conceits against our own experience – that one of Howard Arkley's decorative suburban house pictures, for example, is as rich in meaning and cultural significance as Anselm Kiefer's symbolic elaborations of cultural myth and magic.

Thus it is quite likely that commentary, or at least our overreliance on it, is contributing to the trivialisation of art. Inattentive audiences sustain the need for exegesis, and exegesis indulges inattention. Paradoxically, the more sophisticated and intelligent the commentary, the greater its trivialising effect may be.

There is a public lift at the National Gallery of Australia which offers the quickest way from the foyer to the coffee shop, in case you need a shot of caffeine before tackling the art. (Of course, museums these days are designed to save you all this effort, with cafes and other retail outlets helpfully placed right inside the front door.)

Whether it was motivated by a shortage of hanging space, some mad curatorial compunction to ensure that our art experience could

not be shirked or, much more likely, a playful interest in giving art-works a fresh new context, the effect of *The Lift Project* – for which works of art were hung in the lift for short periods – was to make the journey more edifying, more pleasurable, and more interesting. And, in at least one instance, a good deal more unsettling.

Some colour photographs by Deborah Paauwe were enlisted for *The Lift Project* in 2002, among them *Candy heart* (2000) and *Playing around* (2000). Neither is immediately confronting. At first glance, they are perfectly inoffensive and ordinary, although attractive enough. They might be wholesome advertising images from the fifties, promoting regular brushing, white bread or *Father Knows Best.*

Candy heart shows a prepubescent girl wearing a filmy blue–green dress with cute bows at the shoulders and waist, the sort of dress a doting mother would describe as 'pretty'. She lies on her back, not with abandon but self-consciously, stiffly posed against a piece of fabric printed with a kitsch design of ripe fruit. In her hand she clutches the large, heart-shaped confection that gives the picture its name.

Two things give this image an edge it would not otherwise have. The first is an almost imperceptible mark on the girl's wrist, as though a tight-fitting strap or bracelet has been removed. The second, more immediately apparent, is the cropping. We can see only the girl's torso, not her head or her legs, so she is not so much a person as an anonymous body. We feel we're getting only part of the picture, a detail of some larger view, an extreme close up that seems to concentrate our attention on all the wrong things.

Playing around is a variation on the same theme. Here an equally anonymous girl – for all we know, the same one – is seen only from the top of her breasts to her knees, standing rather stiffly for the camera. She wears a red gingham dress that exactly matches the backcloth and which is gathered at the waist by a matching belt. Even the hoola-hoop she holds is wound with gingham. Her bare arms are the only visible flesh.

I'd already seen enough of Deborah Paauwe's photographs to recognise them instantly as I stepped into the National Gallery of Australia's lift. I'd also read various commentaries about them. Writers such as Wendy Walker, for example, had pointed out that

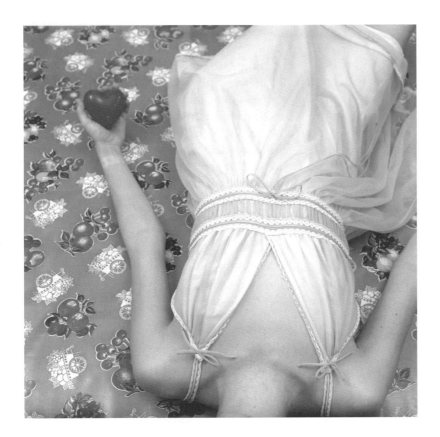

Deborah Paauwe born 1972
Candy heart, 2000
Type C photograph
120 x 120 cm.
Reproduced courtesy of the artist and Greenaway Art Gallery, Adelaide

'[a] surfeit of the feminine diffuses Deborah Paauwe's world, in which an exploration/illumination of female sexuality and desire is intensified through a layering of feminine signifiers ...'[21] Nicholas Tsoutas had suggested that these photographs '... seem somehow to sit outside that continuous movement of time, somehow a frozen composite moment that suggests each image is a filmic detail, that results from a past and a present or perhaps even a space that implies the coexistence of a past and a present rather than a succession of time'.[22] Anne Marsh, no less opaquely, had declared that 'Deborah Paauwe's imagery circulates between art photography and erotica as the artist seduces and assaults the gaze. Paauwe engages with a labyrinthine gaze that Lacan charts as a map full of traps and misconceptions'.[23]

Needless to say, I had not found any of this in the least helpful. Nor had I ever found the photographs themselves especially interesting. I had never felt either assaulted or seduced by them, as Anne Marsh had insisted I should – indeed, the cold detachment of Marsh's writing suggested that she hadn't, either. Time had not stood still for me as it had for Nick Tsoutas.

Yet here, trapped in an intimate embrace in the lift, as we clattered noisily together up to the coffee shop, Deborah Paauwe and I reached some kind of convergence. For once I saw what critics and reviewers meant when they insisted on these works being 'disturbing'. My discomfort was only heightened by a young woman getting into the lift on the next floor and looking at me nervously, as though the photographs' latent eroticism might at any moment prompt me to do something unspeakable.

Why did Paauwe's photographs make such a strong impression on me in the lift that day when they'd failed to do so before (and have failed since)? Clearly it had something to do with the intimacy of the encounter, but it was also, I realised, because this was the only occasion on which I had been confronted by them individually rather than as elements in a solo exhibition. It was the only time I had come upon them unexpectedly. They needed to be seen out of context: they needed the element of surprise.

When we say that a work of art is disturbing, we don't mean it in the way that the SBS newsreader does when she warns that 'the following report contains images that some viewers may find

disturbing'. What that means is distressing, distasteful, nasty. We're
going to see blood, dead bodies, torture, or the like. Disturbance,
on the contrary, is a vague sense of disquiet caused by something
not being directly stated. If a close friend tells you he's going to kill
himself, that's alarming rather than disturbing. It's disturbing if he
seems depressed and the number of a suicide helpline is scribbled
on a memo pad beside his telephone.

This is why Anne Marsh is wrong – or at least careless – to claim
that Paauwe's photographs 'assault the gaze', and why she is a lot
closer to the mark, later in the same essay, in saying that they are
'teasing'. It is not sexiness or violence in these pictures that affects
us, but their absence.

The problem, however, is that the experience of disturbance is
not endlessly repeatable. If our friend stays depressed and the suicide
helpline number remains beside the telephone for months on end,
we begin to wonder whether he's not just toying with our emotions.
Our sympathy starts to wane. Although one or two of Paauwe's pho-
tographs might disturb us when we see them for the first time or in
an unexpected situation, a room full of them will not.

Once you've seen enough of Paauwe's photographs to know
what the theme is and how it is being played out, any feelings of
unease, of things not being said, is revealed as a pose or a formula.
They become camp, because the disturbing elements – the broken
fingernails, the small bruises, the sublimated eroticism – are
revealed as mere performance.

The boredom induced in viewers as a result of their over-
familiarity with a formula was recognised as a problem by nine-
teenth century art theorists. It is even more of a problem today,
when market pressures demand that artists confine themselves to a
brand image that will make their work immediately identifiable.

The romantic notion that art's job is to 'make the familiar
strange' was an attempt to counter the dulling effects of this over-
familiarity, to awaken jaded senses and help us see the world afresh.
The revival of interest in that idea at the end of the twentieth cen-
tury, in the art of the everyday, for example, indicates that repeti-
tion and habit are again being seen as problems, even if 'making
the familiar strange' is not understood in the way Coleridge and
Wordsworth meant it.

Mass media and the global art market tend to exacerbate the problem while at the same time, paradoxically, minimising its apparent effects. The market, in demanding conformity to a brand image, cannot cope well with artists whose works are not of a consistent type. We talk of an artist's 'signature style', which these days need not be anything more profound than the regular use of a particular colour or set of shapes, or a particular way of cropping photographs of prepubescent girls. It's just a kind of logo. The important thing is that we immediately recognise a work as a Deborah Paauwe or a John Young or an Imants Tillers. The effect of this is to militate against artistic or intellectual development, encouraging instead the constant restating of a very limited set of ideas.

The trouble is that, unless we are vitally interested in the ever more subtle distinctions between one Paauwe – or Young or Tillers – and the next, we are likely to think back with nostalgia to the moment when such works first gave us a thrill and be disappointed that that thrill cannot be rekindled. We will go to an artist's solo exhibition not in the lively expectation of being surprised or excited but to reassure ourselves that he or she is still doing much the same thing.

As an artist you cannot make a radical break from your signature style without risking your career. Your brand image has you trapped. Unless you are unusually talented or just plain lucky, you will be forced to go on repeating yourself until you or your audience can bear it no longer, at which point you will drop off the art-world's radar altogether, either because you were not capable of doing anything different or, if you were, because the market could not successfully identify you with a radically different product.

This, however, is where the global market can come in handy, offering a way out of an impasse that is largely of its own making. Although the market can do little to counter over-familiarity or boredom, it can help artists and dealers to find ever new audiences, for whom the work is fresh and exciting, while using the established one as a means of legitimation. If the audience can be constantly renewed, the art doesn't need to change much. Obviously this is preferable from a marketing point of view because it involves a lot less financial risk.

International art fairs are perfect in this way, offering a rela-
tively easy and inexpensive means to tap new markets so that artists
may 'expand their audiences' without the bother of having to
expand their art. 'One of the most obvious features of the art of our
time,' writes Philip Fisher, 'is not what Walter Benjamin called
mechanical reproduction. Instead we live in a time of quasi-replica-
tion, near duplication of works too much like one another, as
though to satisfy the market need to have 'one of those' here in San
Francisco, one there in Houston, and so on. The artist makes what
we might call a batch: using the same recipe, but making each work
distinct enough so that each collector can have his own slightly dif-
ferent but still recognisable example.'[24]

The problem for the contemporary artist is that the necessity
to stick to a brand image militates against these near-replicas
being anything more than cosmetic variations on a limited set of
purely visual cues. It allows very little capacity for conceptual
development. When the novelty wears off, therefore, there is not
much left but an object, a product. What is needed, and what we,
as viewers, have a right to expect, is something to engage with
after the initial surprise has faded. Which brings us back to this
notion of complexity.

4

CULTURAL TRADITIONS
AND PERSONAL DESIRES

Although only in his early twenties, Tokio is already tired of work and tired of life. Sexy, hip and independent he may be, yet he is world-weary, unable to connect with other people and cut adrift from his cultural roots. He experiences the world almost entirely through the lens of a video camera.

When we first meet him, at the beginning of Clara Law's meditative film *Autumn Moon* (1992), Tokio is fishing in Kowloon Harbour, steel and glass office-towers looming up around him – the frigid beauty of modern architecture being one of the film's visual *leitmotifs*. Tokio has come to Hong Kong in search of a good traditional Chinese meal, but his hunger is more than just gastronomic. In his own barely articulate way, he longs for some kind of connection. It is not insignificant that he has come to seek it in a hybrid Chinese society in the throes of great social change.

Here he meets Wai, a fifteen-year-old schoolgirl. Her parents are in Canada, preparing for the family's immigration, and she has been left behind to look after her grandmother in a tiny apartment with a little Buddhist shrine on top of the fridge. Wai is everything

Tokio is not: shy, sincere, naive. In spite of their differences, how-ever, they form an unlikely relationship, which is constantly under-mined by cultural misunderstandings and language difficulties.

One of the film's best and most revealing jokes comes right at the start. Tokio asks Wai to take him to her favourite 'traditional' restaurant. She knows just the place. The following scene opens with them sitting side by side at a restaurant table, although young Tokio looks anything but pleased. As the camera pulls back, we dis-cover why: they are in the local McDonald's, where, Wai tells him sincerely, her family has gathered for birthday celebrations ever since she was tiny.

Wai has confused personal and family traditions with cultural ones, but the difference is by no means clear-cut. Tokio does even-tually get his traditional Chinese meal, not at any restaurant, but an 'authentic' one cooked by Wai's grandmother in her tiny flat. In the meantime, he learns that the very notion of tradition is a good deal more slippery than he had ever imagined. Traditions, he learns, cannot be appropriated, adopted or reinvented without unforeseen consequences.

As Law's film suggests, an interest in cultural traditions and heritage is typical of societies undergoing periods of rapid change. We are concerned about maintaining traditions only when they are thought to be under threat, a conscious interest in heritage being almost always driven by anxiety and a general sense of loss. It is always nostalgic. Like Tokio, most of us sense that something is missing in our lives that no amount of material affluence or mass-produced entertainment can provide. Hungering for something more rooted and more authentic, we look for ways to reconnect with the past and to establish at least a semblance of cultural continuity.

Artists and craftworkers often talk about traditions, although it's not always clear what they are referring to. They might, for example, argue that certain objects 'embody' or draw upon their cultural inheritance, or are symbolic of traditional practices. On the other hand, there are those – probably the majority – who are determined to subvert or break free of traditional practices. Such convictions – that traditions are either good and should there-fore be reconnected with, or a hindrance to be undermined or

discarded – are almost always based on very hazy notions of what traditions are. A great deal is taken for granted.

Can an object embody or symbolise traditions? If so, how? Are cultural traditions and personal customs interchangeable? Can we consciously draw on cultural traditions in order to make sense of our personal experiences? Why are traditions and heritage assumed to enrich our lives and our work at all?

Our understanding of what constitutes an artistic tradition comes from the study of individual works. Paradoxically, however, we decide which works are to be placed within that tradition. Are we trying to have it both ways? Does this make a mockery of the whole notion of artistic traditions, or does it mean that traditions are not fixed but constantly being modified in response to the works, just as we constantly reassess the works in terms of what we perceive the traditions to be?

What we can say is that all art is, in one way or another, a reflection on, and a critique of, the art that came before it. Innovation is possible only if newness can be measured against something. The innovative artist does not reject the past but engages in constructive dialogue with it, reworking and re-inventing the stories that make up the cultural fabric. As George Steiner reminds us, the very word 'originality' carries within it the suggestion 'of a return, in substance and in form, to beginnings'.[1]

Take, for example, Gwyn Hanssen Pigott's spare porcelain vessels. More than once, critics have referred to their perfection. That suggests, however, mechanical contrivance and lack of warmth. In fact, they are far from being perfect because, as in the Japanese tradition, controlled imperfection is an essential part of their communicative power. Their character is determined by slight anomalies, which are carefully nurtured and developed. These imperfections can be so subtle and, paradoxically, so precise – the margin in which accidents are allowed to happen so narrow – that they may be almost undetectable.

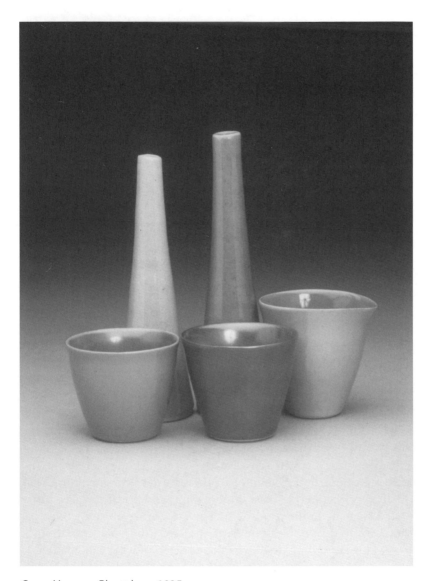

Gwyn Hanssen Pigott born 1935
Still life, 1994
Woodfired porcelain
Height of bottle 28.5 cm. Diameter of bowl 13.5 cm.
Collection: Shepparton Art Gallery, Sydney Myer Fund Australia Day Invitation
Ceramics Award 1995

The flecks of gold that enliven the interior surfaces of some of her bowls are so tiny and so few that they might have settled there accidentally, but the bowls would certainly not be the same without them. That Piggot's small vessels, teapots and lidded boxes are refined, contemplative and 'silent' has now become an article of faith. But we have to try to pin down what those expressions might mean. As her still-life groups suggest, the key lies in comparisons: in the relationships between the individual pieces and the spaces, both physical and metaphorical, around them.

Pigott restricts herself to a very limited number of forms, and within each group there are few appreciable differences between the individual components. This can be disconcerting to those who are used to novelty. On closer examination, however – and the work has the sort of authority that makes close examination irresistible – we discover that the minute deformation of the lip on this bowl, the way it dips and curves, forming an off-centre oval rather than a circle, is more relaxed than on that one. This makes the one appear fluid and rhythmic, the other tight and brittle. The rim of a cup in a still-life group may be fat and generously rounded while that of its companion jug is sharp and thin. The lip of a jug might sag outwards almost dangerously, but the bottle just behind it, narrow, straight and firm, holds it visually in check.

Colour variations are also carefully controlled, one pale buff being ever so slightly more or less transparent than another; the blue on the outside of a vessel a shade warmer than that on the inside. Although these are not accidental differences, they are not controlled in the usual sense of the word. They result from the artist's intuitive understanding of the nature of the medium, what other artists before her have done with it, and how they have articulated meaning in the process. In a way, these are musical concerns; they have to do with relationships, intervals, tones and variations.

And what is more, they are not restricted to what can be seen. If you pick up some of the pieces in a group, you find the dark-coloured bottle heavier than expected, while the jug turns out to be light in weight as well as colour. In the next group, however, the bottle might be unexpectedly light, the jug and cup relatively heavy. In Pigott's work, these contrasts always seem right, the relationships among forms, colours, textures and weights creating a dynamic balance. So,

while these groups suggest stillness, it is the sort of stillness we might admire in a small, clear lake on a warm morning, whose serenity we know to be the result of vast forces and constant change.

Gwyn Hanssen Pigott's ceramics examine our relationship not only to cultural history but also to nature. They reflect her life-long study of Korean and Chinese Song Dynasty porcelains, and her interest in the peasant pottery of France and the still-life paintings of the Italian artist Giorgio Morandi. For all that, there are no direct quotations, nor any obvious homages. She does not appropriate traditions, but extends them. In doing so, she says something entirely fresh about the individual's place in the culture, the culture's place in the natural order and the complex dialogue between past and the present.

This is what distinguishes Hanssen Pigott's variations within a limited framework from those of Deborah Paauwe. Paauwe's photographs present us with a set narrative. Once we know what that narrative is, the rest is repetition. Exploring the subtle differences between one work and another, while it may be diverting, will not lead us to a richer or deeper understanding because the differences themselves are contrived and skin-deep. On the other hand, subtle variations between one work and another constitute the essence of Pigott's still-life groups, giving them their meaning. This is exactly what they are about. Importantly, those variations are not only the result of a dialogue with the art of the past, but also reflect the artist's understanding and careful manipulation of natural processes – the temperature of the kiln, the type of fuel used, the weather on a particular day, the differing molecular makeup of various clays, and so on. Despite their outward similarities, a gallery full of Gwyn Hanssen Pigott's vessels is much less likely to induce feelings of monotony, especially if we are allowed to pick them up. Each suggests new possibilities and delights, because each is a completely new experience.

Knowledge and understanding of the past, our awareness of how things came to be the way they are, by making innovation possible, give meaning to the art of our own time. They connect the individual work of art to the public sphere.

Tradition is the practice of passing down knowledge from one generation to the next. This is why, as Gwen Hanssen Pigott's still-life groups demonstrate, traditions express cultural continuity, cohesion and identity and can be used to structure social relationships. Nevertheless, as the cultural critic Raymond Williams has pointed out, this idea of handing on knowledge clearly implies some sense of duty and respect. [2] Of course, only a very limited number of traditions will be considered worthy of our respect, so we must be selective.

On the other hand, a sense of duty can be artificially induced by faking traditions. This is a common means of social control. Ideas of nationhood, for example, are often promoted by an appeal to 'traditional values' that have little basis in history. The nuclear family, whose very existence depends upon modern labour-saving devices, is an obvious example of an invented tradition serving ideological ends. Perhaps this 'invention of tradition', as the historians Eric Hobsbawm and Terence Ranger call it, is one reason we are often so cynical about the usefulness of historical precedent.

Individualism also leads to the devaluation of cultural traditions. Ceremony, duty and respect do not sit well with the idea of individual freedom and self-expression. Early modernist artists were very conscious of their debt to the art of the past: consider, for instance, Stravinsky, Bartók, Kandinsky and Picasso; James Joyce and Eliot; the Werkbund and the early Bauhaus. After World War II, however, artists were far more likely to want to abandon all conscious reference to their predecessors and to try to start again from first principles. It is no accident that Ad Reinhardt's longing for emptiness, expressed in his famous black paintings, became the symbol of an age. The result has been a lazy acceptance in some quarters that history doesn't matter, that connoisseurship is of little value and scholarly study of historical periods not worth pursuing.

The legacy of modernism, one that would almost certainly horrify many of the movement's early proponents, is a break not just with certain ideas from the past but with the very notion that the past has anything to offer at all.

The great value we put on competitive individualism means a loss of belief in what used to be called the common weal. We have only to look at contemporary political life, where social welfare programs are being progressively whittled away, public utilities privatised and community infrastructures dismantled, to understand the extent to which the special interests of the individual have triumphed over concern for the general welfare.

It should hardly surprise us, then, that when artists and craft-workers nowadays express an interest in making connections with the past, they tend to use cultural traditions indiscriminately as a kind of database for narcissism. How often we hear of artists and craftworkers drawing on some tradition – one which is perceived to be their own or one that they have just picked up along the way like an eye-catching souvenir in a foreign bazaar – to examine the self.

Exploiting traditions to establish individual identity is problem-atic because it assumes that the crossover from the communal to the personal can be achieved without doing violence to the social fabric, and that an individual's needs and desires will automatically serve as a microcosm or distillation of communal interests. So when a woman artist adapts motifs from nineteenth century needlework, for example, or an urban Aboriginal artist borrows designs from Central Australian bark paintings, or an Australian artist of Greek background uses her art to interpret Hellenic folk legends, the personal is assumed to stand for the communal and communal benefit is assumed to flow from self-absorption. This is the trap Wai fell into when she took Tokio to McDonald's: the confusion of personal ritual and cultural tradition.

Communities are not just conglomerations of thousands of individual selves. We cannot automatically assume that the needs, wishes and values of the individual stand for those of the social enti-ty. This is not to say that the results of self-examination can't prove interesting or valuable to others, only that the conscious adaptation of forms or processes from the past in order to throw light on mod-ern problems of personal identity, while it may benefit the individ-ual, and, with luck, some other sympathetic individuals, will probably do more to destroy cultural heritage than maintain it.

Ironically, when 'heritage' is used by individual artists and craft-workers to overcome social isolation and establish identity with a particular group, their very consciousness of that heritage and their ability to objectify and adapt it confirms their status as outsiders. As the British anthropologist Brian Moeran has written: 'the concept of a traditional "folk" art or craft that emerged in Europe in the nineteenth century was a means of identifying the arts and crafts of a lower class, which was generally rural and non-literate and followed local traditions. These folk arts were seen to be communal by nature and in direct contrast to the urban, literate upper-class fine arts ... We should recognise, then, that traditional arts and crafts are at first generally appreciated as such by people living in the 'outside' world, and not by their producers. Moreover, there appear to be certain dichotomies in the lifestyles of those who make and those who appreciate this kind of art – dichotomies like natural/industrialised, rural/urban, handmade/machinemade, and individual/ anonymous that are an inseparable part of the aesthetic vocabulary of "tradition"'.[3]

As a result, when an artist claims to be drawing on his or her cultural traditions, as a woman, as an Aborigine, as a Greek–Australian or whatever, we are right to be sceptical. The connections are not at all straightforward. This is not to say that it is wrong to call on tradition or heritage to validate a certain approach to one's work, but, to be credible, the connection must be based on a realistic appraisal of what can and can't be achieved. What can, on occasion, be achieved is some degree of personal understanding which leads to others discovering something about themselves in turn. What decisively cannot be achieved, however, is a revival of those traditions. Appropriating a dead or absent tradition does not bring it back to life, it just drags out the body to be picked over. For a tradition to meaningful, it has to be rooted in lived experience.

Essentially, all interest in heritage and tradition is an interest in measurement. We examine the practices of the past, or imbue certain objects with the power to evoke the past, in order to test how far we have progressed or declined, what we have gained or lost. It is also, of course, a means of validation. Just as the Anglo–Saxon kings established their social status by means of elaborately

fabricated family trees which traced their ancestry back to Woden or Adam, so modern artists or craftspeople may be tempted to lend their work gravitas by positioning it in a long and venerable cultural tradition.

This does not result in their becoming an authentic part of that tradition, however, or becoming its inheritors, which, as we have seen, is impossible for any individual acting alone. The best they can do is to stand back and subject it to detached and selective examination.

Although certain styles and methods from the past may be considered worthy of preservation or revival, few would argue for a return to the social conditions that gave rise to them – just as the authentic restoration of a period house will usually stop short of a wood-fired copper instead of a modern washing machine or candles instead of electric light. What we choose to use from the past is destined always to be symbolic. 'It more and more seems,' wrote Edward Lucie-Smith, 'that the craftsman of the future must be not only, as Mumford predicted, the amateur, employing for his own satisfaction great stretches of spare time which only technology can provide, but also the ambiguously labelled artist–craftsman. The role of such a craftsman must be that of a maker of symbols, and his own existence is also symbolic. He takes his place in industrial society as a necessary antonym, a visible reminder of where industry has come from. His products speak of individual fantasy, of the primacy of instinct, of direct relationships to materials'.[4]

Over the past two hundred years or so, as industrialism and urbanisation have destroyed many established social customs, we have experienced in response a number of attempts to sustain meaningful cultural traditions in dynamic, pluralistic, urbanised societies.

William Morris, a pioneer socialist, focused on the nineteenth century factory system, which alienated workers from the products of their labours and produced goods for profit rather than for use. Morris looked back to the Middle Ages as a time when 'the best artist was a workman, still, the humblest workman was an artist'. In

his novel *News from Nowhere*, he proposes a modern utopia which takes what he considered to be the noblest elements of medieval society – co-operation based on clearly defined individual rights and responsibilities, the production only of those goods for which a clear need existed, an essentially steady-state economy not dependent on constant growth, and respect for nature – then adapts them to modern life. Morris sought to eliminate the distinction between the professional artist and the worker and to blur that between the makers and the users of goods.

His ideas informed policies at the Bauhaus, at least in its early days, which emphasised the unity of all the creative arts under the aegis of architecture, the interaction of art and technology to create a new visual culture, and the socialist ideal of artists as practical workers in the service of the community. Although ostensibly an educational institution, the Bauhaus was, in reality, nothing less than a project for a new society, built by artists, in which citizens would be freed from drudgery and inequality by efficient, economical design and modern production methods. Despite its faith in modern technology, however, the Bauhaus drew upon ideas about the social integration of artists that go back to pre-Renaissance Europe.

Bernard Leach, the English potter, also had visions for a new society based on synthesis: this time of East and West. His model was modern, that is, inter-war, Japan, where the marriage of Western rationalism and efficiency to the co-operative folk-craft traditions of the pre-industrial era could be seen at its liveliest and most finely balanced. Like Morris and the teachers at the Bauhaus, Leach distrusted individualism and lamented the artificial separation of artist and worker.

Many of these influential ideas about community and labour, respect for nature and the reintegration of art into everyday life found their way into the counter-culture movement of the 1960s, although it was not the visual arts so much as popular music that carried the social and political messages of the times, and it was anarchy and rebellion rather than any new order that were trusted to bring about change. In response, visual artists embraced new, more 'democratic' forms, such as photography, photocopying, underground film-making, posters and land-art, in an effort to re-connect themselves to a mass audience.

To argue that all such idealistic and visionary attempts to rethink the social role of art are bound to fail is to miss the point. Utopias, by definition, are not meant to be achievable; at least not in any direct sense. They are rehearsals for change. What is important about them is that they serve as models of social integration. The fair and just societies they envisage draw upon an understanding of historical precedent: not opportunistic appropriation for the purposes of individual development, but the sort of creative dialogue with the art of the past that aims to change the culture as a whole, so that respect for certain traditions is the natural outcome of social experience, rather than a sentimental hankering for better times.

Importantly, each of these utopian visions has assigned to the crafts a central role, because crafts practice is, at root, the creating of useful things that connect the maker's imagination to that of the user. It is through the crafts that art and work come together.

Or at least they did once. In 1986, when the Australia Council, for reasons of bureaucratic and financial convenience, amalgamated the Visual Arts Board and the Crafts Board into a single unit, these vital connections between crafts practice and the traditions of work and community were thrown overboard. The crafts now became subject to the quite foreign priorities of the visual arts.

Consequently, for example, a highly effective grants program funding potters, glass-makers, jewellers and other craftspeople to set up production workshops was abolished. 'Innovation' now became the main criterion by which craftwork came to be assessed. In effect, craftspeople started to be penalised for honouring the traditions that gave their practice its very meaning.

Now, it is perfectly reasonable that the Visual Arts/Craft Board, as it is now called, should set down guidelines on what it will and will not fund. It has to acknowledge, however, that the guidelines it does set down will have a significant impact upon what gets produced and what gets noticed.

The Visual Arts/Craft Board points out that it has nothing against what it calls traditional crafts practice, it simply doesn't fund

it. This is unobjectionable as far as it goes, but disingenuous. For one thing, it fails to acknowledge that Australia Council policy automatically bestows official imprimatur on certain types of activities while marginalising others. It cannot ignore its own power and the power it might unwittingly confer on others. The Visual Arts/Craft Board interprets 'innovation' in an especially restrictive way, one that, as we have seen, is dependent on the demands of the market, and which, paradoxically, is quite nineteenth century in character.

Take, for example, a master violin maker. If you or I were asked to assess the merit of a stringed instrument, what would we do first? Naturally, we would ask someone to play it. A musical instrument is not something to look at, it is an object whose form has developed over several centuries to fulfil one particular and very specialised function. Everything about it, from its shape to the thickness of the varnish on its surface, must enhance its ability to play music.

In a similar way, a teapot might logically be judged on how well it brews tea, an item of clothing on how well it fits and a chair on how comfortable it is. Of course, these are not the only criteria. Unlike that of violins, the appearance of coats, scarves, teapots and chairs is not entirely dependent on their functions.

Serious problems arise, however, when the ability of a hand-crafted object to adequately fulfil its function is not taken into account. All the Visual Arts/Craft Board's criteria are based on what things look like and, through that, what meanings they might be said to encode. They take little or no interest in what they are meant to do and how well they do it. Assessing a violin on its appearance – structurally it looks much like any other violin, which is, of course, just the point – is analogous to a judge at a motor show assessing a car on the quality of its gleaming paintwork without caring whether the engine works.

As if aware of the problem, the board simply declares that craft-workers who make useful objects according to the traditions of their craft are out of bounds. Their work is 'derivative', that is, based on tradition.

Such policies have not simply distorted the nature of craft production, they have helped kill crafts practice in this country altogether. They have encouraged the glamorous, chic and expensive

individual object of desire, the ostentatious product of the individual ego, the marketable commodity, while discouraging the modest, traditional, derivative object of usefulness. (Let's rescue this word 'derivative' from being a term of disparagement and reinstate it as a perfectly honourable quality for craftwork.) Today, the crafts have been wrenched from their traditional associations with trades and industry, with the working classes and the amateur, and given over to the luxury art market.

Any attempt to redefine our relationship with history must be, at least to a certain extent, nostalgic and utopian, none can succeed unless it is based on a real understanding of the *processes* of history – as distinct from their outward manifestations. Every attempt must recognise the potential of the human imagination to effect social change, acknowledging that change must be based on more than short-term responses to particular problems. Our relationship to our heritage, in whatever way we understand that term, must go beyond the narrow concerns of individualism. It must concern itself with the communal, and it must arise from a dialectical play between past and future.

To try to understand what that might mean in practice, we need to detour briefly into what may at first seem a relatively obscure episode in modern art history, but whose relevance to the argument – and to Australian art – will become clear.

The English potter, Michael Casson, remembers a meeting of the Craftsman Potters Association in the late 1960s at which two of its most respected senior members were asked to explain how they would go about assessing the quality of a piece of pottery. First, the Australian expatriate Denise Wren explained in detail several broad categories under which a pot should be judged. Each category was divided into a number of questions which she felt should be asked about the work. One category alone comprised eighty-seven questions! 'It was,' said Casson later, 'a brilliant piece of planning.'[5] Bernard Leach, on the other hand, thought the judge needed to ask only one question: 'Has the pot "heart"?'

Wren's response, while it might have been pedantic, was at least democratic and a genuine attempt to be helpful. Leach's was anything but. It does, however, provide some indication of why he was among the most influential artists of the twentieth century and of why his modest publication *A Potter's Book*, first published in 1940, was to become an inspiration for a whole generation of potters. It may also explain why he has now been almost forgotten, his flame kept alive by a mere handful of devotees, among whom I count myself, albeit with reservations.

What is now, somewhat misleadingly, known as the Leach–Hamada tradition was based less upon logic, rationality or theory than upon belief. When Leach said that all you need to ask of a pot is, 'does it have "heart"?' he was, of course, separating the believers from the non-believers. The believers would recognise 'heart' when they saw it.

It was this implication of exclusivity arising from a shared sense of connoisseurship that made the Leach–Hamada tradition so attractive to its followers. It also accounts for the decidedly negative reactions from those who, for one reason or another, felt themselves to be outside this particular 'tradition'. Critics of the Leach aesthetic were just as vociferous as its supporters. Indeed, Leach's pomposity and dogmatism have made him an easy target for ridicule ever since.

Nevertheless, his writings and philosophies would not have engendered such intense feelings had they not touched a collective nerve. All the same, it is worth remembering that their impact, although profound, was limited fairly much to those countries that already had some experience of the English Arts and Crafts movement: namely England itself, the United States, Australia and New Zealand. Japan, too, where Leach was held in very high regard, had experienced during the early years of the twentieth century a reaction against machine technology and a revival of folk-craft traditions comparable to the English Arts and Crafts movement. In Europe, on the other hand, where the modernist aesthetic of functionalism held more sway, and in the rest of Asia, where people had little political incentive to admire the culture of Japan, Leach's influence was never very significant.

In essence, Leach revived an interest in Japanese aesthetics which, in the late nineteenth century, had been a cornerstone of the crafts movement. Although his own work was influenced more by Korean and Chinese ceramics and by English medieval pottery than by Japanese styles, Leach's aesthetic philosophies are very much Japanese in origin.

Edward Lucie-Smith has noted that 'Japanese culture was perhaps the first to see craftwork as having a moral value as an activity quite apart from what was actually produced; just as it was the first to see craft as expressing the moral condition of those who practised it. In this sense, the whole modern theory of craft has Japanese roots'.[6] Leach seized upon this sense of moral purpose as particularly pertinent to Western industrial societies where craftworkers had good reason to be anxious about their role in society.

He offered a high-minded vision of unified collective purpose guided by a rigorous standard of professional and aesthetic excellence. Simplistically, he divided pottery production into two distinct categories: machine-made, mass-produced ware, on the one hand, which he saw as 'rational, abstract and tectonic, the work of the engineer or constructor rather than that of the "artist"'[7]; and, on the other, the work of the artist–craftsman, which is 'intuitive and humanistic'.[8]

Like his predecessor, William Morris, from whom he learnt so much, Leach had no argument with the machine *per se* – at least, so he claimed. He did, however, firmly maintain that 'good hand craftsmanship is directly subject to the prime source of human activity, whereas machine crafts, even at their best, are activated at one remove – by the intellect'.[9]

Although such statements raise a whole range of questions, they did give craftworkers a comforting sense of being in a special position at the centre of things. They played into the hands of a prevailing mood of anti-intellectualism and a tendency towards mystification and religiosity. In short, Leach filled a spiritual void while at the same time imposing a rigid standard of excellence. He offered a philosophical anchor in tradition and a collective goal to strive for.

This was important in itself, but the spread of Leach's influence to other countries was not just the result of his tenacious advocacy

or of his and Hamada's personal artistic standing. It involved the happy confluence of many apparently unrelated forces.

Some were social and historical, such as the official policy of the American occupation to quickly rebuild Japanese social structures after the war by promoting that country's cultural and religious traditions. This self-conscious national image-makeover encouraged overseas interest in Zen Buddhism, which was to have a profound impact on European and American art in the fifties and beyond.[10] The counterculture's rejection of rationalism and reason in favour of spontaneity, passion and personal freedom mirrored Abstract Expressionism's emphasis on process, intuition and the archetype. There was something in the air all right, and pottery-making expressed it beautifully, especially in the guise in which Leach presented it: a 'humble craft' using materials drawn directly from the earth, redolent of simple country living and folk traditions.

It was not just romantic fantasy, however, that drove the crafts movement in the sixties and seventies: it was also economic security. The counterculture was fully dependent on the comfort and wealth of the middle classes which it purported to be countering.

That is why *A Potter's Book* had little impact in Australia or the United States when it was first published in 1940. Not until ten years later could it be said to have borne fruit in this country, with Harold Hughan's first exhibition of Chinese- and Korean-inspired stonewares at Georges Gallery in Melbourne. A further ten years was to elapse before the Leach–Hamada philosophy became really important here. Circumstances had to be propitious.

Those who took to Leach's theories in the 1960s and 1970s were, on the whole, products of a post-war primary and secondary education system which put emphasis on the development of physical and cognitive skills and moral character, as distinct from the glorified vocational training which has tended to pass for education since then. It was around this time that certificate and diploma courses in pottery began to be established in tertiary institutions. Their emphasis was on cultural expression and the development of ideas: on the 'whole person', as contemporary jargon might have expressed it. For the first time, an aspiring potter could buy ready-prepared clays and glazes over the counter, and a fully equipped kiln that needed only to be connected to the gas or electricity supply.

Many older potters, justifiably proud of having built their own kilns, dug their own clay and learned from their own mistakes, greeted such progress with dismay.

Any skilled and dedicated young potter in the sixties, armed with a diploma and a well-thumbed copy of *A Potter's Book*, could set up a studio in the confident expectation not only that there was a market for handcraft but that ceramics, as it was now called, had a certain clearly defined place of its own in the artworld. A range of sophisticated services and support networks ensured that, for the first time in Australia, one could build a respectable career making pots – although almost certainly a precarious one financially.

Despite this new atmosphere of professionalism, however, the craft still retained much of the robust good nature it had inherited from its amateur and somewhat larrikin past. In other words, Leach came along at just the right moment. Educational, financial and market opportunities were expanding rapidly while, at the same time, old allegiances held firm and an atmosphere of camaraderie and common purpose lingered.

It is easy to be cynical about the naïveté and idealism fostered by the Leach–Hamada tradition, but these were heady days. As such, of course, they were destined not to last. Nevertheless, the fact that Leach's influence was as strong as it was and lasted as long as it did is testament not only to his own abilities, both as potter and self-promoter, but to the strength and usefulness of the vision he offered.

There are many artists now in their fifties and sixties who look back on this period with great fondness. They valued the small, relatively non-professionalised family nature of their artistic milieu, the sense of common purpose that guided their work, the conviction – these days probably all but impossible – that potting was a way of life, characteristically Australian yet with no hint of jingoism.

Today, however, when we return to what Leach actually had to say in the many books he published over the years, we might be surprised at the intense parochialism of it all. Leach's whole life's work may be seen as an exercise in English nationalism. It wasn't the Englishness that appealed to potters in Australia and America, but the very idea that ceramics might be able to express nationalist ideals.

Throughout the 1960s and well into the 1970s, a great deal of local discussion about ceramics centred around the need to establish an identifiably Australian tradition.[11] Leach seemed to offer a way to achieve this, not only by means of the abstract idea that the crafts were capable of reflecting the moral status of a culture, but also through his advocacy of a 'great exchange' between East and West, leading to a new cultural synthesis.

An Australian pottery tradition could therefore be constructed by adapting Japanese ideas about responsiveness to locality and the particular nature of various materials and applying them to the local landscape. This marrying of Oriental philosophies to local Australian conditions was perfectly in keeping with Leach's desire for cultural reconciliation.

And so it came about that something recognisably Australian developed from an eccentrically English response to Korean and Chinese styles and Japanese aesthetics. But was it the marriage of East and West – 'the great exchange' – that Leach had been seeking?

Unlike the sort of jingoistic nationalism advocated in the Saatchi report, it was certainly a genuine exchange of values, based on mutual respect. It was based on real lived experience. By the 1990s, when Prime Minister Paul Keating was calling for Australians to think of themselves as part of Asia, Japanese and Australian potters had been visiting each other's countries to live, study and teach for more than two decades. The best of the work that resulted represented something entirely new, growing, as it did, out of a genuine dialogue with the past.

Australian potters such as Les Blakebrough, Col Levy, Peter Rushforth, and others, saw a way in which Japanese philosophies could be used to create distinctively local work that still acknowledged its foreign origins. Meanwhile, Japanese potters such as Shunichi Inoui, Shigeo Shiga and Mitsuo Shoji were responding enthusiastically to the colours and light of the Australian countryside. Les Blakebrough recalls watching Shiga at the Sturt Workshops at Mittagong in the late 1960s. 'Everything seemed brighter to Shiga ... He would sit outside with the rest of the workshop staff for morning tea and marvel at the colour of the sky; the apprentices, not appreciating the difference ... would wonder what he meant.'[12]

How remote those heady times seem today. How much has changed for the worse!

At the end of 2002, for example, both the Victorian College of the Arts and the University of Tasmania's School of Art announced that they would no longer be offering ceramics as an undergraduate subject. These were not the first art schools to abandon the subject. Sadly, ceramics at tertiary level would appear to be going the way of calligraphy and wood engraving.

Twenty or thirty years ago, the complete closure of a tertiary ceramics course would have caused howls of outrage. Not so today. While the Victorian College of the Arts announcement sparked some anxious discussion among Melbourne's ever shrinking crafts community, few others seemed to notice.

Predictably, the institutions claimed it was a matter of finances. Not enough students were interested in ceramics to justify keeping the courses open. If one's concerns are limited to the budget bottom line – as those of art school administrators of necessity are – there is an irresistible logic to that argument. Student numbers had fallen drastically. What the art schools seemed not to want to ask themselves, however, was why students were turning away from courses which only a few years earlier had been a vital component of most art schools' training.

Might it be that ceramics, like calligraphy and wood-engraving, is an old-fashioned craft with nothing much to offer the modern world? Is it simply not 'the language of now'? Or is ceramics the canary in the artworld mineshaft, just the most vulnerable discipline whose decline augurs a more general collapse across the board?

As Kevin Murray, director of Craft Victoria, pointed out, students are not likely to be interested in tertiary ceramics courses unless they have been introduced to the subject in secondary school, which is becoming increasingly unlikely. At a time of ever tightening budgets and an ever more utilitarian approach to education, any subject that will not directly help students get a job will find itself under pressure. The humanities are taking the brunt of this narrow attitude, the fine arts in particular. 'As a small depart-

ment,' says Murray, 'ceramics is often the first to go when arts education budgets are trimmed.'[13]

Potentially interested students are not given much incentive, since craft disciplines tend to be ignored by contemporary art institutions, art journals and critics, all of whom are clearly embarrassed by any art that does not immediately lend itself to intellectual analysis. Even state museums tend to neglect the crafts. When the National Gallery of Victoria opened its new Ian Potter Gallery of Australian Art at Federation Square, for example, the gallery's vast collection of Australian ceramics was left in storage. Not a single piece was thought worthy of display, not even the Boyds and Percevals that had had such an impact on the development of Australian art in the 1940s and 1950s.

Art dealers also find it hard to be interested, although one or two make a valiant effort with the occasional solo ceramics exhibition as an adjunct to the main game. The low status of the medium leads to low prices, which makes it an unattractive proposition for gallery owners and that, in turn, helps to confirm its low status. A young artist today who decides to take up pottery will suddenly fall below everyone's radar. It's a bit like announcing that you're going off to live in Tasmania. Being on the margins is all very well in theory, but the theories, of course, are always disseminated from the centres.

The problem is that the centres – in this case the university art schools – have very little interest in the traditions that might give sustenance to a potter. Bernard Leach and his ilk simply don't figure in their collective consciousness. All this vague talk about 'heart' is incomprehensible tosh to the student brought up on the severe rationalities of theory. As the Australian writer Drusilla Modjeska has observed, the teaching of post-structuralism and post-modernism in universities resulted in 'a sophistication ... that was out of balance with the life experience of most students, who were still in their early twenties. There was a lopsided relationship between theory and feeling, with feeling often confused with sentimentality ...'[14]

One response – a perfectly understandable one, given the power relationships involved – was for craftspeople to abandon feeling altogether and try to shoehorn their practices into the theoretical

structures. This pleased state and federal funding bodies because it allowed them to go on funding craftworks without the embarrassment of appearing to be behind the times. Academics in tertiary art departments, however, were quite rightly unimpressed. As far as they could see, craftspeople were just playing a rather pathetic game of catch up.

Damon Moon, a former teacher of ceramics at the Victorian College of the Arts, has given us a sharp parody of the genre:

' "Hi, my name is Troy, and I'm a designer-maker with a ceramics based practice. I am currently developing a body of work which explores the gender politics of domestic objects, and locates the kitchen as a site of abjection."'[15]

Troy, says Moon, 'is a completely understandable product of the average ceramics department, the logical outcome of a system which privileges Habermas over Hamada'.[16]

The nub of the problem, however, can only really be understood when you step into a potter's studio, or a tertiary art school ceramics workshop – if you can still find one. The scene before you is likely to be one of barely ordered chaos, with wooden bins full of wet clay, jars of glazing materials, workbenches, wheels, kilns, and stacks of green wares at various stages of development. It all smacks of hard work. It's messy and it's complicated.

Why go to all that bother when a video, a digital camera and Photoshop can give you a professional-looking work of art in a matter of minutes, without your having to get your hands dirty? And, what is more important, without your having to spend years learning the ropes. Who can blame students for taking the easier and cleaner road to success?

The answer to that hinges on whether we think of the word 'craft' as a noun or a verb. Generally it's used as a noun. When craft organisations say they want to promote craft, it's *things* they mean, rather than the act of making them. For those conscious of the demands of the market, craft is not so much process as product. When the next exhibition is looming, and you have to come up with another couple of dozen pieces in less than a month, any Buddhist notion of the joy of the doing must give way to the necessity of getting it done. Fanciful notions about 'heart' are not going to help you sell anything.

When that very embodiment of 'heart', the eccentric Catalan architect, Antoni Gaudí, was finalising the construction of his Palau Güell in the late 1880s, he was asked to inspect a wardrobe that his head joiner had just completed. (Gaudí took responsibility for every fitting and every item of furniture in the buildings he designed, while at the same time allowing his artisans great freedom to exercise their own imaginations as they worked.) The wardrobe appeared to be made of marble, but Gaudí realised, when he tapped on it, that it was actually made of wood. Congratulating the joiner on his skill, Gaudí nevertheless rejected the wardrobe because its beauty was the result of a deception. 'Art is a very serious business,' he said.[17]

What would Gaudí think of his Sagrada Familia today, I wonder? This great cathedral-like church, to which he devoted the last years of his life and which had stood, half finished, like some bizarre fairytale fantasy for years, has now been 'completed' by a Japanese consortium as a tourist showpiece.

Where Gaudí had insisted on local materials, selected and gathered by the artisans who would work them, today's engineers and planners have settled for cement and epoxy resin. While Gaudí rarely made preparatory drawings, plotting his famous catenary arches with strings and weights in order to stay true to the processes of nature, his successors plan and cost every detail in advance using computers, for to do otherwise would be too expensive and time-consuming. For Gaudí, nature was 'the Great Book, always open, that we should force ourselves to read'.[18] In the eyes of those defacing his fine work with their hastily conceived additions, nature has nothing to do with it.

The last time I saw the Sagrada Familia, work was still in progress. As giant cranes lifted prefabricated fibreglass sections into place where previously masons had squatted with cold chisels patiently expressing their innate creativity, I realised regretfully that, if the building had to be completed, this was probably the only way it could be done nowadays. At the same time, however, I wondered why they were bothering, since they had jettisoned the very thing that made this building unique.

My point is that what the Sagrada Familia looks like is not what is interesting about it. What we value in this astonishing piece of

architecture is what Ruskin valued about the Gothic cathedrals: the complex narrative of its construction, the way Gaudí's epic vision was adapted over the years to changing circumstances, the way the building grew, like some monstrous natural being. The cheap, mechanical prosthesis that has now been grafted onto it – which, to the casual eye, might look the part – is an outrage to everything Gaudí stood for.

Looking the part is not enough, except for those who control the purse-strings. A speaker at an international design forum enthused recently that 'the ultimate rejection by Gaudí of standardisation and efficiency in this building has ironically become an important money-spinner for Barcelona'.[19] Sadly, he wasn't joking.

Craft is like gardening: a never-ending process of learning through doing. It means constant adaptation to changing conditions, constant interaction with nature's methods of operation.

Before going to Japan, while working with Ivan McMeekin at the Sturt Workshops in Mittagong, the potter Les Blakebrough learned how to make a simple coffee mug by throwing a thousand of them, all of which he immediately discarded. Only by repeating the same procedure over and over until it has become second nature can self-consciousness be banished and the form truly mastered. Freedom comes from an innate knowledge of materials and techniques, and that can come only with experience. There can be no shortcuts.

I can think of no better example than that presented by Col Levy's rambling workshop in the Blue Mountains outside Sydney. Evidence of industry and restless experimentation is everywhere – in the dozens of sheds and outbuildings, the innumerable storerooms, the meticulously organised piles of rocks, clays and minerals, the kilns and machinery that fill the site.

The first studio, just down the hill from the house, is the most important, containing as it does thousands of rejects. At first sight, they may be indistinguishable from his exhibition pieces, but Levy can identify every tiny flaw. As he unpacks a kiln, he can immediately intuit the quality of every piece, although he can't always explain rationally why some pieces work better than others. All the pots resting here in pottery purgatory will be used as reference material before being smashed. Yet they are more important to him

than the successful pots, which will go on to be exhibited and sold, because he can learn more from his mistakes, he says, than he can from his triumphs.

Large open bins scattered around the property contain a huge variety of rocks and clays. Levy knows a good deal about their chemical composition and what each will do under different firing conditions. Some of his clay piles have been weathering for twenty years or more and are now almost lost beneath the weeds, but he will get around to using them eventually. He pulverises the large rocks in a big, Heath Robinson-like crusher, whose gargantuan munchings are truly frightening to experience. From there, they will go through a smaller crusher and then a ball-mill until they are reduced to paste.

Levy collects all his own materials, mostly from his local area, testing them repeatedly to determine their usefulness. Both his gas- and wood-fired kilns he built himself, with the help of friends, after much trial and error. There are also several enormous wood piles: pine in one, angophora in another, black wattle in a third. Different woods, of course, produce different effects at differing temperatures and, over the years, Levy has studied their individual qualities in minutest detail, experimenting ceaselessly with the various combinations.

After years of patient experimentation, he has come to know what is likely to work and what is not, although there can never be any certainty, since even a change in the weather can drastically affect the outcome. A particular glaze will emerge from the fire a dull grey when applied to one clay, but lustrous on another. Because everything is unpredictable, nothing is written down. It is all committed to memory – all the formulae, and the almost unlimited number of combinations of bodies, glazes, fuels and firing temperatures.

By far the largest proportion of his output comprises test pieces. An entire building is given over to them. Here are stored some of his earliest celadons and oxblood-red glaze samples, dating from the 1960s.

Although Levy's work has never been consciously influenced by any particular Japanese styles, apart from a series of Bizen-inspired works he made in the mid 1970s, it is certainly Japanese in

character. It honours the central Mingei principle that a pot must express the nature of the place in which it was made. As a result, although Levy appends Oriental names to his glazes to acknowledge his inheritance, and although he is reasonably faithful to traditional Chinese and Korean forms, his pots could only have been made in Australia. In fact, they could only have been made in the Blue Mountains.

The question remains: why does Col Levy go to so much trouble when perfectly acceptable results can be achieved by much easier means? He does, after all, work phenomenally hard to achieve such a small output. A couple of year's intense labour will yield, at best, one exhibition.

The answer, of course, is that he doesn't do it for the results. The labour is an end in itself. It's like asking a gardener why he spends hours digging, planting, weeding and watering when he could get a perfectly acceptable-looking result with paving, gravel and lots of mondo grass.

Col Levy's approach to his work, like that of Bernard Leach, is unrealistic in that it seems to fly in the face of reason. But then if art can't fly in the face of reason, what can?

There is much we can learn from enterprises such as these. It has to do with respecting cultural traditions and striving to understand them, not in order to revive them but to reinvent them. Levy's understanding of the lineage of his practice shows us how we might overcome our market-driven preoccupation with individual achievement. And his conception of art as a process points to ways in which we can reconnect art – and ourselves – to nature, not necessarily by depicting natural forms or by using art to talk about nature, but rather by making art as if that was, in itself, a natural process.

5

WHAT CAN ART DO?

Nearly 250 years separate George Stubbs's flailing horse from Patricia Piccinini's suckling mutants. Yet in many respects they are two sides of the same coin: matching bookends for an era. The Stubbs is violent, terrible, immediate in its impact, whereas the Piccinini creeps up on us, full of insidious dread. Nevertheless, in their different ways, both warn of the monsters that the sleep of reason can breed.

The very fact that Piccinini's twenty-first century forebodings so eerily echo, a quarter of a millennium later, those of her predecessor, suggests that Auden was right when he claimed that art changes nothing. Perhaps, for all our intelligence, we are genetically incapable of learning from our mistakes.

If that were all that was going on here, however, neither of these works of art would be any more than reiterations of a realisation we have all come to at some time in our lives. No, there's more to them than just the moral warnings, as I hope a comparison between them, however idiosyncratic it might at first seem, will demonstrate.

I first saw George Stubbs's *A lion attacking a horse* (c.1765) at the age of ten or twelve while on a school excursion to the National Gallery of Victoria, in the days when it occupied part of the State Library building at the top of Swanston Street. Clattering through the gallery's echoing halls, cheerfully ignoring the teacher's desperate pleas for silence, we sailed straight past it – perhaps because it was thought unsuitable for young eyes – and I gave it no more than a glance. But I woke up that night in a cold sweat, picturing it with startling vividness in my imagination. Was it really as terrifying as I had remembered? I had to see it again. Since that moment, I have never been to the gallery without making the trip up the escalators to the rooms of European art to look at it. I feel I know every brushstroke, yet it never fails to surprise me.

The image itself is deceptively straightforward. A magnificently proportioned white stallion, grazing peacefully in a pastoral, unmistakeably English landscape, has, without warning, been overpowered by a lion, which has leapt onto its back and begun to tear at its flank. The horse's muscular back legs are about to collapse under the impact. As it braces itself with its right foreleg, every tendon straining as though about to burst, it swivels its elongated neck back towards its attacker. The stallion's head, almost exactly in the centre of the painting, is a study in sheer terror: the mouth wide open, teeth hideously bared, eyes bulging, its thick white mane billowing out behind like smoke. The horse's unlikely posture forms a knot of tight interlocking curves, like coiled springs about to explode. We have caught the action at a decisive moment. There is no blood, since the lion has not had time to penetrate the flesh. He has just appeared as if from nowhere. His eyes, half hidden in the shadows beneath the horse's cheekbones, stare directly at us, as though he's spotted us watching and dares us to interfere. The action may have only just begun, but there can be little doubt about the outcome.

In March 2003, while visiting the Patricia Piccinini survey exhibition at the Australian Centre for Contemporary Art in Melbourne, I came upon *The young family* (2000) and, perversely, thought immediately of Stubbs's horse. 'Perversely' because, on the face of it, the two works have little in common. Where the Stubbs is all flailing violence and pent-up emotion, Piccinini's

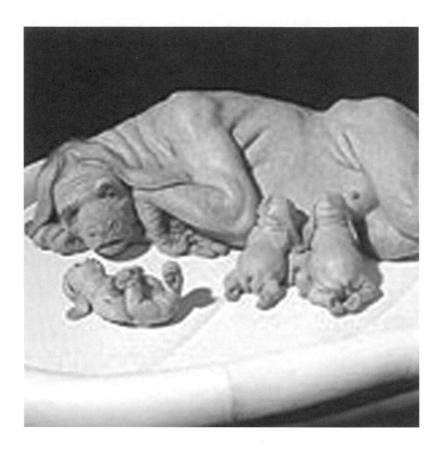

Patricia Piccinini born 1965
The young family, 2002
Silicone, polyurethane, leather, human hair
Dimensions variable
Photograph Graham Baring
Reproduced courtesy Tolarno Galleries, Melbourne

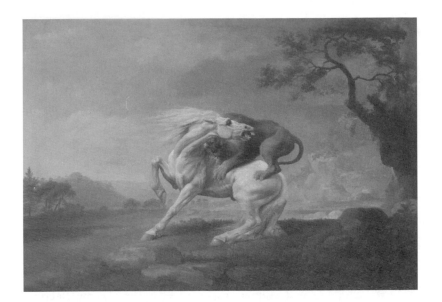

George Stubbs 1724–1806
A lion attacking a horse, c.1765
Oil on canvas
69 x 100.1 cm
National Gallery of Victoria, Melbourne, Felton Bequest, 1949

grotesquerie is peaceful, pathetic and flaccid. While the Stubbs will give you a jolt, *The young family* is irksome, yet likely to provoke certain ambivalent feelings of sympathy. Most obviously, however, there's the time gap. The Stubbs has the distinct disadvantage of being an old master, while Piccinini, as Adam Geczy might have it, speaks the language of now. What could a painting made in England about 250 years ago have to say to us today? Quite a lot, actually, unless we let our obsession with the new blind us to our debt to the past. For all that Piccinini's young family deals with twenty-first century social concerns, the approach it takes to those concerns – the *way* it deals with them – is rooted in European ethical and moral traditions going back centuries.

In Melbourne, at the Australian Centre for Contemporary Art, I watched children screwing up their noses in distaste, giggling with embarrassment, although I like to think that Piccinini's creatures caused at least one or two of them to awaken in fright in the middle of the night, as I did all those years ago after my fleeting encounter with the Stubbs.

Part of their power lies in their absolutely convincing realism. The fat, fleshy creature who lies down to suckle her young, a monstrous combination of sow and woman constructed, lifesize, or what one supposes to be lifesize, from silicone and acrylic, is accurate in every tiny detail. Her feet, which are in fact a combination of human feet and hands, with fleshy opposing thumbs, have calloused heels and overgrown fingernails. Her stumpy legs – could they actually support her enormous body if she stood up? – are veiny and wrinkled, with tiny hairs around the knees. There are pimples and the pink stump of a tail on her backside. Only the ears are unconvincing, looking for all the world like rashers of bacon draped over her skull. At her grossly distended belly, three plump little babies take their fill. They are the spitting image of their mum, with their long ears, misshapen feet and squashed, piggy faces: at once cute and repellent.

Seen on her own, the mother would be little more than a Hollywood freak. But the babies, and her solicitous response to them, introduce a note of pathos. What's really freakish about these creatures is not so much their preposterous physiognomies as their apparent acceptance of their fate. Although we may find them dis-

turbingly unnatural, they are passive and benign, living out their lives as nature intended.

In light of Piccinini's earlier photographs, videos and installations, which often made specific reference to genetic engineering, *The young family* has been interpreted as an allegory on the dangers of messing with nature. This recent work extends its metaphorical reach much further. Like *A lion attacking a horse* and, for that matter, Gwyn Hanssen Pigott's still-life groups, it draws on and reinterprets centuries of cultural metaphor in an effort to clarify who we are, where we've come from and where we might be going.

We can follow two main strands. One is the mythological and symbolic history of the mother image, from the hugely rotund palaeolithic Venus of Willendorf, through such ur-myths as Romulus and Remus suckled by the she-wolf and Atalantis raised by a bear (which would appear to prefigure in poetic form the theory of evolution), the countless variations on the virgin and child theme (of which Piccinini's sculptural group might be a grotesque caricature), and the pietà.

The pietà, incidentally, is a reminder – especially pertinent to a discussion of Piccinini's work – that the mother can represent not only nature, fulfilment and fecundity, but also death. Jesus' body cradled in the Virgin's arms is an echo of the ancient notion of death as a return to the mother, which Milton, in *Paradise Lost,* so gloriously parodied in the hag who guards the gates of hell:

... Before the Gates there sat
On either side a formidable shape;
The one seem'd Woman to the waist, and fair,
But ended foul in many a scaly fold,
Voluminous and vast, a Serpent arm'd
With mortal sting: about her middle round
A cry of Hell Hounds never ceasing bark'd
With wide Cerberean mouths full loud, and rung
A hideous peal: yet, when they list, would creep,
If aught disturb'd their noise, into her womb,
And kennel there, yet there still bark'd and howl'd
Within unseen ...

Here, as so often in art, mysticism and folklore, the mother image, with its associated ideas of birth and death, gets tangled up

with that other rich well that Piccinini has drawn from: that of metamorphosis. Milton's half human, half serpent mother of hounds has her equivalents in the sirens and the mermaids, which, in turn, take their place among the centaurs, minotaurs and satyrs of antiquity, and with all the others, of which Ovid provides a full account, the beasts in human form that crowd fairytales – think, for example, of the wolf-as-mother in Little Red Riding Hood – and the bewildering variety of bestial men and women who were, until quite recent times, said to inhabit unknown lands.

Women were thought by early theologians to be closer to brute nature than men because they suckled their babies 'like sows', so gender politics may also be brought to bear on Piccinini's young family. Women were also thought to be closer than men to the devil, hence this mother's residual tail. Similarly, the poor, the insane, the irreligious and, later, the negroid were all imagined as beastlike to one degree or another, according to need. The contrast between the human and non-human parallels that between the social insider and outsider, a comparison that will have particular resonance for us today.

What all this signals – indeed, what all religion and morality may signal – is the effort to suppress the animal aspects of our human nature: the beast within. In various forms, the anxiety engendered by this suppression still resonates loudly in popular and mass culture today. Hollywood, for example, seems obsessed by it. The recent uproar over the transplanting of genetically engineered animal parts into human bodies differs little from that of 1667 when a London doctor proposed the transfusion of a lamb's blood into one of his patients. In the nineteenth century, vaccinations caused widespread consternation because the use of fluid from cows might 'animalise' humans.[1]

The point is that the immediate, visceral impact of Piccinini's work, as of the Stubbs – the reason it is likely to haunt our dreams – is that it taps into deep seams of cultural myth lodged within our collective unconscious, and seeks to illuminate those myths with the cool clear light of reason. '[T]he fact that we are askers and givers of reasons,' writes the philosopher Matthew Elton, 'leads us to care about right and wrong. Bizarrely we care about right and wrong even though we may have no very clear or coherent account of what

they are. What matters most is that we are committed to the idea that there are answers to our moral questions, whether we can find them or not ...'[2] The trick, I suppose, is to know where to look and how to conduct the search.

In the mid eighteenth century, George Stubbs was taking up a subject which, although more specifically iconographic, had a similarly long and complex lineage. Lions can be found attacking horses throughout the history of European art, from as early as the ninth century BC, as well as in Asian and Middle Eastern art. In ancient and mediaeval times, the lion represented human, especially kingly, power, so this was essentially a tale about the triumph of brute force over weakness.

In the marvellous drawings of fighting animals done by Dürer in 1505, several of which show lions attacking horses, we can detect, however, a fundamental change in outlook. What strikes us about the Dürers is their air of scientific detachment. It is highly unlikely that this artist had actually seen lions attacking horses. What he was almost certainly doing was reinterpreting the ancient artefacts he'd studied during his visit to Rome that year. Dürer, like Stubbs some 250 years later, was responding not to an event, but to a cultural metaphor. We cannot say with certainty that Dürer's lion and horse drawings are about the hierarchies of human power. We know from this artist's other work that he is at least partly motivated by a scientific interest in nature, and this, I think, was new.

It was George Stubbs who would take this objective study of animals to its furthest extent, making the subject of the lion attacking a horse his own, and at the same time imbuing it with Romantic intensity. There are seventeen known examples, executed at various times throughout his life.

'Mr Stubbs, the horse painter', as he was for so long condescendingly known, was born in Liverpool in August 1724. By the age of twenty-five he was working as a moderately successful portrait painter while studying anatomy at York hospital. Anatomy was to remain his lifelong passion.

Perhaps Stubbs's most notable achievement as an artist – and scientist – is his monumental publication *The Anatomy of the Horse*, published in 1766. Forty-one of the surviving working drawings for this, the most thorough examination of the subject ever undertaken,

are now in the Royal Academy in London. Stubbs devised a special tackle for supporting dead horses in different positions while, assisted only by his wife, he dissected animal after animal, carefully stripping away layers of skin and muscle until he came to the skeleton. Each horse, he is reported as saying, lasted about six or seven weeks (presumably less in high summer).

The Melbourne Stubbs demonstrates not only this artist's great scientific knowledge and his skill in applying it, but also his deep love of nature and of horses in particular. Although the theme might have been suggested to him by the art of the past, Stubbs was unusual for his time in turning directly to nature for his training.

Stubbs's moral fable about brute nature overpowering culture and civilisation would have had particular force in an England on the eve of imperial expansion, opening itself up to the world beyond Europe. Like Patricia Piccinini's family group, *A lion attacking a horse* articulates collective fear: of the unknown, the uncontrollable and the uncontainable. Stubbs's lion is the archetypal monster, an ancestor of all those aliens, prehistoric brutes, hulks and vampires that titillate modern movie-goers. Such fear is not, of course, an unexpected theme for art in the Age of Enlightenment. The only surprise may be that Mr Stubbs the horse painter should have been one of the first to articulate them.

Or is this so surprising? Stubbs, as a lower middle-class, provincial English painter at the beginning of the Industrial Revolution, would surely have been in a better position than most to see and understand the effects of rapid social change and the disruption it could bring. As an avid student of nature, he was sensitive to its destruction and to the threats posed by industrialisation to the English ideal of settled, especially rural, domesticity. In religious terms, the Industrial Revolution represented the second Fall, the end of an idea of paradise, a descent into anarchy and despair. Stubbs's painting is a tragic warning.

The landscape in which his drama takes place tells us as much. Behind the horse we see a placid scene of rolling hills and artfully arranged copses, a domestic landscape, in other words. The lion, on the other hand, has sprung from a quite different environment. It is, despite its fantastic appearance, a real place – Creswell Crags, on the border of Nottinghamshire and Derbyshire – but it is not

depicted as real. The gnarled tree, darkened foreground and ominous sky make clear that this is Wild Nature incarnate. If we read the painting as a literal narrative, the alien interloper must triumph, the storm will engulf the countryside and civilisation will fall. Nature overcomes culture; animal passions overwhelm reason.

For Stubbs, the 'horse painter', horses represented private property. Perhaps his painting can also be seen as a story about loss of privilege or at least the shifting economic and political balance which threatened the stability of his own world. Perhaps, at a more personal, psychological level, it shows the battle between the conscious and the unconscious, between the forces of good and evil within the self, between innocence and guilt – all of which brings Piccinini's family to mind again. The possibility of a sexual interpretation of the painting will strike us immediately. While an eighteenth-century viewer might have got a strong whiff of eroticism, we are better armed to articulate it.

It is the almost surreal isolation of Stubbs's lion and horse in a curiously impassive setting that makes his picture so terrifyingly alive. This might simply be the result of the artist's rather peculiar method – he put the animals in first, then painstakingly filled in the landscape around them. From our perspective today, however, the very artificiality of the scene adds its own emotional charge, highlighting the oppositions and contrasts that are the real subject of the painting.

By the beginning of the eighteenth century, traditional, popular notions about the natural world, tainted as they were with fantasy and folk wisdom, had become irrevocably separated from objectified scientific opinion. Distinctions between people and animals began to break down as anatomical comparisons, of just the sort carried out by Stubbs, began to show the physical similarities between them. At about the same time, however, especially in England, Romantic poets and artists began to see nature as a reflection of human emotions and moods. A sympathetic interest in animals developed, which led to the first concerted protests against blood sports and vivisection. Before this time, the spectacle of a lion attacking a horse would more likely have been seen as jolly sport or a manly affirmation of power politics. Stubbs, by the middle of the eighteenth century, could count on his audience's compassionate

interest in the horse's plight and therefore its ability to understand the image as cultural metaphor.

It is as a narrative of human responsibility and compassion that we, the inheritors of Enlightenment ideals, are most likely to interpret the painting today, which is just the sort of reading most of us will bring to *The young family*. We feel compassionate towards this mother and her infants precisely because we know them to be against nature. No process of evolution could have produced such oddities. They could not have any independent existence since they have no natural environment, as the stagey white leather bed on which they lie suggests. In that respect, they can be seen as an allegory of the contemporary urban human condition.

Yet they breed true to type, so they are not chance mutants like the so-called Elephant Man, or like the families with tails, the children born with cloven feet or the abominable sheep and pigs that crop up in folklore from time to time. Darwinian evolution randomly selects genetic traits that favour survival and reproduction. Genetic engineering, like the selective breeding of domestic animals, is different in that it is not random but goal oriented. Stubbs's thoroughbreds are a perfect example of creatures completely foreign to nature that have been bred for human purposes, and it's their forced, unknowing conformity to human ideals of beauty that seems to haunt him. In the case of Piccinini's family, however, as with certain extreme breeds of show birds or lapdogs, that goal appears to have been entirely frivolous. It's a revealing reversal: a random process produces order while here an orderly process, misapplied, has led to anarchy. Like Stubbs, Piccinini is only too aware that chaos can be the result of ordered enquiry, that reason and unreason, far from being opposites, are often close bedfellows.

Unlike the blue check Pomeranian pouter pigeon, which has not the slightest inkling of its own absurdity, Piccinini's bloated mother is quite capable of reflecting on her condition. You can see it in the resigned yet intelligent expression on her face. It's her awareness of

her own predicament and of her powerlessness to do anything about it that we are likely to find especially unnerving, because it is so characteristically human.

Still, there's always the comforting realisation, after the initial surprise subsides, that she is entirely fictitious: not a real creature at all but an abstract idea realised in plastics. Were she and her pups alive and breathing, our responses would be entirely different. Fortunately, this is art, not life – not yet anyway. The scenes that Stubbs and Piccinini have conjured up are both startlingly realistic while at the same time impossible, the Stubbs because pedigree stallions and lions do not coexist in the English countryside, the Picinnini because her creatures, however convincing, are anatomically impossible. Both works present us with a kind of paranoid realism, to borrow a term from a recent London exhibition. In Wordsworth's and Coleridge's terms, then, they take the familiar and make it strange, not by simply re-presenting it in a different form or context, as in the case of the art of the everyday I looked at earlier, but by an act of imaginative transformation.

That in itself might tell us something about the times in which each of these works of art was created. After all, the desire to make things strange, even when genuinely transformative, is conservative at heart. It is a response to boredom, a longing for renewal only within established patterns of thought. Defamiliarisation, instead of searching out something new and fresh to replace what has become too familiar, tries to alter our perception of the old. To see things with new eyes is not the same as seeing new things.

Nevertheless, although both the Piccinini and the Stubbs are anxiety-ridden responses to times of social upheaval as an old order gives way to a new, unknown and potentially threatening one, it seems to me that the Stubbs is the more optimistic work. Drawing on the past for sustenance, it looks to the future with trepidation but courage. Piccinini appears to be more resigned and accepting. There's too little fight in her.

Stubbs suggests some sort of overthrow of the established order which, of course, always hints at renewal, whereas Piccinini seems to be saying that horror arises naturally and insidiously from the established order and is, in turn, absorbed back into it, therefore,

by implication, having a certain inevitability. Stubbs, even as he warns of civilisation being overwhelmed by savagery – that is, of human passion overtaking human reason – reaffirms, through his method, a belief in the effectiveness of rational enquiry. Piccinini, on the other hand, expresses a concern that, as science reveals to us more about our origins and our inner workings, we will become less responsible for our actions. She may, of course, be right, but it's a gloomy prognosis nevertheless, allowing us very little room for manoeuvre.

It's a prognosis that is, I think, unconsciously reinforced by Piccinini's much more literal approach to realism. The imagined environment in which the attack on the horse takes place gives it, as we have seen, a metaphorical context as well as an added emotional charge, the landscape acting as Stubbs's Greek chorus. Piccinini situates her family in our actual world. To all intents and purposes these are real creatures sitting on a display box in the gallery. This may reinforce their isolation in an environment that is not their own, as I have suggested, but it also discourages any metaphorical reading. That this is a limiting factor can be best appreciated by looking at another of Piccinini's works.

Siren mole: exellocephala parthenopa (2000) is a tableau involving two computer-animated mole-like mutants in a display case set into the wall. This earlier work differs from *The young family* in several ways, which the catalogue of the Australian Centre for Contemporary Art exhibition briefly skirts around without ever homing in on.[3]

The floor of the display case is covered in real sand; a tap is mounted on the wall above a bowl filled with water; a food bowl has been tipped over, spilling its real food; a (mock) surveillance camera keeps watch from above; a pair of rubber gloves hangs from a hook; and so on. The effect of all this distracting gadgetry is to turn this from an artwork into a sideshow. The siren moles have even been photographed for art magazines in actual bushland, crawling across rocks among the grass, as though they've just been chanced upon by a David Attenborough camera crew. It is, I think, this rather pernickety imitation of outward appearances that constitutes the work's most significant weakness.

The catalogue claims that the siren moles exist 'in a parallel world of plastic space'. I'm not sure what 'plastic' signifies in this context, but it seems to me that they are situated not in any parallel world at all, but firmly in ours, which is exactly what discourages – perhaps deliberately – any metaphorical interpretation of them. Stubbs's fantastic, although still realistically depicted, landscape *is* a parallel world: the world of the imagination.

Our demand that everything – television shows, movies, zoo enclosures, works of art – be as 'realistic' as possible is a symptom of our materialism, suggesting that we might have lost the capacity for imaginative recreation. We are so much in this world we can hardly conceive of parallel ones any more. The movie version of *Chicago* provides one revealing example. In the 1940s and 1950s, audiences could happily accept the preposterous notion that people in musicals might burst into song at the drop of a hat. Lovers didn't whisper, 'I love you', they sang it, in two-part harmony with full orchestral backing, as they danced down Broadway among the traffic. It was accepted that theatre had its own conventions and was not the same as real life. For the *Chicago* movie, although not, interestingly enough, for the stage version, scenes involving singing had to be constructed as 'dream sequences' taking place in the minds of the characters, because this was the only way those characters could remain believable. Contemporary audiences can't be trusted to suspend their disbelief. Even fantastic creatures such as Warlocks and Hobbits have to be situated in a world that appears as true to life as possible.

Piccinini, although drawn to Romanticism – to a kind of techno-sublime – and given to extraordinary flights of fancy, is constantly pulled back by exactly this kind of materialistic literal-mindedness. She has discovered a powerful metaphor for our times, but keeps reducing it to metonymy. To put it perhaps a little too bluntly, she appears to lack the courage of her convictions. Although she is not afraid to tackle big metaphysical concerns, she appears not to have fully realised the size and power of the serpent whose tail she has taken hold of.

Piccinini's approach also prompts other, more awkward, questions, ones that apply to a good deal of contemporary art practice. If, for example, her works are about human interactions with nature, which they undoubtedly are, although we might argue over the extent to which this is so, then how much does Piccinini know about nature? It's a question we don't often ask of artists, especially those whose work is meant as commentary on some issue of social or cultural concern: 'What are your credentials?'

Many years ago, Giles Auty responded to another critic's claim that Damien Hirst's bisected cow told us something important about life and death by saying, 'I don't need to be told anything about life and death by a twenty-one-year-old.' Pompous, yes, but if you're over forty, you'll know exactly what he meant. We cannot just take artists, or critics or curators, at face value. We must make a judgment about whether the subject they are dealing with is one they have mastered, or at least properly thought through.

Piccinini has obviously thought deeply about her subject, and it is also clear that she has intuited much. Her work has conceptual complexity. The problem, however, is that that conceptual complexity is not brought to full realisation by the artist, since she does not make these things herself, but employs a team of technicians and fabricators. 'I always start,' she says, 'with a very strong image of what I want to see at the end of the process, but that image is not always perfectly literal. Sometimes I have to describe it in terms of qualities rather than exact forms, while at other times I have a quite exact drawing or computer model. I then find the right people to help me bring this thing into being ... During the production phase the process becomes more collaborative, and the work often evolves in a positive way but it is more in the details. I am always there to make sure that the essential ideas come through.'[4]

One critic has likened this to the workshop practices of the Renaissance masters, an amusing bit of wishful thinking on his part. Others are not inclined to be so generous. The now not uncommon idea that artists can farm out their ideas to be fabricated by commercial and industrial manufacturers, which actually takes its cue not from Michelangelo's bustling studio but from twentieth century industrial design practice, makes many people uneasy, and for good reason.

Given that she expresses an interest in exploring the relationships between humans and the rest of the natural world, it is exceedingly odd that Piccinini shows no interest at all in process. Her approach is that of an industrial designer. Having come up with a concept, she has it brought to fruition by others. Her relationship to her art is much like that of the engineers and planners who 'completed' Gaudí's Sagrada Familia. It's all about getting the desired result, not about the processes of work. Nature doesn't enter into it.

This is not an argument about those much derided 'craft skills' – I'm not talking about Piccinini's abilities – although I have to say that, like most other people, I believe there is real pleasure and delight to be gained from seeing artists displaying their manual skills, despite the academy's denigration of them and of the very idea that art might be a source of pleasure and delight. Few of us are impressed by empty demonstrations of technical brilliance unless we feel they have been harnessed to some more important end, but we naturally look for, and admire, evidence that artists have mastered their techniques and can do what they do with flair and confidence.

My argument is more specifically one about whether Piccinini's works are the natural outcome of a process of discovery, or whether they are conceived, manufactured and marketed as mere products: whether, in other words, she is an artist or a designer. I think she is the latter, and I believe the distinction matters. Piccinini makes art about nature, but she does not make art as though that were, in itself, a natural process. To that extent her installations remain at the level of concepts: 'rational, abstract and tectonic, the work of the engineer or constructor rather than that of the "artist"' – to borrow from Bernard Leach. We sense her lack of involvement.

That Stubbs spent years of his life carefully dissecting horses is not incidental but central to his painting. You can see the love, respect and understanding there on the canvas. (His lions look wooden and unconvincing by comparison.) Stubbs's paintings, considered together, are a part of that dissection. Whether he's wielding a surgeon's scalpel or a paintbrush, it's all part of the same process.

We hardly pause to wonder how the people who realise Piccinini's concepts came by their skills. We don't even really know or care who they are, although the artist always thanks them, albeit in small

print in some less than prominent place, since, as mere artisans, they cannot be allowed to share top billing. We just accept that they work in an industry with the technology and the buying power to do whatever is asked of it. We expect that the results will look convincing because we know that modern technology can achieve almost anything. The way in which these creatures are fabricated does not contribute to their meaning any more than the materials they are made from do.

As a result, although they may suggest cultural and social narratives, Piccinini's works are not part of any internal narrative of creation. As viewers, we must begin with the work as it is presented to us and then formulate our responses. Any information we are given about how the work came to be here in front of us is bound to be incidental, no matter how engaging in itself. To be told that Piccinini spent 'a lot of time drawing in anatomy museums'[5] after she left art school is not the same as being told that Stubbs drew the muscles and sinews of horses as he dismembered them. We're not sure why Piccinini's drawing exercises should matter, since we can see little direct evidence that she is using them, but we can see exactly why Stubbs's paintings could not even have come into existence by any other means.

If the finished result is all that matters, if the process by which it came to exist is irrelevant, and if that process is immune to the particularities of place and circumstance – if, in other words, the end justifies the means – then it's very difficult for works of art to transcend their status as commodities in the global market.

At the same time as I was collecting my thoughts about Piccinini's young family, I happened, quite by chance, to come across a book called *Nature via Nurture: genes, experience, and what makes us human*, by the British zoologist Matt Ridley. Ridley's book, as we would expect, is an argument based on systematic research. In order to put his proposition – or his series of propositions – he must first outline those of others and demonstrate why he believes they are wrong or inadequate, carefully considering, then refuting, all

possible objections. He must then convince us that his theories are better at explaining the facts about the subject. His argument is dialectical and it must be rigorous if we are to take him seriously.

The rational, step-by-step exposition in Ridley's book led me to wonder what connection it might have to Piccinini's imaginary mutants. What had her artworks actually taught me about the subject of genetics? Might Ridley, I wondered, have benefited from studying *The young family* before he put fingertips to keyboard? Would his arguments have been influenced by it in any way?

If such questions appear to miss the point, they at least reveal something of the confusion that reigns when we talk about works of art as carriers of ideas. We have even coined an ugly neologism – 'ideas-based art' – which is meant to put art that supposedly investigates issues of social concern above that which is merely aesthetic. Artists often claim that they are 'exploring' or 'investigating' something or other, although they rarely appear to have much idea of what the process of exploration or investigation might involve.

Such confusion is characteristic of the essays in the catalogue of Patricia Piccinini's survey exhibition at the Australian Centre for Contemporary Art, which cannot quite decide whether her works are about the rational exposition of ideas or about emotion and perception. We are told, for example, that Piccinini offers up 'empirical evidence', that her works contribute to 'the tumultuous progression of ideas' and are evidence of 'physical and metaphysical enquiry'. She is 'investigating', 'developing an argument', and so on.[6] We are treated to potted histories of stem-cell research, evolution, cloning and in vitro fertilisation as if her works formed an integral part of those histories.

If any of this were true, then Matt Ridley would have been well advised to study Piccinini's young family. But of course we do not seriously believe that scientists should go to works of art in the hope of furthering their knowledge of their disciplines. Art is not about ideas in this particular sense, and Piccinini has nothing to contribute on this score.

This wasn't always the case. In Turgenev's *Fathers and Sons*, for instance, the nihilist Bazarov, who has no time for art because, to him, it has no practical use, is looking at some drawings of Swiss mountains in Anna Sergeyevna's album. He is annoyed by her

suggestion that he could not possibly be interested in them. 'You said that, because you assume that I have no feeling for art – and it is true, I haven't. But those views might interest me from a geological standpoint, for studying the formation of mountains, for instance,' he tells her.

In 1859 that probably didn't sound nearly as quaint as it does today, although Bazarov's insistence that art is interesting only insofar as it can contribute to some field of knowledge finds many an echo in the modern academy.

George Stubbs's *The Anatomy of the Horse* certainly contributed to scientific knowledge. At least one critic has called him, along with Leonardo, the greatest painter–scientist in the history of art.

Yet it is hardly possible today for an artist to be also a scientist – although, revealingly, there is no reason a scientist cannot also be an artist. Since Newton, science has become too specialised. Artists now cannot hope to be at the forefront of any field of empirical knowledge. Since Stubbs's exact contemporary, Immanuel Kant, put philosophy itself on a scientific basis, artists are probably unable to make any substantial contribution even to the history of ideas. Visual art that is primarily concerned with ideas, other than purely artistic ones, has, since Kant, been necessarily reduced to the role of commentary.

If we want to know something about cloning, we don't go to the Piccinini survey exhibition because, despite the catalogue essays, we know we will not find any evidence there of rational enquiry, investigation of evidence or the development of argument. We go, instead, to books like that of Matt Ridley, or to a television documentary or an article in *Good Weekend* magazine.

Obviously it doesn't matter that *The young family* tells us nothing useful about genetic engineering. That there is no such thing as 'ideas-based art' – in the narrow sense in which that term is normally used – should be cause for relief. Despite what they might claim, artists rarely, if ever, explore or investigate issues of social, political or scientific concern. More characteristically, they adopt a given position, usually the commonly accepted one – multiculturalism is good, racism is bad, modern society is too materialistic, modernist architecture is dehumanising – and simply restate it in a different form. It is a way of making art appear useful, of giving it a purpose. It is a post-Marxist capitulation to instrumentalism.

What art can do, and what I think Piccinini's art does very well, is to suggest something about how we perceive and respond to knowledge. Art is no good at dispensing information, but it can help us to see things from a different perspective, suggesting poetic connections between various subjects, and leading us from the specific to the general. It is a way of articulating cultural memories, 'not to imprison us in the past, but to free us from the traps of habit'.[7] Art is, to come back again to that word, transformative – or at least it has the capacity to be.

Patricia Piccinini has said, 'I think there is a real place for wonder in art'.[8] I agree with her, but I'm not sure whether she and I would define wonder in quite the same way. I see her work as having just as much to do with the sublime, which is wonder's philosophical opposite.

A lion attacking a horse is a very early manifestation of the sublime in art. Stubbs was painting it at about the time Edmund Burke was writing his famous treatise on the sublime and the beautiful, which was first published in 1757. This painting might almost be said to depict the very moment at which classicism gives way to the Romantic imagination. *The young family* might, in some respects, be interpreted as marking the historical moment at which the sublime gives way to wonder – although that might be just a bit of wishful thinking on my part.

One of the reasons the sublime is such a powerful influence on modern thought is that it has taken the place of religion. It's a way of framing our thoughts about our relationships to nature, our obsession with romantic love, and our absorption in our own subjectivity: a way of coping with those fears of death we're told we shouldn't be having –or at least that art shouldn't be concerned with. The sublime allows us to hide religious feelings under the guise of aesthetics.

We tend to deal with religious art by pretending it doesn't exist or, when it simply can't be ignored, by skewing it into something else.

In this way Aboriginal art is presented as an expression of some vague connection to the land, a sort of proto-environmentalism, an object lesson in how we might treat our natural environment if only we were more sensitive and more alive to ancient tribal wisdom. The religious art of cultures other than our own is, of course, relatively easy to sentimentalise. Christian religious art is a good deal more problematic.

The most obvious fact about Colin McCahon, for example, the one that hits you in the eye the moment you look at one of his scrawly, rambling, didactic and darkly passionate paintings, is the one that causes most embarrassment: he was a religious artist. Even worse, he was a Christian artist. Many of his paintings are Biblical texts spilled directly on to canvas. 'In the beginning was the Word, and the Word was with God, and the Word was God.' McCahon's project was to make God's word manifest.

Yet, while contemporary art museums and galleries happily take pornography, violence and obscenity in their stride – while Serrano's crucifix in a shower of piss is enthusiastically promoted as important and cutting edge – McCahon's Christian iconography is frequently passed over as if it were an unfortunate lapse of taste. Curators and critics concentrate, instead, on his art-historical importance, explaining why the formal structures of his paintings have been so influential, or they turn McCahon's Christianity into a sort of pagan nature-mysticism, tossing around reassuring words such as 'spirituality', 'faith', 'the sublime', 'nature', and so on, as though all these concepts belong in the same box, marked 'otherworldly'.

If the experts so often avoid the point, the public is much less inclined to. Visitors to the National Gallery of Australia stand in awe of McCahon's great *Victory over death* (1970) because it quite literally has something to say to them. Even if they are not Christians, it awakens in them something of the import of the faith. Paradoxically, although *Victory over death* is all words, it is not a form of discourse. It is pure ecstatic reverie.

The rather odd phenomenon of wilderness photography presents a more workaday and, in many respects, a more formulaic manifestation of the sublime.

Being a relative newcomer to Tasmania, I am fascinated by the popularity of this genre here and by the artistic status it is generally

accorded. Although it has its origins in America and may be found wherever there are snow-capped peaks and rugged mountain valleys, wilderness photography has developed into something authentically Tasmanian: a truly regional artistic genre. Only the art produced in northern Australia's Aboriginal communities can claim a comparable attachment to place, and the exceedingly rare concurrence of a certain critical respectability and great popular appeal. Not too many contemporary artworks can be found on the walls of leading national and overseas galleries and, at the same time, on postcards and calendars in every local newsagent, as those of Tasmanian photographers Peter Dombrovskis and Olegas Truchanas can. For these reasons alone, this is an artform worth taking a closer look at.

Wilderness photography is art's living fossil. Although the means of its recording might have changed from oil on canvas to light-sensitised paper, the iconography is straight out of the seventeenth and eighteenth centuries. In saying this, I don't intend any disrespect. In the animal and plant kingdoms, living fossils are still living because they have life in them, and their environment continues to provide them with sustenance. And so it is here. Physical sustenance is, of course, guaranteed by the lucrative tourist industry. This is one artform that has successfully transcended its niche and conquered the mass market. In less tangible terms, wilderness photography is sustained by the same sort of urban nostalgia that oils the wheels of the environmental movement.

Perhaps the most striking thing about contemporary wilderness photographs is that they hardly ever give any indication that human beings exist. No tourist buses sully the cliff tops, no boats drift on the placid waters of the lakes, not even a footprint stains the virgin sands.

This, of course, is part of the territory. Wilderness photography depends on the semi-religious notion that paradise is still out there, a pure and innocent land untouched by human hands, promising spiritual renewal. Tasmania's tourism industry trades on this idea continually, luring jaded mainland urbanites with the promise of Eden and carefully screening from them any suggestion of modern industry. The immense popularity of these types of images – in exhibitions and books, on postcards and calendars – is an indication of just how seductive such fancies can be. The doyen of the genre was

Peter Dombrovskis, whose famous photograph of a bend in the Franklin River helped save that wild waterway from the depredations of the Hydro-Electric Commission in the seventies.

It is the very conservatism of these photographs that makes them so interesting as social documents. At a time when innovation and novelty are valued in art above all else, it's intriguing that such a defiantly traditionalist artform should have gained so much art-world credibility through its association with left-wing politics. Wilderness photography has been successfully co-opted as the positive message of the green movement – a counterbalance to all the protest and complaint – and it is this that lends it critical credibility. In this respect, wilderness photography is not unlike Aboriginal dot painting, which similarly transcends its artistic conservatism by means of its association with progressive political ideals.

At the same time, the Tasmanian premier, Jim Bacon, who tenaciously defends the clear felling of old-growth forests in the name of jobs, has unblushingly put his name to an annual wilderness photography prize. One cannot, of course, expect politicians to have much appreciation of irony, but an art that can so readily be used to serve the interests of two opposing sides is, at the very least, compromised.

There's no obligation on landscape photography to consciously express a political viewpoint, of course. Most wilderness photographers would say that they simply want to capture the beauty of Tasmania's natural scenery. Yet they do so in very particular, culturally loaded, ways.

Take, for example, Peter Dombrovskis's *Rock Island Bend, Franklin River, south-west Tasmania* (1979), the image that helped save the Franklin all those years ago. It is composed – I presume unconsciously – according to classic picturesque principles. If we compare it, for example, to Claude Lorrain's *Landscape with Hagar and the angel* (1646) in the National Gallery, London, we find that the arrangement of elements is much the same, except that Dombrovskis has replaced Claude's ancient castle with a natural rocky outcrop, his stone bridge with an arch of trees and his placid lake with a swirling torrent. Senator Bob Brown says that, when he and Dombrovskis were searching for an image to promote the Franklin River campaign, they seized on this one immediately. They

knew instinctively that it would strike a chord, because it conveyed so well the beauty of the Tasmanian wilderness. The real reason this picture stood out, I would suggest, was that its composition conformed to principles that were deeply embedded in cultural memory. As Joseph Addison observed way back in 1712, 'We find the Works of Nature still more pleasant, the more they resemble those of Art'.[9]

Dombrovskis frames his view with rocky cliffs on either side that accentuate its theatricality and stop our eye from wandering out of the picture: a common enough picturesque convention. Between the cliffs, on centre stage, the river's swirling eddies form dynamic patterns that lead us in, past the rocky outcrop which is the centre point of the picture, to glimpses of mist-shrouded forest beyond. The mist perfectly replicates the atmospheric perspective employed by the painters of picturesque landscapes.

Although the structure might be Claudian, however, the effect is not. Where Claude is placid and pastoral, Dombrovskis emphasises wildness. His Tasmanian landscape is inhospitable, mysterious, uninhabited. Nevertheless, people are here by default, as the tightly controlled composition makes clear by implicitly connecting this new-world wilderness arcadia to the old-world pastoral one. Of course, the very act of photographing the place signals a human presence, putting us, as it were, in the picture. The scale of Dombrovskis's views and the rugged inaccessible nature of the terrain he favoured convey not only the grandeur of God's creation but also, by implication, our own smallness and insignificance. These photographs are meant to put humanity in its place and to serve as a moral warning. The deep shadows, stormy skies and mists that are so much a part of the wilderness photographer's repertoire are hints of foreboding.

In common with all sublime landscapes, wilderness photographs of this sort are rent with terrible tensions between, on the one hand, nature benign and its alter ego, nature unleashed, and, on the other, between man as awed spectator and man as destroyer. One important reason that *Rock Island Bend, Franklin River, south-west Tasmania* has become iconic is that we know that it was this very place that would have been obliterated by the dam.

Many readers, I'm sure, will think that a discussion of wilderness photography has no place in a book about contemporary art.

The subject is awfully remote from the concerns of academic art theorists. By the same token, the concerns of academic art theorists are, as a rule, awfully remote from those of the rest of us. Hackneyed, formulaic and predictable these images may seem, but their popularity – and their critical acceptance in places such as Tasmania, where they have a particular social resonance – are an indication that we want our lives to have poetic meaning. We demand not so much answers to the big metaphysical questions, but some idea of which questions it's worth asking. And we don't appreciate being told that such questions are no longer relevant.

Personally, I don't think the conceptual gap between Dombrovskis's river bend and Piccinini's young family is particularly wide. Both acknowledge our almost animist fascination with, and our fears for, what Thoreau called 'that savage, howling mother or ours, Nature'. We long for a way of taming and coming to terms with those fears, of articulating them in ways that connect with what we already know and understand. After all, academic art theory has been largely silent about, if not contemptuous of, such matters for so long.

My problem with the arguments of anti-modernists such as Charles Green is that they are too reductive and simplistic. It is ironic, too, that the post-modernist artworld's critique of modernism should be so deeply rooted in, and so slavishly enamoured of, the mass culture of the United States – the world's last great enlightenment regime.

In order to condemn modernism *tout court* as a hegemonic grand narrative, it is first necessary to construct it as such. The writer and theorist Ihab Hassan, for example, once drew up a table of dichotomies which shows modernism as essentially about power and control and postmodernism as all playful dispersal. Modernism is, he claims, concerned with purpose, design and hierarchy, while postmodernism is about play, chance and anarchy. Modernism concentrates on the finished work, postmodernism on process. Centrality, narrative and transcendence are modernist; de-centring, anti-narrative and immanence are post-modern. And so on.[10]

Hassan did at least have the grace to express doubts about the usefulness of such binary oppositions – which are, surely, quite unpostmodern by their very nature – but others who have taken up the cudgel against everything the modernists stood for have been less circumspect.

Hassan's table is a wish list rather than a disinterested observation of the real world. Many of his oppositions are plainly counterintuitive, not least the claim that modernism is about product rather than process. What about Dadaist and Surrealist performances, Kurt Schwitters's Merzbau, process art, happenings, or, for that matter, Monet and Pollock? Most of the attributes Hassan ascribes to postmodernism could equally be applied to the eighteenth century – to its literature, at least, to Fielding, Swift, Sterne, but also to Hogarth, to Goya's *Caprichos*, the playful taste for the Gothick and Chinoiserie, and the grottos, water tricks and ornamental hermits in eighteenth-century gardens.

One of modernism's most important legacies to postmodernism – one that also has its origins in the Enlightenment – is that of wonder.

While the sublime may be called the aestheticisation of fear, wonder is the aestheticisation of delight. And it may be relevant, if we still believe in national stereotypes, that while the sublime springs from the writings of a German philosopher (Kant), the formulation of a philosophy of wonder was the work of a Frenchman (Descartes).

In his exhilarating treatise on the subject, *Wonder, the Rainbow, and the Aesthetics of Rare Experiences*, the American writer Philip Fisher comes up with his own set of dichotomies to distinguish between wonder and the sublime. In art, for example, Géricault and Delacroix represent the sublime, Manet and Matisse wonder; in architecture, the neo-classical temple style often employed for nineteenth century public buildings is sublime – horizontal, heavy, earthbound, solemn, noble – while the skyscraper, especially the postmodern skyscraper, expresses wonder, being light, vertical, transparent, and full of surprise. By this reasoning, Mies van der Rohe's Farnsworth House, far from being 'a symbol of modernism at its hegemonic, dominating extreme', can be read as an expression of wonder in glass and concrete.

Surprise, according to Fisher, is the key. It's the quality that so much modern and postmodern art have in common. But surprise is not, he warns, the same as shock, another quality that modern and postmodern art often share. Shock, as we have already seen, is a last-ditch response to boredom and habit. It is wholly negative and always has about it an air of desperation and despair. In addition, when artists say that their aim is to shock or provoke in order to jolt audiences out of their presumed complacency, they are assuming a position of moral superiority, playing political games of power rather than doing anything to try to counter them.

Most of us would, I think, regard shock as being more charac-teristic of modernism than of postmodernism. We think, for exam-ple, of Dadaism and Surrealism as the art of shock: despondent, desperate and anxious. So it would seem to me that the sort of shock tactics we find in the performance pieces of Mike Parr, Stelarc or Jill Orr, and in the paintings of, say, Juan Davila, represent mod-ernism's dying breath rather than anything new – not necessarily their work as a whole, I must stress, just this, admittedly fairly cen-tral, aspect of it.

On the other hand, a good deal of what passes as postmodern art goes to the other extreme, settling for what Fisher, citing Descartes, calls astonishment. 'To be dumbfounded by miracles or tricks, the bizarre and the odd,' he writes, 'is just as hostile to the process of wonder as the stupidity that finds nothing surprising. Astonishment is the pleasure we take in the face of magicians' tricks. It never leads to explanation or even to thought. Astonishment is a technique for the enjoyment of the state of not knowing how, or why.'[11]

Miracles, tricks, the bizarre and the odd: that seems to sum up so much of what we experience when we do the rounds of the com-mercial galleries. And it suggests why we are so often dissatisfied, because we find all to often that we are not led on to thought or reflection. Shock and astonishment are frequently the only alterna-tives on offer, along with a sort of school-masterish didacticism that wants to convince us of nothing more than our own supposed inability to think through topical social issues and reach our own conclusions about them.

The reason this chapter has been so taken up with a discussion of Piccinini's *The young family* is that, despite the limitations I have

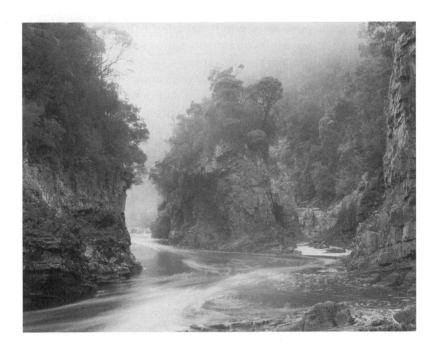

Peter Dombrovskis 1945–1996
Rock Island bend, Franklin River, southwest Tasmania, 1979
Colour photograph
Reproduced courtesy Liz Dombrovskis and West Wind Press, Hobart

outlined here, it provides a good example of the sort of art that seems to me best suited to communicate meaningfully to us now at the beginning of the twenty-first century.

For a start, it is a work that really does communicate, at a time when so much art revels in obfuscation and difficulty and so many artists seem to be interested only in chatting among themselves. The Piccinini survey exhibition at the Australian Centre for Contemporary Art was genuinely popular: members of the public, whether they knew anything about art or not, clearly got a real kick out of it. They did not feel they were being patronised or excluded.

The young family is suggestive and allusive, not didactic or self-consciously intellectual. It manages to surprise us without resorting either to shock or to superficial trickery. It engages our imaginations by means of inventiveness and a sense of fun then leads us on to thought and contemplation. It is precariously balanced between the sublime and wonder – between fear and delight. Importantly, it takes the new and unfamiliar, then normalises them by fitting them into the fabric of what is known. By that means, it helps us to overcome our fear of the new.

When we are made to feel insecure by constant change, we naturally come to have qualms about anything unfamiliar. Those doubts can breed distrust, cynicism and feelings of impotence, contributing to the breakdown of social order by whittling away our sense of self. Our suspicions may be aroused that all innovations and novelties might turn out to be dangerous, especially when they are beyond our sphere of understanding.

Modernism's solution was to blame us for not being able to cope. Modernist artists, assuming that the problem was simply that we were conservative and unadventurous, sought only to subject us to a constant barrage of the new and unfamiliar, in the hope that we would eventually submit, if only from sheer exhaustion. It's a solution still favoured by those who see it as art's job to disturb, shock and unsettle. We don't need that. It leads nowhere. Besides, we are disturbed, shocked and unsettled enough as it is. It's not so much a matter of making the familiar strange any more, but rather of making the strange familiar.

'We know that what is at stake is poetry,' writes the American literary critic Geoffrey Hartman, 'or the faculty of wonder itself: the

romantics' fear, and ours, that a progressive disenchantment of the world, associated with the Age of Reason, will make outsiders of us all.' We are, he goes on, 'in limbo, in suspense between two coldnesses, that of a world without its animating supernatural, without gods or ghosts, genii or genial surprises, and a world created by those who engineer spiritual revolutions, who exploit and instrumentalise our obstinate hunger for the wonderful, which remains a dream always ready to enter the waking life'.[12]

That, surely, is art's challenge now.

NOTES

Introduction

1 V. Lynn, 'Valuing Art', in *Australia Council News*, issue 10, October-Nov, 2002, p. 7.

2 M. Wood, *In Search of Shakespeare*, Television documentary for BBC1, 2003

Chapter One

1 Quoted in D. Harvey, *The Condition of Postmodernity*, London, Blackwell, 1990, pp. 7–9

2 H. Arendt, 'Walter Benjamin: 1892–1940', introduction to W. Benjamin, *Illuminations*, London, Fontana, 1992

3 C. Davidson, 'The Long Legged Fly-Sehnsucht and Stillness', in *John Young: Silhouettes and Polychromes*, Melbourne, 1993, Schwartz City, p.13

4 A. Geczy, 'What's the Point of Painting These Days?', in *Art Monthly Australia*, November 2002, pp. 9–10

5 T. Lubbock, 'What's it all About?' in *London Review of Books*, 6 April 1995, p. 3

6 Quoted in Lubbock, 'What's it all About?

7 H. Kramer, 'New Criteria for Modern Painting', in *Modern Painters*, vol. 2, no. 2, 1989, pp. 80–1

8 In conversation with the author

9 C. James, 'Just a nice man speaking', in *The Times Literary Supplement*, 2 May 2003, p. 18

10 P. Hill, 'Is There a Doctor in the Art School', in *Art Monthly Australia*, October 1995, pp. 11–14

11 P. Hill, 'Mrs Aristotle's Teeth: the Challenges of Research Funding for University Art Schools', in *Art Monthly Australia*, November 1995, pp. 25–8

12 A. Lee, 'Art Schools and Academe', in *Art Monthly Australia*, December 1995, pp. 4–5

13 F.T. Marinetti, 'The Founding and Manifesto of Futurism, 1909', in U. Apollonio (ed.), *Futurist Manifestos*, London, Thames and Hudson, 1973, p. 23

14 J. Clay, 'Art Sauvage: La fin de galeries' in *Robho*, no. 4, fall, 1968. Reprinted in L. Lippard, *Six Years: The Dematerialisation of the Art Object*, London, Studio Vista, 1973. p. 59

15 P. Cabanne, *Dialogues with Marcel Duchamp*, London, Thames and Hudson, 1971, p. 71

16 Lippard, *Six Years*, pp. 188–9

17 H. Haacke, M. Eagle, and P. Timms, 'Different Realities: a Collage of Correspondences', in *Art Monthly Australia*, November 1994, pp. 4–9

18 Haacke, Eagle and Timms, 'Different Realities'.

19 N. Serota, *Experience or Interpretation: the Dilemma of Museums of Modern Art*, London, Thames and Hudson, 1996, pp. 8 and 9

20 Serota, *Experience or Interpretation*, p. 15

Chapter Two

1 P. Costantoura, *Australians and the Arts*, Sydney, Federation Press, 2001, p. 6

2 Costantoura, *Australians and the Arts*, p. 7

3 'Alston Critical of Art for Art's Sake' in the *Australian*, 11 December 2002

4 'Would you like Art with that?' in the *Australian*, 1 November 2002, p. 15

5 Costantoura, *Australians and the Arts*, p. 241, 242 and 243

6 G. Safe, 'Neglected discipline stands tall', in the *Australian*, 20 March 2003, p. 10

7 Safe, 'Neglected discipline stands tall'

8 Quoted by Peter Jenkins in *Modern Painters*, vol. 4, no. 2, 1991, p. 75

9 F. Jameson, *Postmodernism, or, the Cultural Logic of Late Capitalism*, London and New York, Verso, 1991, pp. 4–5

10 Based on *Money for the Visual Arts*, published by the National Association for the Visual Arts, 6th edition, 2002–3

11 G. Walden, 'Leave your weapons at the door', in *Times Literary Supplement*, 26 September 1997, pp. 10–11

12 P. Sutton, P. Jones and S. Hemming, 'Survival, Regeneration and Impact', in P. Sutton (ed.), *Dreamings: the Art of Aboriginal Australia*, Melbourne, London, Auckland, Penguin, 1988, pp. 203–4

13 M. Langton, 'The two women looked back over their shoulders and lamented leaving their country: Detached comment (recent urban art) and symbolic narrative (tribal art)', in *Aboriginal Art in the Public Eye*, Canberra, Art Monthly Australia, 1992–3, p. 8

14 'Painter makes black art rock', in *The Mercury*, 20 August 2003, p. 9
15 M. Hutak, 'Collectables', in *The Bulletin*, vol. 121, no. 30. Quoted on *The Bulletin*'s website, <http://bulletin.ninemsn.com.au>
16 Sotheby's Amsterdam, press release, 28 July 2003
17 Sotheby's Australia, press release, 24 June 2002
18 J. Burke, *Field of Vision*, Melbourne, Viking, 1990, p. 92
19 N. Rothwell, 'Dust to dust', in the *Australian*, 23–4 August 2003, pp. 4–5
20 G. Walden, 'Leave your weapons at the door'
21 R. Archer, unpublished letter to Heather Rose, convenor of the Arts for Forests group, 21 April 2002
22 'Bacon slams "cultural fascists"', in *The Mercury*, 17 April 2002, pp. 8 and 9
23 Archer, letter to Heather Rose
24 J. Carey, *The Intellectuals and the Masses*, London, Faber and Faber, 1992, p. 17
25 D. Gamboni, *The Destruction of Art: Iconoclasm and Vandalism since the French Revolution*, London, Reaktion Books, 1997, p. 257
26 P. Fisher, *Wonder, the Rainbow, and the Aesthetics of Rare Experiences*, Cambridge, Massachusetts, 1998, Harvard University Press

Chapter Three

1 Quoted on Callum Morton's webpage: Callum.Morton@www.contemporaryart.com.au
2 Quoted on Callum Morton's webpage
3 Quoted on Callum Morton's webpage
4 M. O'Toole, *The Language of Displayed Art*, Leicester, 1994, Leicester University Press, pp. 214–15
5 C. Green, *Peripheral Vision*, Sydney, 1995, Craftsman House, p. 8
6 R. Butler, *A Secret History of Australian Art*, Sydney, 2002, Craftsman House, p. 35
7 *Art Monthly Australia*, May 2001, p. 40
8 J. Watkins, *Every Day*, Sydney, 1998, The Biennale of Sydney, p. 15
9 Grant, in *Every Day*, p. 128
10 Butler, *A Secret History of Australian Art*, p. 18
11 Quoted in L. Floridi, *Sextus Empiricus*, London, Oxford University Press, 2002
12 J. North, *The Ambassador's Secret: Holbein and the World of the Renaissance*, London, Hambledon and London, 2002
13 T. Rabb, 'At 27 degrees to the universe', in *The Times Literary Supplement*, 6 December 2002, p. 27
14 Various authors, *Reporting the Arts*, New York, 2002, Columbia University National Arts Journalism Program, p. 12
15 Quoted in C. Banham, 'Coast canned for lack of watchers' in *The Sydney Morning Herald*, 30 May 2002, p. 37
16 Quoted in 'Aunty's blind spot', in the *Australian*, 26 June 2003, p. 13
17 In conversation with the author

18 Quoted in 'Aunty's blind spot'
19 R. Young (ed.), *Allan Mitelman, Paintings 1972-2002*, Melbourne, Victorian College of the Arts, 2002
20 W. Pater, *Studies in the History of the Renaissance*, London, 1873, quoted in W. Steiner, *The Trouble with Beauty*, London, William Heinemann, 2001, p. 48
21 W. Walker, *Rainbow Days*, Catalogue essay for Mori Gallery, Sydney, August 2002
22 N. Tsoutas, *Sugar Nights*, Catalogue essay for Greenaway Art Gallery, Adelaide, December 2000
23 A. Marsh, *Double Dutch*, Catalogue essay for Greenaway Art Gallery, Adelaide, April 2002
24 P. Fisher, *Wonder, the Rainbow, and the Aesthetics of Rare Experiences*, 1998, Cambridge, Mass., Harvard University Press, pp. 145–6

Chapter Four

1 G. Steiner, *Real Presences*, London, Faber and Faber, 1989, pp. 27–8
2 R. Williams, *Keywords, a Vocabulary of Culture and Society*, London, Oxford University Press, 1976, p. 269
3 B. Moeran, 'Japanese Ceramics and the Discourse of Tradition', in *Journal of Design History*, London, vol. 3, no. 4, 1990, pp. 213–34
4 E. Lucie-Smith, *The Story of Craft*, London, Phaidon, 1981, pp. 281
5 Various authors, *The Craftsman Potters' Association: a history*, London, Craftsman Potters Association, 1984, p. 5
6 Lucie-Smith, *The Story of Craft*, p. 90
7 B. Leach, *A Potter's Book*, London, Faber and Faber, 1977, p. 2
8 Leach, *A Potter's Book*, p. 2
9 Leach, *A Potter's Book*, p. 2
10 An informative account of this is *Zen in the Fifties*, by Helen Westgeest, Amsterdam, 1996, Cobra Museum voor moderne kunst
11 Potters had been interested in establishing an identifiably Australian style before this time, mainly through the use of native floral and faunal motifs. See P. Timms, *Australian Studio Pottery and China Painting*, Melbourne, 1986, Oxford University Press
12 Quoted in G. Cochrane, *The Crafts Movement in Australia: a History*, Sydney, 1992, New South Wales University Press, p. 159
13 K. Murray, 'The Future of Ceramics', in *Craft Culture*, vol. 2, no. 244, Spring, 2002
14 D. Modjeska, 'The Present in Fiction', in *Timepieces*, Sydney, 2002, Macmillan, p. 205
15 D. Moon, 'Ceramics and the haptic lapse', in *Craft Culture*, vol. 2, no. 244, Spring, 2002
16 Moon, 'Ceramics and the haptic lapse'
17 Quoted in R. Hughes, *Barcelona*, London, 1992, Harvill, p. 485

18 Hughes, *Barcelona*, p. 468
19 S. Cunningham, 'The Creative Industries', in *Designing Futures*, Perth, Craftwest, 2003, p. 34

Chapter Five

1 See K. Thomas, *Man and the Natural World*, New York, Pantheon, 1983
2 M. Elton, 'Choice products', in *The Times Literary Supplement*, 21 March 2003, p. 25
3 J. Engberg, *Retrospectology: the world according to Patricia Piccinini*, Melbourne, 2002, Australian Centre for Contemporary Art, p. 36
4 P. Piccinini, and A. Foster, 'Interview', in *Photofile*, no. 68, April 2003, p. 23
5 Piccinini and Foster, 'Interview'
6 Engberg, *Retrospectology*
7 J. R. Saul, *On Equilibrium*, Camberwell, Vic., Penguin, 2001, p. 237
8 Saul, *On Equilibrium*, p. 21
9 Quoted in M. Andrews, *The Search for the Picturesque*, Stanford, Cal., Stanford University Press, 1989, p. 39
10 Quoted in M.A. Rose, *The post-modern and the post-industrial*, Cambridge, Mass., Cambridge University Press, 1991, pp. 49–50
11 P. Fisher, *Wonder, the Rainbow, and the Aesthetics of Rare Experiences*, Cambridge, Mass. and London, Harvard University Press, 1998, p. 47
12 G. Hartman, *The Fateful Question of Culture*, New York, Columbia University Press, 1997, p. 24

INDEX